LEGIBLE SOVEREIGNTIES

Legible Sovereignties

Rhetoric, Representations,
and Native American Museums

LISA KING

Oregon State University Press Corvallis

Library of Congress Cataloging-in-Publication Data

Names: King, Lisa (Lisa Michelle), author.
Title: Legible sovereignties : rhetoric, representations, and Native American museums /
 Lisa King.
Description: Corvallis, OR : Oregon State University Press, 2017. | Includes bibliographical
 references and index.
Identifiers: LCCN 2017024580 | ISBN 9780870719127 (paperback)
Subjects: LCSH: Indians of North America—Museums_Case studies. | Rhetoric—Social
 aspects. | BISAC: LANGUAGE ARTS & DISCIPLINES / Rhetoric. | ART / Museum
 Studies. | ART / Native American.
Classification: LCC E76.85 .K56 2017 | DDC 970.004/97—dc23
LC record available at https://lccn.loc.gov/2017024580

COVER IMAGES: (*Top left*) Haskell Babies. Circa 1890. Haskell Archives, Haskell Cultural
Center and Museum, Haskell Indian Nations University, Lawrence, KS. (*Top Right*) Detail
of "Youth Mural," by the Saginaw Chippewa Summer Youth Work Program, 2002. Diba
Jimooyung, Ziibiwing Center of Anishinabe Culture and Lifeways. 2014. Photo by Lisa King.
(*Middle left*) Detail of "Fully Native" panel, 2004. Our Lives: Contemporary Life and Identities,
National Museum of the American Indian. 2014. Photo by Lisa King. (*Middle right*) Detail
of one of two Lenape (Delaware) "Penn" wampum belts, ca. 1682, as displayed in Nation
to Nation: Treaties Between the United States and American Indian Nations, 2014, National
Museum of the American Indian. 2014. Photo by Lisa King. (*Bottom left*) Center Banners and
Medicine Wheel from Honoring Our Children, 2002, Haskell Cultural Center and Museum.
2014. Photo by Lisa King. (*Bottom right*) "Ziisibaakodokaaning: The Sugarbush," 2004. Diba
Jimooyung, Ziibiwing Center of Anishinabe Culture and Lifeways. 2017. Photo courtesy of
Ziibiwing Center staff.

Oregon State University Press
121 The Valley Library
Corvallis OR 97331-4501
541-737-3166 • fax 541-737-3170
www.osupress.oregonstate.edu

To Julian, and his generation:
May we learn to tell these stories truthfully
and well, that you may know where you come from
and where we are going together.

Contents

Acknowledgments

I first want to offer gratitude. I began this project more than ten years ago, with the idea that Native and Indigenous museums were critical as meeting places between Native and Indigenous communities who wanted to engage the public with their own voices and a curious public that had little more than stereotypes to go on. What I quickly learned was that the stories of how to design effective communication and the resulting encounters were far richer than I could ever have anticipated, and that listening—as is mostly the case—was the best thing I could do. Any mistakes in the writing of this manuscript are my own, and what works is due in large part to the input, guidance, and encouragement of the following constellations of people and communities who have helped me make this happen. Anushiik—I am so thankful for you.

I am deeply grateful to the staff at the Ziibiwing Center of Anishinabe Culture & Lifeways for their time, the interviews they gave me, and their generosity with supporting materials and research. I offer my thanks to Director Shannon Martin, Assistant Director Judy Pamp, Curator William Johnson, Research Center Coordinator Anita Heard, and Inaugural Director Bonnie Ekdahl for their words and direction, and for their welcome to Ziibiwing. Thanks to the Saginaw Chippewa Indian Tribe of Michigan's Tribal Council for their support of my project. Thanks to Colleen Green and Josh Hudson for their pointers and perspectives on the work of Ziibiwing and its relationship to Central Michigan University and Mount Pleasant. And thanks to Kenlea Pebbles and Mike Evans for their steady support in good company and food on my research trips.

I am deeply grateful to past and present faculty and staff at Haskell Indian Nations University and the Haskell Cultural Center and Museum

for their help and time in building the HCCM's narrative. Thanks to the founding director, Bobbi Rahder; exhibit designer Theresa Milk; and current Director Jancita Warrington for their invaluable perspectives on the inaugural exhibit and the HCCM's future. I owe thanks in particular to Lara Mann, who served as my faculty sponsor for research through HINU's IRB process and provided vital help in finding resources.

I am deeply grateful to the staff at the Smithsonian's National Museum of the American Indian for their time and input in helping me understand the complex process of creating an institution like the NMAI and the opportunities and constraints offered by such a place. Thanks in particular to Curator and Head of Collections Research and Documentation Ann McMullen; Historian Gabrielle Tayac; Associate Curator Emil Her Many Horses; and Associate Curator Paul Chaat Smith for their interviews, time, and published work discussing exhibit work and strategy at the NMAI over time.

I send my thanks to my anonymous reviewers, who provided tough but excellent feedback that made sure I included my own voice and helped me to think through the needs of the various scholarly communities I am addressing. The book is all the stronger for your readings and suggestions.

I am indebted to my dissertation committee in the Department of English at the University of Kansas, who supported me planting the seeds for the long-term project through my dissertation research. Thanks to my codirectors, Frank Farmer and Scott Lyons, for helping me see it through, and to Bobbi Rahder and Amy Devitt for providing excellent feedback as the first iteration of the project developed. Thanks also to Bud Hirsch for helping me begin on this path.

Thanks again to Scott Lyons for his support in the full book's development, particularly in inviting me to the University of Michigan in 2015 to give a talk and participate in a peer review session of chapter 2. Thanks especially to Joseph Gaudet, Frank Kelderman, Stefan Aune, Michelle Cassidy, Sophie Hunt, Courtney Cottrell, and Ann Evans Larimore for their generous readings and insightful feedback.

This work would not have been possible without the community and moral support of the American Indian Caucus at CCCC, particularly from mentors and colleagues Malea Powell, Joyce Rain Anderson, Rose Gubele, Resa Crane Bizzaro, Angela Haas, Qwo-Li Driskill, Andrea Riley-Mukavetz, Gail McKay, Kenlea Pebbles, Christie Toth, and Chelsea Murdock. Your belief in the value of my work has sustained me.

Here at my home institution, the University of Tennessee, Knoxville, I have many debts to acknowledge. First, this project would not have been possible without the generous fiscal support of the Hodges Fund and its review committees, particularly the Hodges Summer Research Grant and the Hodges Research Grant that allowed me to travel multiple times to the featured institutions and spend the time I needed there. Thanks to both of my department chairs, Stan Garner and Allen Dunn, both of whom have supported this project and never let me doubt it was valuable. Thanks to Mike Keene, who encouraged me not to let the project sit and to "get right on it." A special thanks to Tanita Saenkum, my writing partner and friend, who has provided unending support as we've worked together through the writing and publishing processes on our respective manuscripts. Thanks also to the additional members of the Rhetoric, Writing, and Linguistics division—Kirsten Benson, Russel Hirst, Jeff Ringer, Jessi Grieser, Sean Morey, and Janet Atwill—who have been supportive of my work inside and outside the classroom. Thanks to Carrie Sheffield, for her unflagging encouragement and friendship as a fellow scholar and teacher of Native literatures in the English Department. Another special thanks goes to Julie Reed, who provided valuable support and perspective as a fellow Native studies scholar at UTK, and without whose friendship and experience my work would be the poorer. Thanks to Katy Chiles, Michelle Commander, Amy Elias, and Urmila Seshagiri for checking in on me, for going over early drafts of materials with me, and for providing pointers for how to begin placing my manuscript (with plenty of encouragement). And finally, thanks to Judith Welch, Donna Bodenheimer, Kayla Allen, Pamela Whaley, Teresa Whaley, and Leanne Hinkle for their administrative support in helping me get funding set up, paperwork squared away, and general day-to-day details settled.

My editor at Oregon State University Press, Mary Elizabeth Braun, has been a pivotal part of bringing the project to the finish line, and I am incredibly grateful for her faith in the project, her wide experience, and her investment in young scholars. Thanks also to Marty Brown for making the book beautifully presentable; to Micki Reaman for moving it efficiently through the production process; to Susan Campbell for her patient and thoughtful editing work; and to Erin Williams for her indexing prowess. Thank you.

Finally, I offer my deepest gratitude to the people who have been with me since the first, unflagging in their support, who celebrated the good

days and provided love and care on the days when I struggled. Thanks to my husband, Thorsten, and our son, Julian, for walking with me on this journey, and for never doubting that I would get there in the end.

Introduction

Rhetoric, Sovereignty, and Legibility in Native Museums

Step inside any museum or cultural center, and you will find a series of stories designed to educate the public. Science museums, natural history museums, art museums, ethnographic museums, and community cultural centers all aim to shape our perception of the world and provide a narrative of how things are or how they came to be. We go there to learn, we send our children there on school trips, we make them a part of our vacations. We seek them out as bastions of knowledge, archives of history, and sites for entertainment. We take the stories they tell as truth.

Given this association, and the negative connotation the word frequently carries for the public, "rhetoric" is not a concept often associated with the institutions and exhibits we take for granted as presenting factual material in a straightforward and attractive way. Yet as a discipline, far beyond the connotation of political spin doctors, "rhetoric" more broadly addresses the ways we communicate, the choices we make in communicating, how we try to reach our intended audiences, and how meaning-making is accomplished together between speakers and listeners (or readers and writers, or designers and observers). Museum practices are rhetorical practices in that these institutions are always making choices about which stories to tell, how to tell them, and for whom to tell them toward a particular goal or consequence.

These choices are obviously not without weight, but for the populations and communities who have historically been left out of the choice-making, the selection of options and the ways their stories have been told in many museums have been damaging, because those stories were never put together with them in mind as constituencies or audience members.

1

Many museums have participated in forms of scientific racism and ethnographic debasement that have frozen Native peoples in time and erased them from the present, from their own stories.

While the past few decades have been productive in calling attention to such colonial practices and attempts to revise them, museums and cultural centers remain sites of both friction and potential in their endeavors to represent Native[1] cultures and sovereignties. The long-term rhetorical ramifications of presenting Native peoples as past history and not part of the present are damning: Americans—including Native Americans—over the course of nearly two centuries have been shaped by these stories, these choices. The reworking of these habits of mind will take generations. Merely remaking exhibits to include a few Native voices is not enough; because audiences have been trained to expect particular ideas and narratives, simply providing a different story or adding a Native perspective does not solve the problem. The entire rhetorical frame has to be reconsidered and reconfigured to do justice to Native nations, histories, and cultures.

To Self-Represent: Rhetorics and the Stories That Museums Tell

This book takes for granted the work already done in museum studies and Native and Indigenous studies that calls for a decolonization of museums—here, that is a foregone conclusion. Discriminatory, colonizing practices must be changed, and the stories need retelling. What this study is most interested in is *how* these stories are told and what the consequences (intended and not) have been in museums' attempts at a new kind of meaning-making with their audiences, especially when the museum or cultural center is under some measure of Native control. The telling of the story is only the beginning of the process, and *Legible Sovereignties* works to articulate how it happens in a variety of contexts. It brings together the scholarly conversations in three disciplines that, in their overlaps, can provide insight into how Native-owned or allied museums function and how they can strengthen their abilities to communicate. *Legible Sovereignties* theorizes how we can understand museums as a visual, material, experiential rhetorical act, but one particular to Native communities that seeks to claim rhetorical sovereignty. It is based on the premises that, first, museums are sites of communication; second, that Native peoples have the inherent right to choose and claim public discourses such as a museum to self-represent; and third, that doing communication in a museum, with

its particular structures, is a messy business that, by default, is rhetorical in nature. This study thinks through the overlaps of these claims in order to reveal the rhetorical reasoning behind Native museum exhibits, demonstrating the process of the enactment of rhetorical sovereignty and addressing how that sovereignty is—and isn't—recognized by visitors in how they experience and comprehend the exhibits. One could argue that a statement is sovereign regardless of whether or not an audience understands it. Native peoples do not need non-Native visitors to give them permission to or to confirm they exist. However, I argue that if stereotypes are to be overturned and if education is to happen—if Native peoples want to be heard and understood—then we need to be rhetorically savvy. We need to make ourselves rhetorically legible, and legibly sovereign.

"Legible sovereignties" are the key to this study. My primary argument is that Native communities in the United States are claiming museums' communicative structures to meet their own communicative needs—an act of rhetorical sovereignty (Lyons 2000)—but that Native museum sites are discovering that this is not enough: the act of rhetorical sovereignty must be accessible to a variety of audiences, or the communicative act fails. If museums are colonial institutions at their roots, then utilizing them as a means to rhetorical sovereignty means dealing with the doubled complication of visitors' expectations of museums *and* visitors' expectations of "Indians."

To make my argument, I analyze three distinct contemporary sites over the course of a decade, including the Saginaw Chippewa Indian Tribe of Michigan's Ziibiwing Center of Anishinabe Culture & Lifeways in Mount Pleasant, Michigan; Haskell Indian Nations University's Cultural Center and Museum in Lawrence, Kansas; and the Smithsonian's National Museum of the American Indian in Washington, DC. Each site was selected because it represents a specific level and kind of influence from Native and Indigenous communities, a unique set of communicative exigencies, and a different target audience. Providing a perspective over a ten-year span that documents their inaugural permanent exhibits, audience reactions, and the institutions' consequent choices in strategic reaction, *Legible Sovereignties* offers longitudinal insights into how each institution originally hoped to reach its diverse audiences, the challenges and successes they have met, and the current changes they are making to keep their acts of self-representation legible. My goal is not a checklist for creating the perfect exhibit, but rather an analysis of the strategies that these three diverse sites have and

continue to develop in order to stay relevant, to deal with unexpected challenges, and to engage their visitors meaningfully through their exhibits. In the remainder of this chapter, I sketch the framework for understanding legible sovereignties, the circle of interdisciplinary scholarship from which my work emerges, and my methodological frame for the study.

Making Sovereignties Legible: The Framework

Legible Sovereignties theorizes what rhetorical-sovereignty-made-legible looks like by tracking the actual communicative development of the three institutions named above, the unexpected communicative challenges and opportunities these institutions encountered, and how they envision moving into the future based on their first decade of experience. For better or worse, many non-Native people form their ideas about Indigenous peoples based on what they see in museums; thus, museums and their study are of *vital importance*, both for the general public (to get the appropriate education about Native nations) and for Native nations and communities themselves (to exercise sovereignty in how they present themselves). Furthermore, this book argues that more than a statement of "we are still here"—the original clarion call of each of the inaugural displays—the exhibits that explain story, history, and culture in Native or Native-affiliated museums must do the rhetorical work to make their communicative acts of self-representation legible and accessible to audiences that may not know or fully grasp Native cultures and histories.

To show how I've arrived at legible sovereignties as a frame, a few key terms need explanation. Joanne Barker's analysis of "sovereignty" as a term reveals that far from a definite, fixed definition, sovereignty has roots in Euro-American discourses and has been adapted by Indigenous peoples in the service of self-governance, self-determination, cultural preservation, and more. Barker observes, "There is no fixed meaning for what *sovereignty* is. . . . Sovereignty—and its related histories, perspectives, and identities—is embedded within the specific social relations in which it is invoked and given meaning" (2005, 21).* For every new scenario an Indigenous community or nation meets, in which it needs to exert its rights, sovereignty will take on a new shade of meaning. As already noted, Scott Richard Lyons's work takes the concept of sovereignty into the realm of language and

*All emphases in quotations are original unless otherwise noted.

rhetorical practice. His pivotal argument in "Rhetorical Sovereignty: What Do American Indians Want from Writing?" (2000) introduced the term "rhetorical sovereignty" into discussions about Native peoples' relationship to writing and rhetoric, defining it as "the inherent right of [Indigenous] *peoples* to determine their own communicative needs and desires in this pursuit, to decide for themselves the goals, modes, styles, and languages of public discourse" (2000, 449–450). Lyons argues that public self-representation is tied to what he posits are the twin supports of broader Indigenous sovereignty: "the power to self-govern and the affirmation of peoplehood" (2000, 449–450, 456). Therefore, the articulation of rhetorical sovereignty is about self-representation, but a self-representation that reclaims identity and discursive power for Indigenous peoples. His original argument was situated primarily in the writing classroom, but I see the concept functioning in powerful ways outside the university, particularly in other sites for public education. Museums are one such site, even as deeply colonial as many of their histories are.

In fact, it should follow that if museums are potent public, rhetorical sites, then despite their colonial histories they can also potentially be turned to help undo the work of erasure and suppression of Indigenous peoples and can furthermore be sites for the enactment of rhetorical sovereignty. My previous published work on the Smithsonian's National Museum of the American Indian's inaugural exhibits and the renovations of Hawaiian Hall at the Bernice Pauahi Bishop Museum in Honolulu, Hawai'i, has already extended the discussion into a consideration of the explicitly rhetorical nature of sovereignty and self-representation as a critical Indigenous-based framework for interpretation and revision (2011, 2014a, 2014b). While I agreed that cultural sovereignty is a necessary part of what the NMAI should embody, I argued that cultural sovereignty itself would not be understood unless curators and designers took rhetorical sovereignty into consideration: first make the purpose and role clear for visitors, and then follow with the rest (2011). Similarly, the results of the renovation of Hawaiian Hall at the Bishop Museum demonstrated the role of rhetorical sovereignty in creating a space that effectively communicates Native cultures, histories, and perspectives, especially when such a space is situated among other related and competing narratives, with a wide variety of visitors (2014a, 2014b). Simply stating "we are here and we are sovereign" is not necessarily the most persuasive argument for visitors, and furthermore, descriptions of the difficult histories and consequences of

colonialism is not exactly the stuff that non-Native museum visitors seek out. Connected to museum pedagogy and well-designed persuasion is the question of rhetorical legibility.

In the introduction to their collection *Places of Public Memory: The Rhetoric of Museums and Memorials*, Greg Dickinson, Carole Blair, and Brian L. Ott outline the intersections of rhetoric, memory, and place as they conceive them to meet in museum and memorial spaces. One of the concepts that emerges from this discussion is "rhetorical legibility," or "a sense of readability or understanding of an expression" in public sites (2010, 4). But far from being transparent, rhetorical legibility is "predicated in publicly recognizable symbolic activity *in context*. That is, rhetoric typically understands discourses, events, objects, and practices as timely, of the moment, specific, and addressed to—or constitutive of—particular audiences in particular circumstances" (4). Rhetorical legibility also presupposes a multiplicity of meanings based on social norms, accepted cultural practices, accepted histories, and orientations toward the symbol or meaning-making in general (4). No object or sign is ever neutral in its meaning, and a rhetorical approach "takes discourses, events, objects, and practices to be activities of a partisan character, embracing some notions and despising others, willfully or not" (4).

Rhetorical legibility is useful in that it helps point out part of the work that has to be accomplished if Indigenous statements of self-representation in museum exhibits are to be understood by their audiences. While most Indigenous museums and exhibits often try to keep their Indigenous audiences in mind, and may even be constructed primarily for those audiences, those same museums and exhibits also frequently seek a broader cross-cultural set of audiences with whom to have the conversation and to persuade, and also often rely on outside or non-Indigenous audiences for support. Sovereignty, in all its forms, can be argued as a process of emergence in the presence of others; as Robert Warrior has noted, for Indigenous nation–peoples, sovereignty is "not a struggle to be free from the influence of anything outside ourselves, but a process of asserting the power we possess as communities and individuals to make decisions that affect our lives" (1995, 124). Similarly, Lyons asserts that "rather than representing an enclave, sovereignty here is the ability to assert oneself renewed—in the presence of others" (2000, 457). In the context of a museum, rhetorical sovereignty may not be sovereignty at all without the participation of the exhibit's audiences. Yet if there is a responsibility to tell the difficult

truths that will challenge non-Native museumgoers, what can be done? Sovereignty must be made legible.

What I set forward with the idea of legible sovereignties is a means to approach and think through public declarations of rhetorical sovereignty that acknowledge the communicative needs of all potential audiences but tell the difficult truths and assert positive Native and Indigenous presence. How can museum exhibits best accomplish this? As Malea Powell has argued in "Down by the River, or How Susan La Flesche Picotte Can Teach Us about Alliance as a Practice of Survivance," rather than the "us" versus "them" that shapes so much of our understanding and colonial discourses, we need new frameworks and new language for making sense of multiple histories and voices. She asserts, "We need a new language, one that doesn't convince us of our unutterable and ongoing differences, one that doesn't force us to see one another as competitors, . . . [one] that allows us to imagine respectful and reciprocal relationships that acknowledge the degree to which we need one another (have needed one another) in order to survive and flourish" (2004, 41). "Rhetorical alliance" could then be understood as work toward a mutual dialogue across cultures and communities that "honor[s] a complex notion of texts that encompasses both beadwork and books as artifacts produced by users who have 'the ability to act quickly, effectively, and prudently within ever-changing contexts' (Johnson 53), but that doesn't ignore the particular circumstances of their production and meaning within specific cultural discourses" (2004, 44). While Powell makes this argument within the context of rhetoric as a discipline, I understand it in terms of its broader applications for cross-cultural discourse and here for its consequences for conceptualizing how museum exhibits might function to support legible sovereignties. What kind of language do we need, can we create, to build alliances and tell the hard stories together?

A note on what I am not doing here: I am not about to argue for pandering to non-Native visitors, or for Indigenous rhetors to identify so far with their non-Native visitors that the impact of difference is lost (Stromberg 2006, 3). I am also not arguing for a prescriptive step-by-step checklist for Indigenous museums and exhibits. It should also be acknowledged that in some contexts, a given exhibit's rhetorical purpose may indicate a need for exclusion or, at the very least, a tailoring to very specific audiences. Sometimes public displays are meant primarily for one audience and not for another, or are meant to address the needs of one audience in particular and ask others to observe but keep their distance. Additionally, as Barker has

already argued, sovereignty will be enacted according to given situations, purposes, and communities, and so will not be the same sovereignty in every place or space (Barker 2005, 21). Museums shift over time with their missions, their goals, their funding, and their visitors' needs, and it will show in their exhibits—therefore, no absolute mandate will work here. Yet what I do argue is that these cross-cultural spaces are precisely where a legibly rhetorically sovereign practice would be useful, those places that seek to engage the widest possible audience or that must, by default, work with multiple audiences. Effective, understandable—*legible*—communication is key.

To summarize, a study predicated on legible sovereignties recognizes the flexibility of the term "sovereignty" to encompass multiple routes and means to self-determination, and the intrinsic right of Native and Indigenous peoples, communities, and nations to self-represent in whatever means, modes, and public stages they choose as appropriate. It accepts the multiple possibilities of meaning-making in a given rhetorical act or display, and that care must be taken to make the communicative act comprehensible in its intended way. It acknowledges the grim truths and colonial histories that precede any present communication, but also desires to build alliances with its audiences, for without alliance and recognition the communicative act may fail. Finally, such a study seeks, in each given rhetorical situation—and its particular histories and specific set of variables—to find the most effective opportunities both to communicate the Indigenous community's self-representation and to assist audiences in grasping that statement of rhetorical sovereignty.

Taking the above into account, legible sovereignties as a framework for rhetorical action seeks to

1. Take Indigenous self-determination in communication first and foremost as the primary goal;

2. Understand and examine the communicative intent of a given act or display in support of the represented Indigenous communities;

3. Observe how the communicative act functions in reality, that is, assume it does generate multiple meanings for different audiences and take those multiple meanings into consideration of its total effect;

4. Analyze the tensions between the communicative intent and the multiple meanings generated;

5. Provide constructive rhetorical critique toward eliminating disconnects and strengthening communicative alliances between an exhibit's goals (and the community it represents) and its audiences.

Bringing All Our Relations Together: Completing the Circle as an Interdisciplinary Conversation

Understanding legible sovereignties goes beyond one disciplinary purview, and the work I seek to accomplish locates itself at the intersection of rhetoric studies, museum studies, and Native American and Indigenous studies. The overlaps between each scholarly community create a kind of exigent chain or circle, and in order to fully contextualize the relationships that support legible sovereignties, it helps to imagine them as a Venn diagram (figure 1). The three major circles represent the three fields, but the conversations that interest me most happen in the spaces where these scholarly communities touch and overlap. These interdisciplinary intersections meet fully in the center, where this book makes its claims about legible sovereignties and the significance of museums as a site of Indigenous public display and self-determination. For the sake of context, I briefly outline here some of the major perspectives from these disciplinary overlays in order to demonstrate their shared interests and to frame the enactment of legible sovereignties in museum spaces at the center.

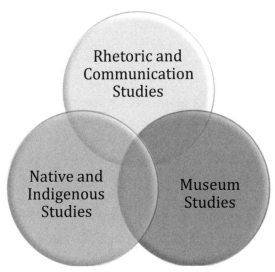

Fig. 1: Disciplinary Overlaps Venn Diagram

In the field of rhetoric and communication studies, legible sovereignties builds on and extends the work already developed in visual and material rhetorics, with an added emphasis on cultural specificity and representation. If rhetoric has traditionally been defined as persuasion or communication through speech or writing, the last several decades have seen a decided turn to the consideration of the rhetorical nature of the visual and material that demonstrates how visual and material elements participate in displays as a series of choices toward meaning-making and representation. Germinal collections of scholarly work in Jack Selzer and Sharon Crowley's *Rhetorical Bodies* (1999) and Charles Hill and Marguerite Helmers's *Defining Visual Rhetorics* (2004) have brought the visual and material aspects of communication into focus, foregrounding the nature of communication as visual and material and calling for a reconsideration of traditional perspectives that consider the spoken or written word as the primary or even only form of rhetorical or communicative practice. Bodies, architecture, performances, and grocery store layouts all communicate to the people in their presence. This work is broad in its range, but does not yet fully engage with Indigenous peoples or cross-cultural communication.

At the same time, rhetoric studies has been building connections to museum studies, and rhetoric elucidates some of the key questions about how museums and memorials *are* rhetorical and not transparent in what they communicate. Carole Blair's powerful piece, "Contemporary U.S. Memorial Sites as Exemplar's of Rhetoric's Materiality" (1999), takes memorials as her focus for discussion and examines five different memorials and the rhetorical impact they make on their visitors through their existence and the experience visitors have as they interact. More than a transparent idea that is easily communicated at each site, the nuance of these spaces and the way visitors interact with them has a tremendous impact on the meaning that will be communicated. "Rhetoric," she argues, "has material force beyond the goals, intentions, and motivations of its producers, and it is our responsibility as rhetoricians not to just acknowledge that, but to try to understand it" (22). It goes without saying that memorials are built with particular intentions, to help retain the memory, in a certain way, of a specific event or person; yet those intentions are not the end of what the memorial is capable of communicating. Blair observes, "We must ask not just what a text means but, more generally, what it does, and we must not understand what it does as adhering strictly to what it was supposed to do" (23). Because communication is a negotiation between the memorial (with

the intentions of its sponsors and designers) and its visitors (with their own intentions and desires), intention is only the tip of the iceberg. In analyzing the selected memorials, then, Blair asserts that we should consider the significance of the memorial's existence; the material it is made from and the durability of that material; the memorial's ability to be reproduced or preserved; the ways that the memorial interacts with other nearby texts (other memorials, or other means of communication); and finally, how it acts on the people who visit it (1999). Communication occurs through all of these rhetorical, material facets.

Lawrence Prelli's collection *Rhetorics of Display* (2006) further elaborates on the intentional nature of communication through public display, asserting that "whatever is revealed through display simultaneously conceals alternative possibilities, and therein is display's rhetorical dimension" (2). Whatever we choose to display also suggests that which we chose not to display, and furthermore, "whether constituted through vocal enunciation, textual inscription, visual portrayal, material structure, enacted performance, or some combination, rhetorical study of displays proceeds from the central idea that whatever they make manifest or appear is the culmination of selective processes that constrain the range of possible meanings available to those who encounter them" (2). Displays are the end product of a process of selection, and thus do have some power to guide viewers' perceptions and limit what kinds of meaning might be made.

As we move clockwise into the circle of museum studies, it should be noted that dividing it from discussions of communication and rhetoric is in many ways an artificial boundary. I maintain that boundary here only for the sake of discussing museum studies' own terminology for its work, while simultaneously pointing out those connections and similarities it bears to rhetoric that might find a place in the overlap. It should be noted that museum studies scholar Bruce W. Ferguson actually put the terms "exhibit" and "rhetoric" into the same essay title in 1994 as "Exhibition Rhetorics: Material Speech and Utter Sense," demonstrating the growing reconception of exhibitions as rhetorical, narrative acts and an acknowledgment of the blurred disciplinary lines between rhetoric and museum studies. That essay is indicative of how this present rhetorical review and analysis, done in terms of museum studies discourse, further elucidates the past and present debates on communication, ethics, pedagogical intent, and visitor reactions—in other words, concerns with purpose, rhetorical strategies and their implications, and audience. Because museums have

such a tremendous meaning-making influence over their visitors, engaging their rhetorical implications is essential in order to understand why Native peoples care so much about museums at all, and what kinds of responsibilities museums have to both their visitor constituencies and their represented communities, and to all the overlaps in between. Furthermore, the frame of legible sovereignties points vividly to this exigence and the link between rhetoric and museum studies.

As already noted, museums have tremendous influence as disseminators of knowledge and shapers of public perception. Scholar Steven Hoelscher argues that the power of museums as purveyors of truth should not be underestimated; as American museum research has shown, he notes, "'Americans believe they recover "real" or "true" history at museums and historic sites'" (2011, 210; Rosenzwieg and Theilen, as quoted in Hoelscher). Thus museums have far-reaching persuasive and rhetorical power for their visitors. Other discussions of rhetorical work have been taken up by scholars such as Eilean Hooper-Greenhill (1999a [1992], 1999b, 2000, 2007), who consistently references the "pedagogy" of museum sites and their educational and communicative capacities. Hooper-Greenhill is overt in her assertion that museums employ "pedagogical style" and "pedagogy"—her words—to teach visitors through exhibits and displays, and that museums therefore do attempt to shape visitor perception (*Museums and the Interpretation of Visual Culture* 2000, *Museums and Education* 2007). At the same time, she recognizes visitors bring their own expectations to the exhibits, and no matter what curators or exhibit designers want visitors to take away, the process of meaning-making is always a mutual process that works with, through, and sometimes against visitor perception and knowledge (2000, 4–5). The "pedagogy" that Hooper-Greenhill acknowledges is therefore a practice of persuasion, and thoroughly rhetorical in nature. However, explicit pedagogical practice is not the only means through which curators, designers, and visitors negotiate meaning. As Bill Hillier and Kali Tzortzi observe, the very layout of an exhibit and how visitors find their way through it creates what they call "space syntax," the particular ways display and arrangement allow for broader or narrower opportunities for interpretation (2011).

Research on museum visitors and their motivations has also been pivotal in understanding how to construct (rhetorically) effective exhibits. Judy Rand's insights into visitor needs, phrased as her "Visitors' Bill of Rights," underscores the imperative to work with visitors, not to patronize them;

her list includes basic "orientation," making visitors feel welcome, helping visitors "have a good time," "respect—accept me for who I am and what I know," "communication—help me understand, and let me talk, too," and "choice and control—let me choose; give me some control" (2012; original 2000). John Falk and Lynn Dierking's research (2011 [1992], 2013) has been instructive in sorting out what museum visitors actually do with the exhibits they encounter, and in particular Falk's article "The Museum Visitor Experience" argues that one of the primary reasons visitors go to museums is less to be educated and more to reinforce narratives about their own identities, often into one of five observed categories: the "explorer," who is curious; the "facilitator," who is "socially motivated"; the "professional/hobbyist," who "feel[s] a close tie between the museum content and their . . . passions"; the "experience seeker," who wishes to have "been there and done that"; and the "recharger," who seeks a "contemplative, spiritual and/or restorative experience" (Falk 2012, 324–325). Those visitors who do not find what they seek may furthermore be offended or upset by what they find: as the backlash over a 1991 Smithsonian exhibit titled "The West as America: Reinterpreting Images of the Frontier, 1820–1920" showed, those visitors will reject what they see and challenge it, defeating the communicative goals of the exhibit (Simpson 1996). Overall, as Falk and others observe, to stay relevant, museums need to better understand and anticipate visitors' needs and reactions, and find the rhetorical means to reach them.

At the same time, museum studies has marked a shift in the way that museums serve communities other than visitors. Museums are now recognizing responsibility to the communities whose cultures and lives form the basis of many collections and exhibits. Edited collections such as Sharon Macdonald's *A Companion to Museum Studies* (2011) and Gail Anderson's *Reinventing the Museum: The Evolving Conversation on the Paradigm Shift* (2012) bring together a range of perspectives that point to a growing awareness, since the 1970s and again since the 1990s, to rethink what it is that museums can and should do, often under the frame of the "new museology movement." Museum experts and scholars acknowledge that, more than acting only as collection sites or perpetuating the condescending and distorting narratives of colonialism or presenting master narratives of history—or functioning outright as a "mausoleum," as Andrea Witcomb asserts (2003)—museums need to change their practices and change how they serve their communities, both those represented in the exhibits

and collections and those who visit. For example, through her work with Dutch and Indonesian museums, Christina Kreps demonstrates the shift toward a "new museology" in her critique of the Eurocentric hegemony of museum practices that focus too much on preservation and conservation, ultimately undermining the abilities of communities to curate their own heritage, as well as the abilities of Indigenous communities to reclaim control over their heritage and "speak for themselves" (2003, 155). Other scholars such as Ruth B. Phillips (2006, 2011) and Annie Coombes (2006) continue to document the ways in which Indigenous peoples around the world in North America, the Pacific, New Zealand, and Africa work to have a say in how museums and exhibitions represent them, or develop their own heritage sites altogether.

While not an exhaustive overview of museum studies scholarship, this review demonstrates the amount of attention being paid to rethinking museum paradigms concerning collection and display, and the consideration of museum visitors' needs (which, admittedly, is both a function of desiring a successful experience/education for visitors and of acquiring adequate financial support through visitor numbers). What is clear now is that museums serve more than one constituency: they work with the communities who are part of the displays *and* the communities who come to see them, and as such the needs of both should be met. Communicative, pedagogical choices—rhetorical choices—are part of this endeavor in the construction of exhibits, as are the worldviews of all parties involved.

Moving to the overlap between Native studies and museum studies, representations of Native peoples in museums are part of this history, and historically such displays created by non-Native scholars and curators frequently depicted white ideas of "Indians" that had little to do with Native self-representation or contemporary life. Scholarship recognizing the colonial roots of museums as a communicative structure and the influence of Western ways of perceiving Indigenous material cultures has already been published (see for example Kreps and West below; also Barringer and Flynn, 1998; Edwards, Gosden, and Phillips, 2006). Devon Mihesuah's collection *Repatriation Reader* (2000) vividly illustrates the multiple demands on museums and collections that house Native American remains and material culture as a result of colonial practices of collecting and display. In the United States, that discussion has been particularly shaped by the passing of the National Museum of the American Indian Act (1989) and the Native American Graves Protection and Repatriation Act (NAGPRA) (1990).

The Smithsonian published *The Changing Presentation of the American Indian* (West 2000), a collection of scholarly essays that traces the European and North American history of representing American Indian peoples in museums and provides critical context for how and why American Indians have been represented as exotic, fossilized, or vanishing cultures. Mary Lawlor's work *Public Native America* (2006) did groundbreaking work on the relationship between several forms of Native public self-representation, including Native museums, powwows, and casinos, and how those performances are designed to resonate with non-Native audiences. Self-definition and self-determination are key in these instances, because—in the face of the narratives created in traditional histories and tourism of Native communities—Native peoples do have some choice about how to define themselves and present themselves to the public. But how does this process reach success? How are these sovereignties made legible?

The construction and opening of the National Museum of the American Indian in 2004 on the National Mall in Washington, DC, sparked major discussion concerning Native and Indigenous representation in museums. Although the NMAI is not the first or only museum with extensive ethnographic collections from North or South America, as one of the most visible sites and as part of the Smithsonian Institution, the museum drew much attention and critique that has rippled outward to other institutions. Two special issues of *American Indian Quarterly* in 2005, on the opening of the NMAI, explored the multiple perspectives—ranging from the celebratory to the highly critical—offered on the museum's design and inaugural exhibits, demonstrating the wide range of scholarly reaction. Amy Lonetree and Amanda Cobb-Greetham published the series of essays again as *The National Museum of the American Indian: Critical Perspectives* (2008), working through the history of the NMAI, the attempts to use Indigenous methodologies and collaboration in its construction, the scholarly interpretations and reactions to the space, and the questions concerning nationhood and identity that the NMAI raises. Meanwhile, the United Nations formally adopted the "Declaration on the Rights of Indigenous Peoples" in 2007 (2008), including provisions for Indigenous self-representation and cultural preservation on those communities' terms.

The Smithsonian has continued to publish work on the present and future of Indigenous museums, including *Vision, Space, Desire* (2006), *The Native Universe and Museums in the Twenty-First Century* (2005), and *Living Homes for Cultural Expression* (Cooper and Sandoval 2006). Conversations

over the difficulties and conflicts in creating Indigenous museum spaces have endured, and Susan Sleeper-Smith's edited collection *Contesting Knowledge: Museums and Indigenous Perspectives* (2009) provides yet another look into the challenges and difficulties of Indigenously grounded meaning-making and representation in a museum space, whether that space is a national museum or a tribal museum. Regardless of these challenges, Sleeper-Smith affirms that "while museums may have emerged as part of the original colonial project, they have been put to new purposes. . . . Indigenous peoples are using museums to emerge from invisibility and to deconstruct the colonization narrative from the viewpoint of the oppressed" (4).

Finally, one of the most recent monographs on the topic of Native museums, Amy Lonetree's *Decolonizing Museums* (2012), offers a historian's perspective of exhibition creation and construction and calls for more critical conversations in examining and telling the "hard truths" of colonization in Indigenous museums. For the sake of decolonizing these spaces, Lonetree argues, "it is time for us as communities to acknowledge the painful aspects of our history along with our stories of survivance, so that we can move toward healing, well-being, and true self-determination" (6). Lonetree's work is groundbreaking in the way she provided genealogies of the museum sites she worked with and critique toward decolonizing museums and telling the harder, more difficult histories of colonization instead of relying on celebration to carry an exhibit. She ultimately argues for ways to make these "places matter" to Indigenous peoples, as she asserts in her conclusion. The concept of legible sovereignties, in contrast, calls attention to the rhetorical, communicative structures on which such practices depend and that make Native and Indigenous self-representations clear, comprehensible, and relevant to multiple audiences in the moment of opening and over time.

The critical conversation surrounding museums and exhibits in Native American and Indigenous studies is ongoing. This is in no small part because they are public displays that create both an opportunity for self-determination and a way to communicate to and educate a wide variety of audiences. At the same time, because contexts, histories, and Native and Indigenous communities vary so much, no blanket solution exists, and tensions continue between attempting to theorize overarching ideas to support Indigenous self-representation and dealing with the nuance of a given situation. Every communicative choice that goes into an exhibit has

a consequence, and trying to prioritize community and visitor needs—on both the macro and micro levels—creates considerable pressure, particularly given the colonial history of museums. Thinking in terms of legible sovereignties helps orient this discussion in a way that highlights its rhetorical elements and the actual strategies for addressing audience concerns without losing sight of Native communities' priorities.

In many ways, scholars in Native and Indigenous rhetorical studies—the overlap to the left on the diagram in figure 1—bring us full circle as they articulate the ramifications of rhetorical study and public display for Indigenous nations, communities, and individuals. Working our way further clockwise on the diagram, the discussion in Native and Indigenous studies concerning the tension between representations made *of* Native peoples and representations made *by* Native peoples has been vigorous, and legible sovereignties offers a further rhetorical consideration of these issues. Historical scholarship tracing colonial manipulation of Native images has already laid the groundwork in many ways; Roy Harvey Pearce's *Savagism and Civilization* (1988) and Robert F. Berkhofer Jr.'s *The White Man's Indian* (1979) both trace in detail how European colonists and American settlers have created their own representations of Native peoples to serve as a contrastive foil to whatever version of civilization stood in question. S. Elizabeth Bird's edited collection *Dressing In Feathers* (1996) provides some important popular culture examples of non-Native representations of Indigenous peoples, and Philip J. Deloria's 1998 monograph *Playing Indian* documents the many ways non-Native Americans have put on their idea of Indianness to suit their particular needs. The arc of such scholarship demonstrates the ongoing ways that non-Native individuals and organizations manipulate images of the "Indian" for their own purposes, with little regard for Native peoples themselves. At the same time, Native peoples have not been and are not absolutely helpless. Deloria's second book, *Indians in Unexpected Places* (2004), rewrites the narrative to reveal the multiple ways Native peoples have challenged their historical erasure by active participation in a society that imagines them vanished. Scott Richard Lyons's (2010) book *X-Marks: Native Signatures of Assent* argues in part for considering the actions of Indigenous peoples as participation in modernity—sometimes a coerced participation, as with a treaty signature—but active, chosen participation nonetheless. In short, there is a long history of making representations of Native peoples and of Native peoples making representations, and the tensions in that

meaning-making are key to understanding current debates on Native self-representation. This points to legible sovereignties.

As already discussed, Lyons's concept of "rhetorical sovereignty" has become one of several crucial frames for discussing the relationship between rhetorical practice and Indigenous sovereignties. The articulation of rhetorical sovereignty is about self-representation, but a self-representation that reclaims identity and discursive power for Indigenous peoples well beyond Lyons's original conceptualization for the classroom. Malea Powell's contributions to the field in her historiographic work on Native rhetoricians and public figures such as Charles Eastman, Sarah Winnemucca Hopkins, and Susan La Flesche Picotte, her criticism of modes of rhetorical analysis that erase Indigenous peoples, and her most recent work on the rhetorics of Indigenous makings—basketry, beadwork, and their related activity—underscore the wide variety of Indigenous rhetorical and meaning-making practices, past and present (2002, 2004, 2008). Ernest Stromberg's edited collection *American Indian Rhetorics of Survivance* (2006) begins theorizing Indigenous rhetorical strategies as deployed in various genres of texts produced by Native Americans, including speeches, the oral tradition, novels, boarding school narratives, and prison writing. In considering the wide range of contributions to the collection, Stromberg identifies a general pattern: to reach a white or non-Native audience, Native rhetoricians have to work across divisions between themselves and a non-Native audience while still "maintaining an insistence of difference" (3). Angela Haas's work with wampum-as-hypertext has called attention to Indigenous rhetorical makings as a pivotal part of "the intellectual history of technology, hypertext, and multimedia studies" that demand recognition (2007). Andrea Riley-Mukavetz's privileging of story as methodology illuminates the ways Native rhetors enact and "Native rhetoricians examine *how* American Indians make and disseminate knowledge within various intellectual sites," including "community-based research" and "embodied and visual rhetorics" (2014). Additionally, Joyce Rain Anderson's long-term collaborations with Boston-area and regional museums demonstrate the ongoing process of shifting away from static representations of Native peoples toward a more rhetorically aware practice of consultation and exhibit construction (2015).

Therefore, recent rhetorical study in Native rhetorics covers not only the more traditional consideration of spoken words or written texts, but also the visual and the material across a vast array of sites. In the shared space with museum studies and display, we understand that

meaning-making happens through a series of choices about what we choose to put forward—what we choose to display and how we display it—and yet while the series of choices narrows the opportunities for interpretation and sharpens intent, actual intention is not the end of the communicative process. For Native and Indigenous studies and related communities in the overlap to the left of our diagram, this means that public rhetorical practice is inextricably tied up with self-determination, and as Stromberg sharply observes, "In the aftermath of white military conquests and subjugation, Indians who would speak or write on behalf of Native rights and cultures were and often still are addressing an audience that assumes its own superiority. It is not a rhetorical situation conducive to mutual dialogue" (2006, 5). The challenge is how to make that public communication, that selected display, work in terms of sovereignty and for the good of Indigenous communities. It is in this way that legible sovereignties finds its roots in the rhetorical turn to the visual and material as well as the foundational work of Native and Native-allied scholars in rhetoric, and continues expanding the conversation while bringing Native and Indigenous perspectives to the fore.

In sum, legible sovereignties as a frame both articulates the connections in these three fields and creates a meeting place within this interdisciplinary constellation[2] for discussing the rhetorical impact of Native American museums. Rhetoric studies tells us that meaning is communicated in more than just written text, and that places, spaces, and displays are deeply rhetorical acts. Every choice a curator or designer makes has rhetorical resonance in how a visitor will experience and interpret an exhibit. Museum studies points to the persuasive and pedagogical nature of exhibits and the necessity of paying attention to visitor needs. Moreover, museum studies has been developing a self-reflexivity in order to consider the Eurocentric tradition of museums and how Indigenous communities should have a say—if not control over—the handling of their own heritages. Native American and Indigenous studies underscore the need to address the problems with past and present museum representations of Indigenous peoples and communities and the ways in which these communities can take representation into their own hands through this communicative medium. Native Americans have a particular stake in discussing rhetorical practice, be it their own or the ways in which they have been and are depicted, because rhetorical practice has a direct effect on visitor perception—often with material and policy consequences.

For this study, legible sovereignties is the framework for rhetorical action to address the questions that develop out of this nexus of ideas as they reflect diverse experiences at a range of museum sites: How do we make the most of museum exhibits to serve both Native and Indigenous communities and their visitors? How do we make sure that Native voices are prioritized, but visitor needs are not ignored? How do we handle the "hard truths" of history and the realities of colonization? These questions are significant in the endeavor to use a loaded communicative framework for new purposes that must serve multiple interests and needs if Native communities wish to shift public discourse and representations of Native peoples.

Notes on Methodology

It could be argued that these questions go beyond museums, and that legible sovereignties is a framework that could be employed outside a museum space. I fully support that assertion. Grasping how this kind of communication functions goes beyond a given museum exhibit. At the same time, it is in part through the above-outlined interdisciplinary work and the public attention museums receive that theorizing this process is possible. Additionally, museum exhibits offer vivid and concrete examples that make applying legible sovereignties to other contexts easier.

With that in mind, my own approach as a rhetorician to answering these questions in the context of these exhibits takes some support from rhetorical genre theory and its methodologies. It should be noted that museum scholar Gwyneira Isaac, for example, has begun applying the term "genre"—or in her work, "genres of expectancy"—and rightly observes that audience expectations of an exhibit or subject matter may guide audience reaction, and that problems with exhibits may emerge when curator and audience expectations do not align (2008). However, rhetoric studies has a more fully articulated understanding and methodology regarding genre that more systematically addresses genre and communication and can be useful in its application here.

Rhetorical genre theory shares the assumption that communication of any kind is often a typified act in response to a perceived set of circumstances, that genres function to do the work of groups or communities and that in turn those genres support, shape, and maintain the boundaries of that community (Devitt 2004; Barwarshi and Reiff 2010). It is communication understood as social action (Miller 1994). Genres ask users

to take on particular roles in relationship to each other in the course of using those genres and participating in the activities they support. Genres are also inherited, and what users do with them in the present is in part constrained by the handed-down expectations entailed with that particular genre (Jamieson 1975; Devitt 2004). At the same time, genres are both sites of creativity and constraint. On that essential point, Amy Devitt argues,

> Without genres, writers would lack significant ways of under-standing their experiences and of making meaning through language. With genres, writers are subject to the manipulation of others and to the constraints of prior expectations, assump-tions, values, and beliefs. Janus-like, genres inevitably look both ways at once, encompassing convergence and divergence, simi-larity and difference, standardization and variation, constraint and creativity. Rejecting these dichotomies and sustaining these tensions, genre can become, as language, infinitely and essen-tially creative. (2004, 162)

As such, in examining communication, a genre researcher looks for generic patterns that users employ, the reasons they do it (the rhetorical goals), the expected (intended) effects, and what actually happens with given ut-terances in that generic form as they make their way through that genre's community of users. Does the genre change? Does it signal something different for each user, playing a different role (think what a medical intake form means to a doctor versus a patient)? What role does the genre itself play in the community? What meaning-making impact does it have?

Within *Legible Sovereignties*, the opportunities for application point to local and larger rhetorical structures. In terms of more than just expecta-tions, museums as institutions and, one could argue, genres, have been created to support the education of the masses and have routinely reflected the ideological frames of their creators. Colonialism and the display of colonized peoples were a strong part of this, and it is these same com-municative structures and methods that curators and designers struggle with today. Museums and their genres support particular versions or ideas of history, culture, and science, shaped in part by their creators and funders, which in turn shape us. Museums as conceptual lenses are inher-ited, as are the roles played by curators, designers, and visitors. Especially when museums attempt to do something different or change the rules,

the constraints become clear in curators' struggles, visitors' frustration, or funders' dissatisfaction. If participants' expectations are challenged, so too are the roles they know how to play; to challenge expectations is not merely asking participants to get used to something new, but rather to change participants' roles and thus their relationship to the genre and its supporting communities. This can disorient participants to the point of being unable to function and possibly rejecting the change in the genre and thus all it attempts to communicate. At the same time, knowing these constraints provides insight into how to change the structure, and there is room for creativity. The museum itself has the potential to take on new meaning as a purveyor and keeper of knowledge when it is placed in a new setting or situation, and though there is a chance for its inherited meaning-making tendencies to shadow each attempt at remaking it, there also exists the chance for something new. This is the work I see Native American and Indigenous museums doing.

Legible Sovereignties, however, is not a rhetorical genre theory study per se; it is instead a genre-theory-informed rhetorical analysis that has the enactment of effective rhetorical sovereignty as its primary goal, as I have already addressed. A rhetorical genre theory–based study of museum exhibits conducted with the purpose of defining them as genres or inter-locking sets of genres would be an entirely different project (and a study of what goes on in Indigenous museums to differentiate them would be some-thing still different). At the same time, this study does to an extent take for granted the readers' previous experiential and nearly intuitive knowledge of what museum exhibits are, and the roles that we play, at least as visi-tors, when we enter such a space. Rhetorical genre theory provides some useful guideposts for how I approached data collection and how I present my findings in order to be responsive and responsible to the museums' communities, taking into account the original intentions of the exhibits (and not simply imposing my own reading from the outset), and paying attention to what visitors do with those spaces. Genre theory also points to museum exhibits as spaces of both creativity and constraint, for designers, curators, and visitors, and usefully highlights those tensions not as anoma-lies or failures, but as part of the ongoing process of communication.

Additionally, rhetorical genre theory emphasizes a holistic approach much in line with the discussions of memorials and displays above, and so reinforces Blair's and Prelli's assertions about rhetoric, experience, and display, with the added advantage of emphasizing community use of the

genres. This overall approach requires not just reading the alphabetic text of the brochures or exhibit labels, but also examining everything that makes the genre what it is. In the case of museum exhibits, this means considering layout, color, lighting, displays, selection of objects, labeling, sound, narration, guided or unguided tours, the mission statement of the institution and guiding statement for the exhibit (to establish intentions), and interviews with staff for their understanding of the intentions of the space, the process of making the space, and what they observe people actually doing with the exhibits. Ideally, a visitor study would be part of this, but given cost and time constraints, few museums ever do this, and rely more on observation of visitors, direct feedback through visitor books and other correspondence, and feedback from sponsors. In short, rhetorical genre theory has provided me suggestions for the "how" of this project, if not the goal itself.

My own research was conducted at the Saginaw Chippewa Indian Tribe of Michigan's Ziibiwing Center of Anishinabe Culture & Lifeways (Ziibiwing), the Haskell Indian Nations University's Cultural Center and Museum (HCCM), and the Smithsonian's National Museum of the American Indian in Washington, DC (NMAI), over the course of two time periods: first, 2006–2007, a few years after each institution initially opened and after the proverbial dust had settled; and second, during the summer of 2014, as each institution met or approached its ten-year anniversary. Further follow-up visits have been conducted as necessary. The first round of research I conducted was part of my efforts to understand what the theory of rhetorical sovereignty would look like in practice, especially as Indigenous communities sought to create public spaces for cross-cultural education and self-representation. The second round of research was conducted specifically with this book in mind, in order to understand how each museum site had maintained, shifted, or altogether changed its approach to support its efforts toward rhetorical sovereignty over time.

I visited each site multiple times during each phase of research to document the details of each museum's permanent or inaugural exhibits in photographs and to interview curators and designers to better understand what they intended or desired the communicative effect of the exhibits to be, in their words. I also asked for anecdotal and documented evidence for visitor responses to the exhibits, or what studies on visitors might be available. This kind of analysis also involves me, the researcher, in roles as both visitor and scholar. For each site, I went through each space first as a visitor

to experience it as a new visitor would, and then went through multiple times more to photograph the exhibit for my records and analysis. As a result, I have two bodies of data—photographs, interviews, and my own experiences there as visitor and as researcher—that provide the comparison and the longitudinal insights into rhetorical sovereignty in museums as an ongoing communicative process between Indigenous communities, museums, and visitors.

A final note on methodology: I take to heart Linda Tuhiwai Smith's call for decolonizing research methodologies, and her pointed questions about and demand for self-reflexivity in the process of research are just as pertinent now as when she first published *Decolonizing Methodologies: Research and Indigenous Peoples* in 1999. To my mind, this is not a genre study or distanced rhetoric study per se, because it needs to be a study in rhetorical sovereignty, in self-determination. Tuhiwai Smith locates self-determination as the center goal of an Indigenous research agenda (2012 [1999], 120–121), and I hope it is clear that the guiding force for this book is the desire to support the power of Indigenous self-determination and expression through museums. All of the processes she names—healing, decolonization, transformation, and mobilization—happen at Ziibiwing, at the HCCM, and at the NMAI, but in different ways, and with varying successes. As I outline below, this book is an effort to strengthen the effect of these processes, for the good of all communities involved.

Chapter Overviews

I have endeavored in this introductory chapter to lay out the moment of necessity to speak, as the disciplines of rhetoric studies, museum studies, and Native American and Indigenous studies are having increasingly overlapping conversations about the best ways to communicate Indigenous self-representation and self-determination in a museum space. The conceptual framework of legible sovereignties is a product of this conversation and my own research with the three distinct museums/cultural centers named above. Creating and maintaining legible sovereignties is fine to talk about in theory, but the best observations and analysis can be had in how these processes play out on the ground in the life of an institution. In the following chapters, I use the framework of legible sovereignties to analyze the permanent or inaugural exhibits at Ziibiwing, the HCCM, and the NMAI to demonstrate the variety and complexity of attempts and methods for

making sovereignties legible in three distinct situations. Their individual chapters also examine the present state of these exhibits and the way their institutions have shifted in their thinking about Indigenous self-represen-tation through museum display, and the ways they are currently making changes to better reach their audiences.

Chapter 1 begins this analysis of legible sovereignties in actual mu-seum sites, and it focuses on the tribally owned and operated Ziibiwing Center and the ways it has attempted to enact legible sovereignty. This chapter works through Ziibiwing's formation, mission, and permanent exhibit; analyzes the permanent exhibit and the original intentions behind it; and then turns to an examination of the present state of the permanent exhibit and the plans the staff and community have for it. As the only trib-ally owned and operated institution in the analysis, the Ziibiwing Center provides particular insight into how legible sovereignty can be enacted, moving from a reaction to NAGPRA to an active community centerpiece that serves the immediate Saginaw Chippewa community, a range of Native and Indigenous communities that seek it out as an example, and broader educational initiatives in the surrounding area. While its primary goal and audience is always the local Saginaw Chippewa and surround-ing Anishinabek communities, the Ziibiwing Center continues to build bridges to and relationships with the surrounding city of Mount Pleasant and beyond. By beginning with a tribal cultural center, I also frame the sub-sequent discussion in terms of these local, tribally centered efforts toward legible sovereignties.

Chapter 2 continues the on-site rhetorical analysis of legible sover-eignties at the Haskell Cultural Center and Museum, an intertribal museum that represents both the multiple Native communities included in the stu-dent body at Haskell Indian Nations University (HINU) and the institution's own beginnings and history. This chapter examines the museum's history, mission, and inaugural exhibit; analyzes the original intentions behind that first exhibit, which still stands ten years later; and then moves to an analysis of the present condition of the exhibit, the site, and future plans. What is singular about the HINU Cultural Center and Museum is the university's history as a boarding school, its situation between tribal communities and the Bureau of Indian Affairs, its diverse audiences—the university body represents more than 150 tribal nations and communities—and its mission to be both a site to confront the past and a keeper of Haskell's history. Leg-ible sovereignty here has to do with meeting the multigenerational needs

of Haskell students (past and present), making do with limited resources even as federal funding is cut, and maintaining the site as a place of healing that is also relevant in more ways than the boarding school narrative.

Chapter 3 addresses the final site, one of the best-known Native-allied museums in the United States: the National Museum of the American Indian. This chapter provides a descriptive overview of the museum's history, mission, and three inaugural exhibits; moves to an analysis of intentions of the original exhibits and the critiques that arose; and finally shifts to an analysis of the present state of the NMAI and its future plans. Particular to this site, legible sovereignty has had to deal with ownership by the Smithsonian Institute and to encompass an audience of millions that comes in from around the world, including tourists and policy-makers from Capitol Hill who seek an education about Indigenous peoples of the Americas. It has also had to answer the initial and still-ongoing critiques that it does not address the difficult truths of colonialism in the Americas in a blunt enough fashion or make itself relevant enough to the average museumgoer. The chapter ends with a focus on *Nation to Nation: Treaties Between the United States and American Indian Nations*, the first new installation (September 2014) to take the place of one of the inaugural exhibits, and one that reflects the altered approaches the NMAI is now taking with its exhibits.

The conclusion presents the summative findings of the analyses of legible sovereignty at the museum sites, drawing together their commonalities as well as providing a last discussion of how legible sovereignty comes to mean something particular to each institution's history, mission, and audiences. Again, not a checklist for a successful exhibit but rather a reflection on strategy, the conclusion reviews the key ideas that each institution provides in thinking through its own attempts at an accessible statement of rhetorical sovereignty. This final chapter also discusses the future of Native museums, and how thinking through the process of making an exhibit's or institution's communicative act of sovereignty accessible is now a pivotal consideration for present and future exhibitions. Simply put, all three sites acknowledge that stating "we are still here" is not enough, calls for decolonizing practice are not enough, and that what Native and Indigenous statements of rhetorical sovereignty ultimately must do is find expression in a way that both supports Native and Indigenous communities according to their needs and makes itself relevant and understandable to visitors. These stories of Indigenous resilience and self-determination

are too powerful to go unheard, but their power alone will not get them an audience; in telling some these institutions' stories, I hope to provide insights into how they and other institutions can keep gaining the audiences they deserve and telling the stories that audiences need to hear.

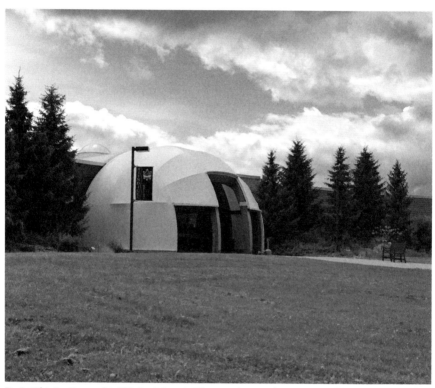

Fig. 2. Ziibiwing Center of Anishinabe Culture & Lifeways. July 2014. Photo courtesy of the author.

1

Protecting the Knowledge, Nurturing the Community
The Ziibiwing Center of Anishinabe Culture & Lifeways

The Ziibiwing Center of Anishinabe Culture & Lifeways sits a little ways back from the street, and south, across from the large Soaring Eagle Casino and Resort complex near Mount Pleasant, Michigan, on the Isabella Indian Reservation. It is a low brick complex whose entrance hall breaks the standard institutional architecture in the center with its white lodge-shaped dome that overlooks the spreading lawn. Officially opened on May 21, 2004, the Ziibiwing Center is owned and operated by the Saginaw Chippewa Indian Tribe of Michigan and houses extensive collections of artifacts and historical documents owned by the tribal nation. Yet more than a simple storage facility for these collections, the Ziibiwing Center is, as it calls itself, a cultural center that actively promotes area Anishinabek cultural practices and provides a site for preserving, interpreting, and displaying Anishinabek history for the Saginaw Chippewa and the surrounding communities.

It is this very history that the Ziibiwing Center preserves and presents to the tribal community and larger non-Native community. In this chapter, I examine what the concept of legible sovereignties can show about how a tribal community site such as the Ziibiwing Center functions in its endeavors to enact effective self-representation for a tribally specific audience, for a broader pan-Indigenous audience, and for non-Native audiences in local communities and beyond. Unlike the HCCM and its pan-tribal university audiences, or the NMAI and its tremendous visibility and primarily non-Native tourist visitors (discussed in subsequent chapters), the Ziibiwing Center's rhetorical priorities lie with supporting the Saginaw Chippewa

community and communicating its sovereignty first, and then providing resources for others. First I provide some historical context and a rhetorical analysis of the Ziibiwing Center's mission statement and a description of its permanent exhibit, *Diba Jimooyung: Telling Our Story* (2004). Next I consider the rhetorical intention and rhetorical effects of the exhibit and the cultural center, and the milestones and challenges the museum staff has experienced in its first years. Then I describe and analyze the current state of the Ziibiwing Center, observing the changes and expansions it has recently made as it considers its audiences, specifically through a rhetorical analysis of a recent changing exhibit, *Debwewin/Truth: The Mount Pleasant Indian Industrial Boarding School Experience*. Finally, I discuss the ramifications of legible sovereignties within this space over the past ten years and the ways that the Ziibiwing Center functions to keep its histories relevant and living for all its visitors. As this chapter demonstrates, because of its deep roots in the community, the Ziibiwing Center has an inherent relevance for the Saginaw Chippewa and has played unexpected roles in supporting its home community. At the same time, the surrounding non-Native audiences perhaps present the biggest challenge for legible sovereignties, particularly given the long and fraught local colonial history in Isabella County.

Creating a "Gathering Place," Keeping the Culture Alive: The Birth of the Ziibiwing Center

Accordingly, some context is essential to understanding the importance of the Ziibiwing Center's work and why its communicative choices matter. The Saginaw Chippewa Indian Tribe of Michigan has a long history in eastern Michigan; Anishinabek peoples have been in the Great Lakes region since the 1200s, and the Saginaw Chippewa—comprising the Saginaw, Black River, and Swan Creek bands—are recognized in treaties with the United States beginning in 1785 ("History of the Tribe" 2015). The Isabella Indian Reservation was established through treaties in 1855 and 1864, reducing Saginaw Chippewa land to 130,000 acres, which were then further and drastically reduced by predatory lumber practices and questionable legal arrangements. By the time of the reestablishment of the Saginaw Indian tribe under the Indian Reorganization Act in 1937, that pattern of land loss was slowly being reversed ("History of the Tribe" 2015). Cultural erosion was also a problem hastened by institutions such as the nearby Mount Pleasant Indian Industrial Boarding School.

Since the reestablishment of the Saginaw Chippewa as a self-govern-ing tribal nation, the tribe has worked to regain some of its ancestral lands and rejuvenate cultural knowledges and practices. In the Saginaw Chip-pewa Indian Nation's process of development since the Indian Reorganiza-tion Act in the 1930s, the establishment of an economic infrastructure has allowed the tribal nation to turn from providing basic needs to three broad goals: "economic development, education and preservation of our cultural heritage" (*Diba Jimooyung* 2005, 137). Under the umbrella of cultural pres-ervation, the Seventh Generation Program was the first major endeavor planned, and it was established in 1993 with a Kellogg Foundation grant to build and maintain community-based cultural activities (*Diba Jimooyung* 2005, 138–139). In reaction to the passing of NAGPRA and as a way to extend cultural preservation as a goal, several tribal members organized the Ziibiwing Cultural Society in 1993 to respond to the notices the tribe was beginning to receive regarding items available for repatriation (139). In 1994, the Ziibiwing Cultural Society was officially sanctioned by the Saginaw Chippewa tribe; by 1996, the society had received and reburied 108 ancestral remains (139).

According to current director Shannon Martin, a place like the Ziibi-wing Center had been discussed from the perspective of tribal reorganiza-tion, and became a steady part of conversation in the 1980s. With the sup-port of the Saginaw Chippewa tribe and its Ziibiwing Cultural Society, the cultural center itself began to take shape in the mid-1990s (Martin 2008). Slowly the goals of cultural preservation expanded to include the construc-tion of a full cultural center, now embodied in the Ziibiwing Center of Anishinabe Culture & Lifeways. In addition to housing the permanent exhibit—*Diba Jimooyung: Telling Our Story*—it houses the "documents and records of our cultural identity" and the tribe's extensive collection of art and artifacts. It is also the site for multiple formal and informal cul-tural programs (*Diba Jimooyung* 2005, 142–143). The name "Ziibiwing" is an Anishinabe word meaning "by the river," signifying and honoring an "ancestral gathering place along the Chippewa River near the city of Mt. Pleasant" (Ziibiwing Cultural Society 2005; "4-Year Report" 2008). The Ziibiwing Center thus represents the close tie to Anishinabek homelands and the cultural knowledges on which it rests.

As with any museum or cultural center, the mission statement is worth consideration as the intended frame for rhetorical meaning-making in this place, and in this case it is a preliminary declaration of rhetorical

sovereignty. At its opening in 2004, the Ziibiwing Center affirmed its mission: "The Ziibiwing Center is a distinctive treasure created to provide an enriched, diversified and culturally relevant educational experience. This promotes the society's belief that the culture, diversity and spirit of the Saginaw Chippewa Indian Tribe of Michigan and other Great Lakes Anishinabek must be recognized, perpetuated, communicated, and supported" ("Mission Statement" 2015 [2006]). "Ziibiwing," as explained, is an Anishinabe word and name that is purposefully evocative of culture through language, and it is invoked at the Cultural Center to "[honor] the ancestors, who against tremendous odds, protected and passed down the cultural knowledge, language, and teachings of our people" (Ziibiwing Cultural Society 2005, 1). Unlike institutions with obligations to tribal communities with diverse cultures and backgrounds, the Ziibiwing Center focuses on the preservation and perpetuation of a single cultural group— broadly Anishinabek—that also supports the immediate Saginaw Chippewa community it serves. It is also located on traditional Anishinabek lands (the Great Lakes region), and so has the ability to root itself directly to place.

The mission statement is noteworthy, too, in its reference to relevance and diversity. A form of the word "diversity" appears twice in just two sentences, suggesting it as a significant priority in the Ziibiwing Center's work, though it appears to refer primarily to the diversity of Anishinabek experiences. Likewise, the language of "enriched" and "treasure" point to its value and place in the Saginaw Chippewa community as a site where culture is "supported" and "communicated"—and thus already orients the Ziibiwing Center toward a site for rhetorical sovereignty. In terms of audiences, it appears the assumed audience, especially for the perpetuation of culture, would be the Saginaw Chippewa community first and foremost, together with all related Anishinabek communities. The "culturally relevant educational experience" in the mission supports this assumption. At the same time, "recognizing" Anishinabek cultures as valuable and worth saving appears to suggest the language of sovereignty, and thus outside audiences are part of this, too. The invitation to a broader set of non-Anishinabek or even non-Native audiences is clarified in a 2004 press release citing Ziibiwing's inaugural director, Bonnie Ekdahl. In it, she states that with the Ziibiwing Center, they have "the opportunity . . . to share the history of our survival, our spirit of sovereignty, and our message of hope for all people of the world" ("Press Release" 2004). The Ziibiwing

Center overview book (Ziibiwing Cultural Society 2005) also portrays the Ziibiwing Center as a forum meant in part to share the story of Saginaw Chippewa survival with all people. Overall, the mission statement reads as a statement of sovereignty, in that Anishinabe culture is a kind of wealth, highly valuable, worth keeping, and worthy of recognition by all people. It is a story worth telling, and the Ziibiwing Center exists to do just that: communicate the story, and interpret its value and relevance.

Similarly, the architecture of the Ziibiwing Center makes a rhetorical statement about its priorities. Called "Kinoomaagegamik," or "The Teaching Place," the tall, round white entrance hall faces east "to greet the new day and welcome the eastern direction's gift of knowledge" and is shaped like a traditional teaching lodge to reflect "a place of teaching, learning, sharing, and healing" ("4-Year Report" 2008, 5). The floor incorporates a floral design drawn from Woodland beading traditions, and the copper embellishments around the building, down to the door handles, reflect the Anishinabek use of the metal in everyday life and ceremony (Ekdahl 2005 quoted by Hoffman 2004). The botanical features surrounding the building are part of *Bbaamoseg Gitiganing: All Will Walk About the Plants That Grow*, a seasonal "plant walk" that teaches about traditionally used flora and includes more than forty varieties of plants labeled in English and Anishinabemowin ("Plant Walk Exhibit" 2014). The entrance to the permanent exhibit, *Diba Jimooyung: Telling Our Story*, is centered in front of visitors as they come through the door; to the right is the changing exhibit space, and to the left is the "Meshtoonigewinoong" (Place Where We Trade At) gift shop. To the back and right, a hallway leads to the north wing where the research center and offices are located, and to the back and left, the hallway leads to the south wing meeting rooms for cultural programs, conferences, and other events. In all, the shape of the space makes an overt argument for the Ziibiwing Center as a place of learning that incorporates traditional design and knowledge into an accessible space for contemporary use.

As the central site for telling Saginaw Chippewa history, the *Diba Jimooyung: Telling Our Story* exhibit is one of, if not the most important rhetorical features of the Ziibiwing Center. Covering nine thousand feet of the facility's total thirty-two thousand square feet, *Diba Jimooyung* traces the Saginaw Chippewa's history, both as an individual nation and as a group part of the larger Anishinabek cultural world. Bringing together spiritual, historical, and geographical narratives, *Diba Jimooyung* uses a variety of museum genre features such as dioramas, video (both animated

and documentary), scale models, object displays, archival documents and photographs, and artwork to depict the Saginaw Chippewa sense of community history and identity.

The major narrative that drives the exhibit is the "Seven Prophecies," which are Anishinabek teachings from the oral tradition that encompass both the historical time line of the Anishinabe (and specifically the Saginaw Chippewa) and an explanation of guiding traditional beliefs about Anishinabe purpose and origin. The "Seven Fires" are therefore the thematic backbone of the exhibit, and the exhibit itself has been divided into fifteen topical and roughly chronological "Areas" under the Seven Fires organization. Large oval explanatory labels function to introduce topics and mark when one of the Seven Fires is being addressed (usually mounted on the walls as guides), and rectangular panels explain exhibit sections and displays in more specific detail (these are usually mounted on display railings in front of the materials for which they provide information). Each panel has two titles: first, one printed in red in Anishinabemowin, then beneath it, an English title printed in black. The majority of explanatory text is printed in black and is in English, but wherever an Anishinabemowin word appears, it is printed in red. Motion sensors activate voice-over narratives to provide additional explanation in many sections. The sound of a drum signals the beginning of the narrative, followed by a short narration in Anishinabemowin, then a narration in English.

Upon entering the *Diba Jimooyung* exhibit, a visitor will discover a variety of means—in addition to the printed text and aural storytelling—deployed to educate viewers about Anishinabek and Saginaw Chippewa history. With the exception of Area 2, Areas 1 through 5 are life-size dioramas that introduce the visitor to the seasonal life cycle of precontact Anishinabek peoples, beginning with a model of the Sanilac petroglyphs made by Anishinabek ancestors to preserve sacred teachings, through a walk-through model of a teaching lodge, a series of dioramas depicting the harvest of maple sugar and wild rice, and then a walk-through model of a winter lodge, complete with a hunter bringing back a deer. Interspersed through the dioramas and models are artifacts and replicas of objects used within each setting, and terra-cotta mannequins are dressed in replicas of precontact clothing. On the walls facing the dioramas, maps are mounted to trace the Anishinabek migration route from their place of origin to their current locations in the upper Midwest and Canada. Area 2 contains the "Creation Theater," which introduces visitors to an animated version of

Fig. 3. Ziibiwing Center, *Diba Jimooyung*, "Niibing/Summer." July 2014. Photo courtesy of the author.

the Anishinabek creation story to provide a foundation for the lifeways the dioramas depict.

Areas 6 through 8 address European contact (in this narrative, they are the "Light-Skinned People"), first with "Contact and Co-Existence," depicting peaceful trade relations (Area 6) via artwork illustrating contact (by both historical and contemporary sources) and a display case that shows mannequins in Anishinabe clothing that incorporated European trade items. Area 7 depicts the effects of colonization, but in this space the displays emphasize paper archival sources—full reprints of treaties, photographs of tribal members and children in boarding schools, excerpts of letters from US government officials, and a mock-up of what a treaty signing table might have looked like—to demonstrate the losses the Anishinabek and Saginaw Chippewa sustained. Area 8, "Environmental Changes," also draws on archival sources to demonstrate the destruction of the landscape caused by logging and overhunting.

Areas 9 through 15 are a recovery and reassertion of Anishinabek and Saginaw Chippewa identity in the face of loss, beginning with sections on "Blood Memory" (Area 9), "Language" (Area 10), "Anishinabe Strengths" (Area 11), "Introduction to Sovereignty" (Area 12), "Identity Theater (Area

13), "Spirit of Sovereignty" (Area 14), and "Continuing the Journey" with the Seven Grandfather Teachings (Area 15). Areas 9 through 11 assert an Anishinabek identity based in blood, language, and community that has survived the losses of previous eras, and visitors may rest in the "Blood Memory" alcove, interact with the hands-on Anishinabemowin vocabulary displays, and examine displays depicting traditional arts (beadwork, basket weaving) that have survived into the present, as well as displays that show contemporary Saginaw Chippewa community members participating in these arts, learning Anishinabemowin, or taking part in community activities. Areas 12 through 14 introduce visitors to Anishinabek and Saginaw Chippewa understandings of sovereignty, citing both US historical sources and their own history as precedent for claiming sovereignty. The "Identity Theater" provides a documentary-style short film that introduces viewers to contemporary Saginaw Chippewa community members and how community identity is maintained, and Area 14 traces the contemporary history of the Saginaw Chippewa's struggle for sovereign recognition, including its adoption of a US-style constitution, its claims to local hunting and fishing rights, and the development of gaming on the Isabella Reservation. This section employs a combination of artwork, archival photos, and mannequin figures sculpted to depict contemporary Saginaw Chippewa leaders (these have motion-sensor-activated narration for each). At the end, using Woodland-style Richard Bedwash artwork, Area 15 explains the Seven Grandfather Teachings that are the foundation of Anishinabe life, challenging the visitor to live in a similarly respectful way. The final panel visitors see as they exit is a dedication to "All Our Relations," past, present, and future, and a "thank you" to contributors and supporters of the exhibit.

The changing exhibit space houses temporary exhibits that are supplements to *Diba Jimooyung*, and exhibit topics have covered a wide range of historical and contemporary material that layer onto and complement the permanent exhibit. At the opening of the Ziibiwing Center, the space hosted portions of the Caleb E. Calkins collection, based on the artifacts donated by Mr. Calkins (a Saginaw Chippewa member) at his death (Hoffman 2004). Other exhibits from the first years after the Ziibiwing Center's opening include *Woodcarvers of the Saginaw Chippewa* (2006), *Powwow: Celebrations of Life: 35 Years of Powwow Posters by Joe Liles* (2006), and *Woven by Tradition: Black Ash Baskets of the Great Lakes Anishinabek* (2007). Demonstrated by the topics covered in even just this sampling, one can see how the changing exhibit space functioned to extend the discussions

of traditional and contemporary Anishinabek life with new material and more detail than *Diba Jimooyung* could in its large historical overview.

Additionally, there have been and still are a series of small installations throughout the Soaring Eagle Casino across the street and in the hallways and meeting rooms of the Ziibiwing Center, titled *The Enduring Spirit of Our People: A Photographic Retrospective of the Saginaw Chippewa Indian Tribe of Michigan*. The photo series functions as far more than decoration for the casino and traffic spaces of the cultural center, providing glimpses into Saginaw Chippewa history. Beginning with an introductory panel at the end of the casino complex adjoining the hotel and arranged thematically—including "Sports," "Elders and Youth," "Humor," "Tribal Council and Indian Reorganization Act," and "Art"—the images document Saginaw Chippewa life and history and pique interest in casino visitors to learn more about the tribal nation. The continuation of the exhibit into the Ziibiwing Center's hallways and meeting rooms, as clearly indicated on the map in the *Enduring Spirit* brochure available in the casino and as a PDF file (2015), makes a visual connection that again suggests a relevant link for visitors to follow.

With the long look at history narrated from a Saginaw Chippewa point of view in *Diba Jimooyung*, the detail that the changing exhibit space affords, and the exhibit connection to the casino, the Ziibiwing Center presents a community-based telling of Saginaw Chippewa and Anishinabek cultures. It asserts Anishinabek presence and the legitimacy of Saginaw Chippewa existence and culture, past and present. Its mission and scope as a tribal museum create a powerful frame for communication that other kinds of museums will have trouble matching, and as I discuss below, the kind of rhetorical sovereignty it articulates is both enabled and restricted by its rootedness and specificity.

Legible Sovereignties at the Ziibiwing Center: Rhetorical Intentions, Rhetorical Effects

Tribal museums have proliferated in the last few decades, and as Brenda J. Child observes, "tribal museums share some of the same objectives as conventional museums, such as public history education; but the practice for which they are celebrated, extensive community involvement and collaboration, helps reproduce tribal values within the museum setting" (Child 2009, 252). Put in rhetorical terms, while tribal museums may share some

of the same goals and have some of the same genre features as conventional museums, their primary communicative goals differ in that the tribal museum is meant to represent and perpetuate that specific community's values and cultural practices to their audiences. The original intentions, as captured in the mission statement, in the Ziibiwing Center exhibits, and particularly in *Diba Jimooyung*, reflect this key difference. The mission statement (first crafted in 2004 and unchanged as of 2015) articulates the goals of the Ziibiwing Center in terms of reproducing Saginaw Chippewa cultural practices and communicating those to visitors. It also does so with subtle wording—especially "recognized"—that suggests that sovereignty, in all its forms, is part of the function of the space and the *Diba Jimooyung* exhibit.

In terms of rhetorical intentions, the permanent exhibit is designed to tell Anishinabek and specifically Saginaw Chippewa history from a Saginaw Chippewa perspective, countering both the "vanishing Indian" idea and the ways that histories written by outsiders have characterized them. Using the multiple exhibit techniques described above, the curators and designers of the exhibit endeavor to portray a history, from creation to the present, through Saginaw Chippewa eyes. The intended audience is both Saginaw Chippewa/Anishinabek and non-Anishinabek, however the Saginaw Chippewa audience is privileged in the sense that, as Anita Heard (Ziibiwing Research Center coordinator) describes it, the *Diba Jimooyung* exhibit is about "self-identity" and "self-definition," and so is geared toward supporting community heritage and teaching Saginaw Chippewa identity to present and future generations (personal interview 2007). Ekdahl put it more directly: the exhibit was designed "for our own people first. Knowledge is healing, and this is about knowing one's identity" (personal interview 2007).

For example, the opening text panel to the exhibit establishes this approach from the entry into the space. Beginning with the title of the exhibit at the top—first printed in red, in Anishinabemowin, then in black, in English—it defines what the name "Anishinabe" means and describes Anishinabek origins. The main text affirms,

> Who we are and our origins are very unique. We have our own Creation story. Many *Anishinabek* believe that the Creator places us in North America near the Great Salt Water (East Coast). We had established societies and family structures with our own language and spiritual beliefs. Many *Anishinabek* believe that we

were given Seven Prophecies from the Creator. These Prophe-
cies were foretold many generations before European contact.
These Seven Prophecies will always guide the future of the
Anishinabek. ("Diba Jimooyung" 2004)

The label highlights the community orientation to the telling of this his-
tory immediately, starting with the origins of the Anishinabek peoples,
their Creation story (and it is "our own"), language, societal structures,
and guiding prophecies. The language here implies that this is not going
to be an exhibit framed by a detached anthropological or archaeological
approach without community investment; the Saginaw Chippewa are in
charge of their own history, and their rhetorical power to be so extends
"many generations before European contact." Thus what visitors are
about to see is part of a continuous story that extends from the creation of
the Anishinabek peoples to the present.

The idea of how little mainstream audiences know about Native history
or any particular Native nation's history, *Diba Jimooyung* also seeks—some-
times subtly, sometimes overtly—to challenge the historical narrative
about the Saginaw Chippewa, and to present it from that community's
perspective. The exhibit is not meant to be exclusionary, as the final words
of the label turn back outward from the Saginaw Chippewa to its poten-
tial audiences: "Take a journey with us," it reads, and "Let us tell you our
story" ("Diba Jimooyung" 2004). Here there is a direct address from insid-
ers of the community speaking to/inviting in outsiders. In reference to
the use of the "prophecies" and the community debate surrounding their
inclusion in the exhibit, Ekdahl stated, "The prophecies include all people,"
and so the story told in *Diba Jimooyung* is not for the Saginaw Chippewa or
Anishinabek peoples alone (personal interview 2007).

At its opening, the Ziibiwing Center was a point of interest for sur-
rounding communities and an already-incorporated part of the Saginaw
Chippewa cultural programming fabric. As its roots in the Ziibiwing
Cultural Society indicate, the need for its presence and its usefulness to
the Saginaw Chippewa community predates its opening. The coverage of
the cultural center was largely positive, indicating that the rhetorical inten-
tions were largely understood and communicated effectively to invested
communities. Regional news outlets from places such as Mount Pleasant
and Detroit covered the opening of the museum (Hoffman 2004; "Mount
Pleasant Facility" 2004). Although those articles are not particularly

evaluative in nature, their presence signals an interest from the surrounding non-Native communities at the time of the Ziibiwing Center's opening. The Saginaw Chippewa *Tribal Observer*'s archives reveals a series of updates toward the opening day ("Center to Enlighten" 2004), and the June 1 issue from 2004 devotes a two-page spread to photographs covering the May 15 tribal "sneak peek" of the facilities and exhibition and community members' enthusiastic reactions ("Community Pride" 2004; "Ziibiwing Center" 2004). Later, a first-anniversary article authored by then-director Ekdahl highlights the successes of the cultural center's first year and the ongoing efforts to evaluate its programs and marketing (Ekdahl 2005). The Ziibiwing Center's own archive of its press releases underscores the multiple ways that it hosts and supports Saginaw Chippewa community programming and events.

Likewise, the kinds and numbers of awards that the Ziibiwing Center has received in intervening years underscores the perceived value of the work its staff does, both with programming and with the exhibits. A quick rundown of awards reveals both the local and national impact the Ziibiwing Center has been making: in 2005, the Gold Muse Award for the Creation Theatre film and "the highest standards of excellence in the use of media and technology for interpretation and education in history and culture," from the American Association of Museums ("Awards" 2014); and in 2006, the Museum Award from the Michigan Cultural Alliance "in celebration of outstanding creativity and commitment to building Michigan into a state that values, supports, and uses culture to make our communities better to live, work and visit" ("Awards" 2014). In 2008, the Ziibiwing Center received the Harvard University Honoring Nations award, from a committee that argues that "tribes themselves hold the key to generating social, political, cultural, and economic prosperity and that self-governance plays a crucial role in building and sustaining strong, healthy Indian nations" ("Awards" 2014). Then, in 2009 and again in 2014, the Michigan Indian Education Council awarded the Ziibiwing Center its Distinguished Service Award for "outstanding work in educating tribal citizens and the general public about Anishinaabe culture, history, and lifeways" (PDF under "Awards" 2014). National to state-level organizations, Native to non-Native, have recognized the Ziibiwing Center for doing outstanding work in its endeavors to educate both Saginaw Chippewa and non-Native audiences.

The scholarly work inspired and supported by the Ziibiwing Center is also noteworthy in how it underscores the way the Ziibiwing Center

has become not only an educational resource, but also an institution that provides an example for decolonizing methods in museum studies and archaeology. Scholar Amy Lonetree had already given *Diba Jimooyung* a glowing exhibit review, published in the *Journal of American History* (2008b), that explained the exhibit's value in terms of how it demonstrated ways that the difficult colonial histories could be effectively told within an exhibit space. This review grew into an article for Susan Sleeper-Smith's collection *Contesting Knowledge* (2009), and then a significant portion of Lonetree's 2012 monograph, *Decolonizing Museums*. The goal in each of these works was the same: to demonstrate how "hard truths" of colonialism must be addressed in museums if justice is to be done in the telling and in community action, and how the Ziibiwing Center is an example of that decolonizing practice. Scholar Sonya Atalay had similar reservations about the NMAI ("No Sense of the Struggle" 2008), and likewise has similar praise for the Ziibiwing Center and the work that it accomplishes. Atalay's book chapter in *World Archaeological Congress (WAC) Handbook of Postcolonial Archaeology* (2010) discusses the *Diba Jimooyung* exhibit as an example of decolonized archaeological practice, and her 2012 monograph *Community-Based Archaeology: Research with, by, and for Indigenous and Local Communities* uses examples from her partnership with the Ziibiwing Center repatriation efforts to demonstrate what that kind of decolonized archaeological practice might look like. The Ziibiwing Center has also received attention in scholarly collections such as *Evaluating Multiple Narratives: Beyond Nationalist, Colonialist, Imperialist Archaeologies* (Habu, Fawcett, and Matsunaga 2008) and *Transforming Archaeology: Activist Practices and Prospects* (Atalay et al. 2014). In the wider scholarly communities in museum studies and archeological studies, the Ziibiwing Center is setting a powerful example for what Indigenous community-based efforts can do and produce.

My own rhetorical reading of the exhibit space's communicative intentions shifts the emphasis to self-representations and how they are made legible. While it is unquestionably significant that the Ziibiwing Center enacts decolonized museum and archaeological practices, how are they communicated to various audiences through the cultural center and particularly the *Diba Jimooyung* exhibit? In what ways has the Ziibiwing Center taken the communicative genre system of the museum and turned it to do this decolonizing work, to tell the hard stories in a convincing way? The rhetorical context and structure play a strong role here, for several reasons. First, the Ziibiwing Center is a tribal community museum, and so its scope

is specific and clear. That is not to say that the staff and community did not encounter challenges in choosing how to present their story, but rather that there is only one Native cultural frame to address and so obligations and narrative choices are automatically focused in one direction. Second, because it is a tribal community museum, the most important audience is already built in; the Ziibiwing Center already has a primary audience that needs it, and the cultural center was constructed to fill that community need. Finally, that need establishes the Ziibiwing Center's relevance for the long term. In rhetorical terms, the exigence for this work is already firmly in place, and so relevance—at least for the Saginaw Chippewa—is implicit. Having this framework of rhetorical need and clearly defined rhetorical scope from the beginning allowed the Ziibiwing Center, I would argue, to take conventional museum structures and make them unconventional.

For example, many of the means to this "decolonized" presentation are fairly traditional museum structures, especially the dioramas. When asked about the design of the first gallery Areas, Heard noted that the dioramas were a little "dangerous" because of their tendency to "freeze" history (her adjectives); on the other hand, she also asserted that "people learn best from what they know—objects under glass [and the like]—but the story should be from the community's point of view" (personal interview 2007). In other words, so long as the community's perspective is privileged and shapes the use of dioramas and object-based displays, traditional museum techniques—or genres—can be used to reach an audience that might otherwise find the Saginaw Chippewa inaccessible.

Via the spatial organization, the *Diba Jimooyung* exhibit is a carefully structured narrative that provides a significant amount of control over visitor movement, in that with the exceptions of the theaters and the model lodges, visitors cannot skip over a section of the exhibit, nor can they wander randomly to areas of their choice. The exhibit is laid out in such a way that visitors must move from one Area to the next, in the chronological and Prophecies-guided order of the Saginaw Chippewa story. Within sections, however, visitors may explore, for several are sizeable, with several subsections or displays. Furthermore, the shape of the individual Areas' spaces is intended to influence visitor perception: current Ziibiwing director Shannon Martin describes the general design as "curved for harmony, and jagged for hard times" (personal interview 2007). As a visitor may observe, the sections telling the precontact history of the Anishinabek are curved, and the Creation Theater is a perfect balanced circle, but the end of

Area 6: Contact and Co-Existence turns a sharp corner into Area 7: Effects of Colonization, which is a section full of sharp edges. It in turn gives way to Area 8: Environmental Changes, which has both a curved wall and a crooked wall: the curved wall shows photographs of unspoiled landscape, and the crooked wall displays archival images of lands that were stripped for lumber. With Area 9: Blood Memory, the walls become curves again, and continue so through the end of the exhibit.

The specifics of language and image also play an innovative role, and within the context of Ziibiwing and the *Diba Jimooyung* exhibit, language becomes plural with the use of Anishinabemowin alongside English. Though the linguistic explanatory texts are still primarily in English—a choice that encompasses a larger selection of audiences—the labels on those texts are always first in Anishinabemowin, as observed above, and then translated into English, sometimes with additional Anishinabemowin vocabulary interspersed in the text. The voice-over narrative is also partly in Anishinabemowin, allowing visitors who prefer to listen to an Anishinabemowin narration to follow it as a guide, rather than the English narration. The result is a mixture that underscores the multiple facets of contemporary Anishinabemowin and Saginaw Chippewa existence, one that speaks more than one language. Furthermore, the use of Anishinabemowin highlights the fact of the language's continued existence and use, which furthers the purpose of creating a Saginaw Chippewa identity many community insiders and outsiders may find more "authentic" and lends authority to the history told within *Diba Jimooyung*.

The English-language narration itself also presents a departure from the scientific/anthropological language associated with traditional museums, for while it does employ more academic-sounding terms on occasion—"colonization," "subsistence economy," "decimation"—and technical labeling for objects, the majority of the narrative text is told in a first-person plural "we," and none of the labels are signed by curators or community members. The narration also consciously continues the work begun in the "Diba Jimooyung" panel and challenges popular historical narratives at times, as in the "Ezhimaamiikowaadjimigoo Yaang: The Outlandish Stories Told About Us" oval panel, which directly addresses with considerable irony the stereotyping used by non-Native artists and media to portray the Saginaw Chippewa during the period of colonization as "barbarians" and US government figures, such as Michigan territorial governor Lewis Cass, as heroes of civilization. In this particular label, there

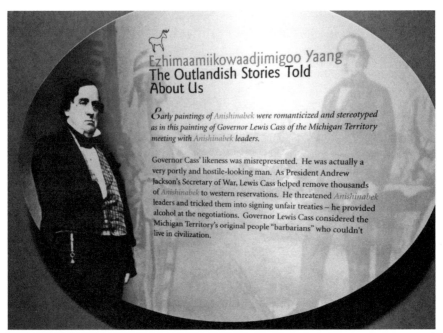

The following is inside the image:

🦌
Ezhimaamiikowaadjimigoo Yaang
The Outlandish Stories Told
About Us

Early paintings of Anishinabek were romanticized and stereotyped as in this painting of Governor Lewis Cass of the Michigan Territory meeting with Anishinabek leaders.

Governor Cass' likeness was misrepresented. He was actually a very portly and hostile-looking man. As President Andrew Jackson's Secretary of War, Lewis Cass helped remove thousands of Anishinabek to western reservations. He threatened Anishinabek leaders and tricked them into signing unfair treaties – he provided alcohol at the negotiations. Governor Lewis Cass considered the Michigan Territory's original people "barbarians" who couldn't live in civilization.

Fig. 4. Ziibiwing Center, *Diba Jimooyung*, "Ezhimaamiikowaadjimigoo Yaang" panel. July 2014. Photo courtesy of the author.

is an archival photograph of Cass next to an idealized painting of Saginaw Chippewa leaders meeting Cass that clearly depicts the Native figure in feathered profile facing a full image of a kind and physically fit Cass from the front. The text is strategically placed over this romanticized image, leaving only the photograph of a rather dour-looking Cass clearly visible. It reads,

> Early paintings of *Anishinabek* were romanticized and stereo-typed as in this painting of Governor Lewis Cass of the Michigan Territory meeting with *Anishinabek* leaders. Governor Cass' likeness was misrepresented. He was actually a very portly and hostile-looking man. As President Andrew Jackson's Secretary of War, Lewis Cass helped remove thousands of *Anishinabek* to western reservations. He threatened *Anishinabek* leaders and tricked them into signing unfair treaties—he provided alcohol at the negotiations. Governor Lewis Cass considered the Michigan Territory's original people "barbarians" who couldn't live in civilization. ("Ezhimaamiikowaadjimigoo Yaang" 2004)

In this way, the stereotypes that have been written into American history as fact are challenged with both visuals and the Saginaw Chippewa's perspective on Cass as a historical figure. The Saginaw Chippewa perspective literally overwrites the romanticized image, leaving the photograph as evidence of the misrepresentation. The aural narration at this point in the exhibit reads off historical excerpts of letters written by Cass in which he disparages Anishinabek communities, thus underscoring the historical distortion that has typically depicted the Anishinabek as uncivilized or deserving of removal.

The visuals used throughout the exhibit play a supporting role to the text narration, and sometimes also take center stage in the exhibits. The dioramas and model lodges in the first portion of *Diba Jimooyung* are three-dimensional visuals that provide a more vivid and immediate demonstration for visitors than could sketches or labels of the objects used in these activities. The lodges in particular create a more experiential element—one can walk inside, smell the sage and the leather inside the teaching lodge, and though one may not touch the hides, baskets, shakers, and tools, one can at least get a better contextual sense of their use. The theaters provide concise multimedia introductions into foundational aspects of the exhibit and Saginaw Chippewa identity that are more immediate than reading a label. Archival images and document reproductions are also powerful tools, for the photographs provide historical documentation and support for the Saginaw Chippewa story, as do the complete reproductions of the pivotal treaties between the Saginaw Chippewa Nation and the US government. In those places where specifically Saginaw Chippewa archival images are difficult to find or have little place, broadly historical, archival images and artwork are used to continue the story and illustrate ideas, for example in paintings from Area 6: Contact & Co-Existence and in the Richard Bedwash depictions of the Seven Grandfather Teachings in Area 15: Continuing the Journey. By using images that pay more attention to historical detail—or in the case of Richard Bedwash, a Woodland Native vision that reveals connection and relationship—*Diba Jimooyung*'s narrative avoids the romanticized past and foregrounds the Saginaw Chippewa telling of history.

In sum, if legible sovereignties seek rhetorical action that promotes Indigenous rhetorical sovereignty, then *Diba Jimooyung* presents a powerful example of a tribal nation taking charge of its history's rhetorical frame and telling it in a way that supports Saginaw Chippewa self-knowledge while

inviting in visitors from outside the community. The exhibit is intended to serve the Saginaw Chippewa community first, but does not limit itself to that audience. It is intended to educate everyone.

At the same time, even with such clear goals, it is possible for an exhibit to generate multiple meanings and to resonate in a variety of ways depending on who the visitor is. For the Saginaw Chippewa, Ziibiwing is a cultural center that supports the community's culture; *Diba Jimooyung* is its historical heart, but it also hosts multiple cultural programs, including dance classes and exhibitions, ceremonial feasts open to the public, and artwork demonstrations and classes ("Calendar" 2016). Within this context, the main exhibit and the changing exhibits are spaces for maintaining cultural knowledge and continuity, and although open to the public, the target audience appears to be primarily Saginaw Chippewa.

For Native visitors who are not Saginaw Chippewa, Ziibiwing and *Diba Jimooyung* have provided a powerful example for how a tribal museum can successfully articulate its own history. As the awards and scholarly publications also indicate, the Ziibiwing Center has established itself as an example in Michigan and among other tribal cultural centers and museums within the United States. For other Native communities, it represents the possibilities for Native communities to speak powerfully on their own history and culture, and even as those other communities would have other histories to tell and stories to explain, Ziibiwing and *Diba Jimooyung* have acted as a springboard for other communities' efforts. To the state of Michigan, the cultural center and exhibit represent a Native resource that can enrich understandings of the region's history and culture in a way that no other state institution can.

For non-Native visitors who enter this space, Ziibiwing and *Diba Jimooyung* provide a narrative of Saginaw Chippewa history that they cannot find anywhere else. The cultural center and exhibit encompass a compelling narrative that in many respects satisfies the typical museumgoers' desire to see objects on display—even if that approach leaves the possibility for stereotypical expectations for display—while at the same time providing a narrative that does not conform to mainstream versions of history. This balancing of audience expectations against challenging material is a rhetorical tactic that appears to function well for *Diba Jimooyung*, and makes the direct contradictions to what visitors may think they know about Indians more palatable. It should also be noted that the clearly defined bounds of the Saginaw Chippewa story (in contrast to covering multiple

communities/nations or multiple geographical regions) lends itself well to becoming a narrative, thus making the information easier to grasp.

Yet for all its successes, it can be argued that Ziibiwing and *Diba Ji-mooyung* have more work to do. Rhetorical exigence changes over time with community needs, and the past ten years since the cultural center's opening have created more opportunities and revealed particular challenges that Ziibiwing now works to address. Several tasks worth consideration emerge.

One of the major challenges for Ziibiwing and *Diba Jimooyung* is maintaining relevance for the Saginaw Chippewa community. Given the cultural center and exhibit's powerful role in maintaining the historical and cultural narrative, that relevance will not wane quickly. At the same time, there are ways to continue making *Diba Jimooyung* better. New funding, new technology, and the acquisition of new collections and property all contribute to the enhancement of the exhibit and cultural center spaces, and offer new opportunities to fulfill the original vision in ways that were not possible before. In a similar way, the changing exhibit space adjacent to *Diba Jimooyung* creates opportunities to enhance and expand the foundational ideas in the permanent exhibit in new ways, even to the point of paving the way for a physical expansion of Ziibiwing's mission, as we shall see with the *Debwewin/Truth* exhibit.

Furthermore, if Ziibiwing and *Diba Jimooyung* want to fulfill the part of the mission that teaches more than a Saginaw Chippewa or broadly non-Native audience, then a second ongoing consideration is how Ziibiwing addresses attracting more than Saginaw Chippewa visitors or enhances and designs its outreach. Its orientation to the community is powerful, but also potentially dissuades other visitors—by default, not on purpose—by virtue of its emphasis and location. Regarding its emphasis, it is not uncommon for non-Native audiences to perceive a Native cultural center designed to support its own community first as something that does not or should not concern non-Natives. While Ziibiwing and *Diba Jimooyung* certainly do not intend to do that, and much of its design has to do with addressing misperceptions, the perceptual barrier is one that needs constant attention. In a more physical sense, its location on the Isabella Reservation means that non-Native visitors have to come onto clearly delineated reservation land[1] to visit the museum, something that many might hesitate to do without an explicit invitation. If non-Native visitors perceive Ziibiwing as a place intended for Saginaw Chippewa citizens on the reservation, the likelihood of them seeking it out unless they have a vested interest is less than that of

a site located within a predominantly non-Native population. This means that if the Saginaw Chippewa want a broader set of audiences for the Ziibiwing Center, then explicit outreach becomes a priority.

It should be noted that Ziibiwing is not at all far from the Soaring Eagle Casino and Resort, and as already documented, a short series of archival materials begins telling the Saginaw Chippewa story inside the resort building, next to the casino (*The Enduring Spirit of Our People* 2015). Whether casino visitors consider this as an invitation to visit Ziibiwing or as decoration in a Native casino remains a question, as is whether a casino visitor's intent to participate at the casino even corresponds with an interest in the Native community that owns the casino and cultural center. While Ziibiwing does appear on the map of the casino included on the Soaring Eagle website, the marketing of the casino plays to gambling, shows, golf, and spa activities without mentioning Ziibiwing at all, which suggests that resort visitors are not immediately targeted by Ziibiwing as a potential audience ("Soaring Eagle Casino and Resort" 2016). *The Enduring Spirit of Our People* may be a localized hook for visitors who are already there, if visitors have such an interest. Other potential visitor pools include the city of Mount Pleasant and Central Michigan University, which present their own rhetorical challenges, as I discuss later.

In sum, legible sovereignties find a powerful articulation in the Ziibiwing Center, and particularly in *Diba Jimooyung*, in the ways Saginaw Chippewa self-determination take precedence in history, in its displays, and in its articulation of Saginaw Chippewa presence, past and present. It does function in different ways for various audiences, but toward the unified goal of Saginaw Chippewa rhetorical sovereignty; it could be argued that it is precisely because it is a tribally owned and operated museum that it has this unifying power. At the same time, the work at Ziibiwing is not finished; *Diba Jimooyung* has to be recast into the present to maintain its relevance, and drawing in multiple audiences remains an ongoing goal.

Gathering Everyone in This Story: Cultivating Presence and Planting New Outreach at the Ziibiwing Center

Since the Ziibiwing Center's establishment as a site for cultural renewal and teaching, its role in the community has continued to evolve, in both taking on new tasks and extending its original mission. For Ziibiwing, legible sovereignties involves supporting the home community while finding

ways and opportunities to reach out to others, even if that relationship between the Saginaw Chippewa and surrounding communities has been historically difficult. At times, this has meant seeking ways to extend the work that is already going on at Ziibiwing and in the spirit of *Diba Jimooyung*. At other times, it has meant taking up work that the staff at Ziibiwing had not originally imagined, but which has proven immensely valuable to the tribal community when its sovereign rights have been at stake. In this sense, Ziibiwing demonstrates how a legible declaration of rhetorical sovereignty has tangible effects.

Local programming and exhibit maintenance are two of the basic ways that Ziibiwing works to sustain its message and visibility within the Saginaw Chippewa community and for other local communities. While the message of *Diba Jimooyung* has not changed, general wear and tear on exhibits requires upkeep, and the evolution of technology sometimes makes new possibilities available over time. Current director Shannon Martin observes that there have been some issues with media within the exhibit, but that those issues offer opportunities for rethinking or revamping places within *Diba Jimooyung*. For example, the small image of the galaxy outside of the Creation Theater was printed at its present size because, at the time of the exhibit's design, a larger quality print was simply beyond the budget. Now, however, printing technology has improved enough that costs have dropped, and the opportunity is there to replace that image with something more in line with what the tribal exhibit designers had originally imagined (personal interview 2014).

Similarly, staff members have been rethinking the three cradleboard images that are the center of the Blood Memory space in *Diba Jimooyung*. This particular place in the exhibit is important in how it sits between the sections detailing historical injustice, abuse, and loss and the sections that move into cultural renewal under the Seventh Fire prophecy. There, a visitor can sit in a quiet alcove, and on the facing wall the original designers have placed three life-size images of cradleboards: one each for the Three Fires, the Anishinabe, Ottawa, and Potawatomi peoples. It is a space intended for quiet reflection and reconnection, but the growing sense was that images of cradleboards were not enough; there needed to be something there to touch, to interact with, something made by the community for the community. Assistant Director Judy Pamp explains that the ongoing project in 2014 was the making of three cradleboards to be hung there in place of the pictures (personal interview 2014). Any visitor—Saginaw

Chippewa or not—was invited as they came into the foyer to sew some beads onto the backing already prepared with designs for beading. Those who already knew how could pick up a needle and choose a part to bead; those who did not know how could learn from a staff member at the table. All the names of those who contributed were collected as visitors added their beads, and this list will become part of the exhibit as well. Such a project thus captures multiple means of drawing a community together and extending the literal and figurative making of meaning to everyone willing to try. They will become part of the history, part of *Diba Jimooyung*, for the foreseeable future.

Programming has followed a similar pattern. Some programs having to do with arts, language, and dance have become staples, but Ziibiwing has found itself having to reevaluate other programs for whether or not they support the mission in consistent ways. For instance, the popular Bike Blessing and Rez Ride was drawing close to a hundred motorcycles and riders by 2007 ("Press Release: Bike Blessing" 2007), but Martin observes that the event did not really support the mission of Ziibiwing per se. It was popular with area motorcyclists, but the event served as publicity for the casino more than it did as a cultural program at Ziibiwing (personal interview 2014). Conversely, the annual Monarch Butterfly Celebration blends a community event (open to the public) with children's events, storytelling, facepainting, and the opportunity to "adopt" a monarch butterfly, with proceeds going to the Monarch Butterfly Tracking Program ("Press Release: 3rd Annual Monarch Butterfly Celebration" 2009). The event also connects to powwow culture in that the women's fancy shawl dance is often also known as the "butterfly dance," and so the afternoon's activities include a dance exhibition. Unlike the Bike Blessing, the Monarch Butterfly Celebration therefore creates a family-oriented event that provides a mutual interest—saving monarch butterflies—for a variety of audiences, and blends science, environmental awareness, and Native culture in a way that has the capacity to appeal to multiple communities.

Yet, as noted above, there are particular challenges to be met with other communities in the area, and relationships are complicated and sometimes fraught. For example, the city of Mount Pleasant and the Isabella Indian Reservation overlap, and since the founding of Mount Pleasant and the creation of the Isabella reservation roughly correspond, around 1855 ("History" 2015; "Creating the Isabella Reservation" 2014), relationships between Native communities and white settlers have not always been easy.

A quick search of historical sources from both sides document the unscrupulous acquisition of tribal lands and prime timber in the second half of the nineteenth century ("Loss of Reservation Land" 2014; *Diba Jimooyung* 2005, 51–52), and even the founding of Mount Pleasant itself is a contested history. Did David Ward, noted as the founder of the city on the city's website, simply "purchas[e] land from the United States government" in 1855 ("History" 2015)? Or did he "clai[m] land on the Isabella Reservation in May 1856" after the 1855 Treaty of Detroit, which was the basis of the reservation's founding, such that the commissioner of Indian Affairs at the time had to nullify his claims in order to stop Ward and other speculators from taking Saginaw Chippewa land (*Diba Jimooyung* 2005, 52)? Mount Pleasant's telling of its own history—at least on its public website—and the Saginaw Chippewa history frame the story very differently. Even the city seal reflects this working tension and a tug-of-war over what Native presence means there. As a circle, quartered, it contains an "Indian" head in profile in the top left quarter, with grain to the right, an oil rig below, and then a mortarboard on the bottom left; these represent the influences of "Native American heritage and culture; agriculture; ...the discovery and production of oil; [and education]" ("History" 2015). It is telling that the image of the Indian only represents "Native American" heritage in the vaguest sense, without citing any direct relationship to the Saginaw Chippewa, their next-door neighbors. Here the image on the seal is simply one of many commodities, reduced to prominent cheekbones and feathers in the stylized image, now part of a "rich heritage" that remains unnamed so that it can be more easily claimed. Though only one example, the tension in these sources alone demonstrates how the relationship often plays out in the present.

As a result of this history, Ziibiwing has found itself playing unexpected roles beyond cultural revitalization and teaching. For example, both Martin and Pamp brought up the supporting role that the Ziibiwing Center played in the 2010 court ruling in favor of the Saginaw Chippewa against the state of Michigan, Isabella County, and the City of Mount Pleasant in *Saginaw Chippewa Indian Tribe of Michigan and United States vs. Granholm, et al.* In this particular court case, the federal government intervened in a long-term dispute over the Isabella Reservation's existence and its boundaries, and therefore the jurisdiction for taxation, law enforcement, the application of the Indian Child Welfare Act, land use, and revenue sharing ("US Court Approves Agreement" 2010; Cloutier 2010). In order to establish

jurisdiction, the Ziibiwing Center archives and Coordinator Heard's exper-
tise played a pivotal role in assisting the Saginaw Chippewa's case (Martin
and Pamp, personal interviews 2014). In this case, the Ziibiwing Center
became involved in maintaining not just the community's rhetorical and
cultural sovereignty, but its political sovereignty as well. Even if that was
not part of the original goal of Ziibiwing, its existence, its resources, and its
abilities to support and interpret Saginaw Chippewa history have become
essential in political arguments over land rights and the tribe's right to self-
governance. Rhetorical sovereignty in this case led to directly supporting
political sovereignty.

In a second recent example, Ziibiwing played a supporting role for
the Human Rights Committee of Isabella County's investigation into
micro-aggressions and racist acts against Native community members,
particularly in Mount Pleasant (personal interviews 2014). The report,
undertaken in 2012 and filed in 2014, used qualitative methods to docu-
ment the experiences of more than one hundred tribal members in the
community as they have experienced micro-aggressions and discrimi-
nation, and also to document how Native community members try to
respond to them ("Report of Findings" 2014). Evident in the report is a
number of stereotypes of Native peoples that surface repeatedly in these
encounters: "historical Indian," "dirty Indian," "poor Indian," "lazy In-
dian," "uneducated Indian," "alcoholic Indian," and "undeserving Indian"
("Report of Findings" 2014, 13–21). Several Native participants in the
study point out that much of the problem is education about the Saginaw
Chippewa (or lack of it) among local non-Natives. The fact sheet from
the study ("Study of Micro-Aggressions" 2014) lists both a short form of
what the study revealed and tips for Native recipients of such encounters
on how to respond constructively. Among the tips are "start where they
are, not where you are" and "use it as a teachable moment" ("Study of
Micro-Aggressions 2014), and the results from the interviews also indicate
a growing desire on the part of participants to educate offenders ("Report
of Findings" 2014).

The importance of the study for Ziibiwing in this analysis is two-
fold. First, Ziibiwing served as a support site for the study itself, provid-
ing a place to "coordinate the distribution, receipt, and organizing of the
materials involved" and staff members to assist in this effort ("Report of
Findings" 2014, 40). The Human Rights Committee had not yet even been
formed at the time of Ziibiwing's opening, and so Ziibiwing's participation

in the study constitutes an extension of its mission that could not have been anticipated at its formation. Here we see how the cultural center, by its presence, played a pivotal role in representing the Saginaw Chippewa community in another new way. Second, the results of the report underscore the importance of Ziibiwing's original mission. If education of the non-Native populace is one of the desires of community members and part of the solution to ending micro-aggressions and discrimination, then Ziibiwing is more important than ever as a site of education and teaching. At the same time, how to get non-Native visitors from Mount Pleasant and the surrounding community through Ziibiwing's doors remains a challenge, which is why small events and opportunities like the Monarch Butterfly Celebration are more crucial than they may initially seem.

A related issue—or perhaps a subset of the same—is the Saginaw Chippewa relationship with Central Michigan University, also located in Mount Pleasant. The university has an official relationship with the Saginaw Chippewa in large part because of its use of the "Chippewa" as a mascot (though in recent years the visual representation of that mascot has been restricted to the "flying C"). According to the university's own website, CMU began using the mascot/nickname without permission in 1942, with the goal of making themselves more visible and to "[open] up unlimited opportunities for pageantry and showmanship," which "in practice . . . amounted to stereotypical imagery and mockery of Native ceremonies" ("Central Michigan University Chippewas" 2015). Even with official sanctioning of the "Chippewa" mascot in 2002, and the declared "strong historic and cooperative relationship that complements each entity's goals" ("About the CMU and Tribal Relationship" 2015), that relationship has not always been easy. Given the evidence from the Human Rights Committee report, Native-sponsored mascot or not, the general perception of Native peoples is still largely based on stereotypes.

CMU has made some effort at combating these stereotypes, providing web resources on the university website through the Office of the Provost and Institutional Diversity's webpages ("To Be a Chippewa" 2015), which include a history of the mascot, an explanation of the relationship between the university and the Saginaw Chippewa, and a description of and link to the Ziibiwing Center's home page. Non-Native students are exhorted to take responsibility and "use the Chippewas nickname in a respectful and understanding manner" by taking a Native studies course, attending cultural events, and "refraining from disrespectful behavior"

("Central Michigan University Chippewas" 2015). According to Martin
(personal interview 2007) the Ziibiwing Center used to do educational
tours for incoming athletes to make sure that they understood what it was
they were doing when they took up that name and represented both the
school and, in a sense, the tribal community. Saginaw Chippewa students,
meanwhile, are offered a transfer agreement designed to make matricu-
lation from the tribal college to CMU smoother ("About the CMU and
Tribal Relationship" 2015).

Ziibiwing's most recent involvement on the campus, however, has
been an exhibit space in the new campus Events Center. Collaboration
between Martin, as a representative of the Ziibiwing Center along with
several tribal members, and university advocate Colleen Green, director
of the Student Transition Enrichment Program and the Office of Native
American Programs, together with representatives from the athletic de-
partment, has yielded a four-section exhibit based on Saginaw Chippewa
history and contemporary life. The exhibit is thematically arranged: the
north wall contains displayed items from the Ziibiwing Center, the east
wall depicts Saginaw Chippewa history, the south wall describes the re-
lationship between the Saginaw Chippewa and CMU, and the west wall
represents the 2011 repatriation of Saginaw Chippewa ancestors (Shaffer
2013). A touch screen on the east wall contains more photographs. The
goals of the exhibit, as observed by Athletics Director Dave Heeke, are
to have "a space that would be a visible reminder of the original inhabit-
ants of this region, and our obligation...to respect their history, their
culture and their heritage" but also "reflect an incredible partnership
and relationship that has evolved and developed over the years between
Central Michigan University and the Saginaw Chippewa Indian Tribe"
(Shaffer 2013).

This is clearly an attempt at making Saginaw Chippewa history and
self-representation more a part of the fabric of campus life and less a
convenient means to "pageantry," and its potential for making this self-
representation legible is recognizable. In creating this space, students
and visitors will be exposed more regularly to this history, and Saginaw
Chippewa presence cannot so easily be ignored or cordoned off to the
reservation. "Chippewa" is not so easy to appropriate as a moniker with
the physical evidence of actual Chippewa people, past and present, fully
present. One would hope that it would be much more difficult to appro-
priate the name with this kind of presence. Furthermore, the display's

availability makes it easier than ever for students and visitors to access this history—it is right on campus, and is located in a building that is central to campus events—in a way that is more comfortable to them. If students are uncertain about visiting the Ziibiwing Center proper, here at least they have a chance to approach this history on their own terms. Simultaneously, however, this context for Saginaw Chippewa history does make it easier to appropriate in some respects. As a visitor to the Ziibiwing Center, a student would be obligated to respect the space and the history and literally approach it from a Saginaw Chippewa–oriented perspective. From the structure and directed use of the space to the tour guides and supplementary materials, the Saginaw Chippewa have considerably more influence over how understanding happens at Ziibiwing that it does on CMU's campus. The exhibit on campus, on the other hand, will resonate differently simply by being in a primarily non-Native context. Here, the university can use the display as evidence of being Native-friendly (whether or not it ultimately is), and students might consider their obligation to the Saginaw Chippewa fulfilled just by quickly perusing this small exhibit. Thus, the extension of exhibiting Saginaw Chippewa history to CMU's campus cuts both ways: it creates a more visible Saginaw Chippewa presence, but also opens up more possibilities for interpretation that it may not intend or that it cannot control. For now it accomplishes a great deal in increasing visibility, but over time that impact may weaken and other programming may need to be developed. It cannot stand alone.

Overall, the Ziibiwing Center has found a variety of ways to continue its mission and extend what *Diba Jimooyung* can do, beginning with taking care of the home community and then using the work at home to begin outreach elsewhere. Since Ziibiwing's opening, part of these efforts have been devoted to maintaining the widely praised permanent exhibit and finding ways to enhance what it already can do. As a powerful example of tribal rhetorical sovereignty, it can still be made better to continue building and maintaining its legibility. At the same time, as described above, outreach has been a challenge because of historical and recent tensions with non-Native communities and institutions. Events like the Monarch Butterfly Celebration provide a nonthreatening platform from which to teach, and taking available opportunities to educate at CMU's campus creates further opportunities for education and dialogue. The challenge for legible sovereignties now and for the future is finding ways to meet

the needs of these audiences while still telling the hard truths, upholding tribal sovereignty work, and meeting cultural needs for the Saginaw Chippewa community.

Telling the Truth Together: Debwewin/Truth Exhibit and the Mount Pleasant Indian Industrial Boarding School

As a final illustration of the ongoing work the Ziibiwing Center does, the recent *Debwewin/Truth: The Mount Pleasant Indian Industrial Boarding School Experience* in the changing exhibit space offers both proof of the alliances being made and evidence for the long healing work ahead. It is an exhibit that vividly displays the pain the boarding school experience inflicted on many Saginaw Chippewa and regionally Indigenous students and indicts the policies and attitudes held by non-Natives that created the institution in the first place. At the same time, it was intended as a space for discussion and the revelation of this history for all the local communities—for cleaning the wounds, so to speak—and making way for healing to become a possibility.

The changing exhibit space, directly adjacent to *Diba Jimooyung* from the foyer of Ziibiwing, has hosted a variety of displays since the cultural center's opening. Two of the most recent are *Native Skywatchers: Reach for the Art in the Sky* and *Healing Through Culture and Art: Shawl Collection*. The *Native Skywatchers* exhibit showcased four Native artists as part of "an indigenous led initiative to revitalize and rebuild the knowledge of the Ojibwe and D(L)akota peoples" and, much like the Monarch Celebration, targeted audiences interested in building Indigenous understandings of the cosmos and in fulfilling Michigan State K–12 Science Standards that mandate the teaching of multiple cultures' understandings of science ("New Changing Exhibit" 2015). Similarly, the *Healing Through Culture and Art* exhibit uses a display of thirteen shawls made by Dr. Suzanne L. Cross, a Saginaw Chippewa tribal member, "to increase awareness and emphasize cardiac health and care" through traditional art with a contemporary application ("New Changing Exhibit" 2014), though it appears to target the Saginaw Chippewa community specifically. Other exhibits have displayed contemporary Great Lakes art, tribal members' photography, historical and contemporary basketry, powwow posters, and more.

Just this quick sampling illustrates the broad range of topics the changing exhibit space can and has covered, and also its emphasis on blending traditional and contemporary culture in support of Saginaw Chippewa

cultural knowledges. In these respects, the *Debwewin/Truth* exhibit was no different. At the same time, this particular exhibit tackles an extremely sensitive topic that is not easily celebratory. In fact, it could be argued that, in addition to the material on boarding schools and cultural destruction documented in *Diba Jimooyung, Debwewin/Truth* goes a step further and goes into more depth, discussing the local impact of the boarding school era through local history, the testimony of survivors, and the memorials to those who died as students. This is part of the context for being able to celebrate today's art and cultural revitalization, and a powerful reminder of why relationships between the Saginaw Chippewa and local communities are often strained. Without recognition of this part of the past—without telling the truth, as the exhibit title implies—there can be no healing and no reconciliation. It is the work of this exhibit to bring the Saginaw Chippewa community's truth forward for everyone to consider.

Named for one of the Seven Grandfather Teachings, *Debwewin/ Truth: The Mount Pleasant Indian Industrial Boarding School Experience* combines the value of truth for the sake of community and healing with the telling of the formation of the Mount Pleasant Indian Industrial Boarding School (MPIIBS). Structured in a circle around the gallery space, starting to the left of the entrance, the exhibit walks visitors through historical and contemporary photographs, historical documents, artifacts, memorial quilts, and video testimonies from former students and their families. The introductory label, "Let Debwewin/Truth be revealed" (2014), first cites Richard H. Pratt's famous declaration of such schools' purpose ("Kill the Indian in him, and save the man") and then explains the exhibit:

> The Mount Pleasant Indian Industrial Boarding School (1893–1934) consisted of 37 building on 320 acres of land, with an average enrollment of 300 American Indian students per year in grades K–8. Daily life was extremely regimented and strict like many other American Indian boarding schools throughout the country. Students were forbidden to speak their language, honor their culture, and practice their Anishinabe spirituality.
>
> The children performed manual labor such as laundry, farm work, cleaning, sewing, and other menial tasks for the majority of the school day. Basic academic instruction was secondary. Many children were subjected to malnourishment, physical and sexual abuse, and poor healthcare.

Today researchers continue to uncover shocking informa-
tion regarding the undocumented deaths and abuse, as well as
the triumphant stories of resilience, love, and defiance. This
period of time, known as the *Era of Stolen Children* or *Ameri-
can Indian Holocaust*, has been hidden from US history ("Let
Debwewin/Truth be revealed" 2014).

The rest of the exhibit is framed through labels that outline the pur-
pose of the MPIIBS, student treatment, and student memories. Interspersed
through these labels are quotations from the assimilationist-era thinkers
who advocated for cultural eradication (such as Pratt) or advocated for kill-
ing the Indian outright ("Chivington" 2014); these violent quotations are
strikingly represented on small chalkboards in children's handwriting. As
the visitor progresses through the exhibit, these quotations are gradually
replaced by the words of the students themselves, first in painful memory
of their treatment and the deaths of fellow students, and then in defiance
of said treatment, then in support of Anishinabe cultural revitalization.
The objects are arranged to support the narrative of grief, endurance, and
resurgence, and the commissioned quilts that hang from the center of the
exhibit form the centerpiece around which the exhibit circulates.

I quote the introductory label at length in part to let the exhibit speak
for itself, but also because of the way it captures the goals of this exhibit: in
defiance of the attitudes toward Native cultures that founded such schools,
this exhibit is intended to document what the children endured, remember
the forgotten ones who died at the school, and then use this narrative as a
means to explaining *why* Anishinabe cultural revival is so very important.
In a challenge to any easy celebrations of diversity, it openly grieves these
losses, calls for reconciliation, and only then celebrates the cultural revi-
talization efforts of the present. The wording of the introductory label
emphasizes its desire to tell this "hidden" history, but do so with the incor-
poration of historical backing and researched materials.

The combination of display materials helps support this goal. For
example, the discussion of undocumented student deaths—perhaps one
of the most emotionally laden parts of the exhibit—does not base itself
in pathos alone. In the large label introducing this segment of the exhibit,
the writers are quick to demonstrate that the charge of hidden or badly
documented child deaths at the boarding school is not an idle or angry
accusation. The research team details the sources it used to triangulate its

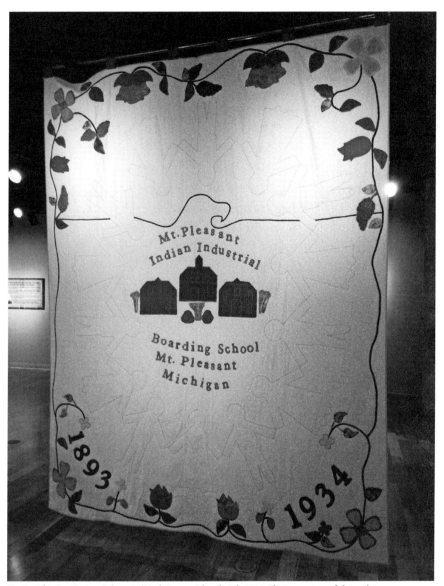

Fig. 5. Ziibiwing Center, *Debwewin/Truth*, memorial quilt. July 2014. Photo courtesy of the author.

data against the federal administrative records, including the "Register of Pupils of the Mt. Pleasant Indian School (1893–1932) from the National Archives and Records Administration, internet sites such as Michigan Genealogy on the Web (MIGen Web), Seeking Michigan and Mainly Michigan, as well as archived regional newspaper articles" ("Undocumented Deaths" 2014). Instead of the mere five children documented as deceased during

the school's entire tenure, the researchers have documented 215 deaths, and counting. A memorial quilt (one of two quilts in the display) that honors these students' lives hangs directly adjacent to this panel. On one side, a white background provides stark contrast to the three red schoolhouse buildings appliqued into the center, with the title of the school in lettering above and below it. A brightly colored border of Woodland-pattern flowers blossoms around the outside edges of the quilt, leaving considerable white space. The white space, however, is not empty. The figures of children's outlines made visible by black stitches create a circle of boy and girl figures, unidentified but present in that space. The back of the quilt contains a list of the known names of these children, forming two and a half columns on the quilt, top to bottom, on a red brick field that matches the photographed brick of the school buildings. The space on the back is only half filled, anticipating the discovery of more names. A short scripture from the book of Genesis 4:10 reads across the top right corner: "And he said, what has thou done? The voice of thy brother's blood crieth unto me from the ground."

Together, the label describes the research and the quilt embodies the community's still-felt loss. As the label observes, "these children were never able to become Chiefs, healers, Ogitchedaw warriors, singers, doctors, or artists for their communities. Their contribution will never be known." Yet what is perhaps most noteworthy, behind the terrible information and grief they impart, is the effort to communicate this across community boundaries. Native and non-Native visitors alike understand the significance of historical records and how important it is to be able to provide evidence when such stories are told. Similarly, there is a shared—colonial, but also contemporary—history of quilting in Native communities and rural Midwestern communities, and that potentially shared background creates a common ground: both communities understand that quilts are made for special occasions, for giving, and for commemorating. That appreciation in both cases perhaps makes for an easier telling of this history.

However, the exhibit does not focus only on past and present grief; it is determined to make something positive in the present. The next label, "Honoring, Healing, and Remembering" (Johnson 2014) discusses the pain of bringing these stories forward but emphasizes the present necessity of doing so: "Only by direct confrontation will we find peace in our hearts again. Let us be brave as our contemptuous adversary becomes our friend

to forgive. May kind nurturing pave the way for our future. . . . The spirit of the Anishinabe people never left the students as they endured a new way of life. Today that same spirit resounds with the promise that they will never be forgotten" (Johnson 2013). From this point on in the exhibit, the displays are those of survivors and reunions, and document both the White Bison Wellbriety Journey for Forgiveness in Mount Pleasant as well as repatriation ceremonies and the "Honoring, Healing, and Remembering" events held on the boarding school grounds in 2013.

Also of note is the example of alliance in a free-standing panel that is part of the array of information in the second half of the exhibit. Titled "Archaeology at the Mount Pleasant Indian Industrial Boarding School" (2014) and emblazoned with a small version of the CMU logo at the top (but not the Chippewa "C"), the panel explains the CMU Department of Sociology, Anthropology, and Social Work's ongoing relationship with the Saginaw Chippewa and discusses the ways in which many of the artifacts—many of them quite small—were found and retrieved. The panel further elaborates on the process of locating the foundations of the older buildings on the property and continuing to investigate the site in cooperation with the Saginaw Chippewa. The existence of this panel helps provide basic information for how many of the artifacts on display were found and identified, but it goes a step further: the panel itself is evidence of both the Saginaw Chippewa and the university communities' willingness to form a mutually beneficial relationship in recording this history and informing the public. In this way, it is a public declaration that MPIIBS is not merely Saginaw Chippewa history, but part of the region's history. For a visitor, it is confirmation that there are ways for community members to work together, and that perhaps some kind of reconciliation is possible.

While there do not appear to be any reviews of *Debwewin/Truth*, the exhibit did receive local coverage in Mount Pleasant (Mahaffey 2014) when it opened. Holly Mahaffey, the journalist covering the exhibit, also notes that the exhibit had been requested as a traveling exhibit at two further locations, and that the Ziibiwing Center had plans for making a second exhibit out of selected material from the MPIIBS grounds (2014). Levi Rickert at *Native News Online* also ran a piece on the opening of the exhibit, citing the exhibit's desire to fill in gaps in US history regarding Native peoples (Rickert 2014). Finally, the Ziibiwing Center makes available a twenty-four-page history and curriculum guide on the MPIIBS for teachers and students with the goal of supporting further education, which

preceded the exhibit and remains a mainstay (*American Indian Boarding Schools* 2011).

While total impact may be difficult to assess, what can be said is that the Ziibiwing Center has used the changing exhibit space to tell a more difficult story. Legible sovereignties in *Debwewin/Truth* have to do not only with articulating the horrors of the MPIIBS, but also the survival, cultural revitalization, and desire for healing within the Saginaw Chippewa and broader Anishinabek communities. The exhibit is a kind of outreach to Mount Pleasant and CMU, even if the story told is not a pretty one and does not have the appeal of butterflies or dancers. This is a reckoning, a recognition of tragedy, grief, and survival into the present. In many ways this exhibit may still have served primarily those visitors who have a direct attachment to the story and family and community investment in it—after all, this is clearly a space to remember, to grieve—but it is also a space that does not dwell only on that. As the final label states, "Our return to Mno Bimaadiziwin (Good Life), as prophesied in the Seventh Fire, is reignited within us. We look ahead knowing that the transference of cultural knowledge to our children is essential to sustaining our Anishinabe Nation for many generations yet to come." It is also a space that does desire to turn the adversary to friend, if the visitor is willing. Whether or not non-Native visitors took the invitation is something that the future will show, as the Saginaw Chippewa continue to develop the MPIIBS site for archaeological investigation and historical documentation.

Conclusions from the Ziibiwing Center's First Ten Years

Within the first decade of its opening, the Ziibiwing Center has demonstrated its power as a keeper of Saginaw Chippewa culture and history and as a site of education and a statement of rhetorical sovereignty. *Diba Jimooyung* in particular embodies a strong and ongoing self-representation of Saginaw Chippewa history in the ways it effectively makes this history accessible to both tribal members and communities from outside. Yet the impact of this site does not end there. What emerges from this analysis is a picture of how Ziibiwing's very existence has given rise to new opportunities for the expression of sovereignty—rhetorical and otherwise—that enhances its abilities to communicate to its potential audiences and gives it the foundational ethos to tackle even tougher stories. The challenge that remains for Ziibiwing and its exhibits is to continue making these

histories—the ugly and the beautiful—legible to a constellation of audiences that, given long-standing conflict, ignorance, and racism in varying degrees, may find these histories difficult to engage.

In more precise terms, the work being done at the Ziibiwing Center points toward a number of key ideas for effectively articulated legible sovereignties. First, given its primary and foundational audience, telling these histories from a tribal community's perspective is essential. Ziibiwing's establishment and the construction of *Diba Jimooyung* are acts of rhetorical sovereignty. Because of the creation of *Diba Jimooyung* as an interactive exhibit space, visitors have the ability to self-educate in this space. They elect to walk through its doors, and they choose to interact with it. While the story itself is relatively tightly choreographed and spoken from a Saginaw Chippewa point of view (which some non-Native visitors could potentially consider "biased"), its expressed desire is to educate everyone who is willing to learn. By presenting a Saginaw Chippewa–told history that has been missing in the region's story of itself—and revealing that the accepted history carries its own bias—it provides visitors with a broader vision and deeper understanding of people and place.

Second, the community-based development of Ziibiwing and *Diba Jimooyung* has given it tremendous staying power in terms of its relevance. As Martin and Pamp noted in their interview, the continuing goal of the cultural center is to stay attuned to the vision of the center and to the Saginaw Chippewa community, therefore building programming and exhibits that reflect that need. Similarly, reevaluation of *Diba Jimooyung*'s features and acceptance of community feedback provide new insight into how best to maintain the exhibit space's relevance. Smaller but meaningful changes, such as the making of the cradleboards and inviting visitors to contribute beads to the designs, continue to build ties within the community and with visitors. Programming such as the Monarch Celebration creates opportunities to draw Native and non-Native communities together.

Third, the last decade reveals how the Ziibiwing Center by its existence has changed the range of possibilities for telling this story both to the local and the wider publics. Creating displays, telling community history, and supporting scholarly research were all part of the original endeavor. However, by its presence, its collections, and its centrality to community, the Ziibiwing Center has become a resource for tribal community efforts to extend and maintain its sovereign rights in other arenas. As demonstrated above, the Ziibiwing Center has played a crucial role in helping

the Saginaw Chippewa maintain its land rights as well as enter into public conversations about racism and discrimination in the wider Mount Pleasant community. Likewise, it has become a point of contact for education in the university community.

These last efforts underscore how the work of outreach is crucial, and this perhaps poses the greatest challenge to Ziibiwing. If the *Diba Jimooyung* history is to continue making an impact beyond the tribal community, as it is designed to do, and the impediments of documented racism and ignorance are to be overcome, the Ziibiwing Center becomes a focal point for the continued articulation of Saginaw Chippewa presence, identity, and culture. The exhibits there—because of what they are *as* exhibits and the way that visitors seek them out to learn something—become a crucial way of doing this work, whether those exhibits are on campus, at Ziibiwing, or travel elsewhere. The *Debwewin/Truth* exhibit stood as a milestone in this respect: while it served an immediate role for the healing of the Saginaw Chippewa community, it underscored the necessity of non-Native communities to participate in this process of recognizing destructive past events in order for all communities to heal.

Though it will always serve its tribal community audiences first, as it should, the Ziibiwing Center demonstrates how powerfully tribally owned and operated museums and cultural centers can be in speaking tribal histories, revitalizing culture knowledge, and nurturing their communities. At the same time, outreach to other audiences emerges as a necessary long-term goal that will only reach fruition with consistent and persistent efforts to engage non-Native communities.

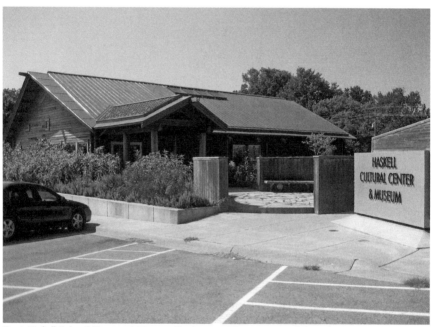

Fig. 6. Haskell Cultural Center and Museum. October 2007. Photo courtesy of the author.

2

Confronting History, Celebrating the Present
Haskell Cultural Center and Museum

Forty-five minutes west from Kansas City, twenty minutes east from To-peka, and situated on the edge of Lawrence, Kansas, the Haskell Cultural Center and Museum (HCCM) sits on Barker Avenue, directly across from the historic Haskell Arch and Memorial Stadium. One of the first build-ings a visitor encounters on the drive into the campus of Haskell Indian Nations University, the HCCM is a modest cypress-log building nestled in its surrounding garden and lawn. The HCCM's location near the outer edge of the university's campus has multiple functions for both the campus community and the larger Lawrence and Kansas City area, and the insti-tution serves as an archive, a museum, a cultural center, and a welcome center. It opened officially on September 14, 2002, and its existence created a range of ways for the campus and outside community to begin actively and publicly reflecting on the university's history and present.

Given the history of the university as a boarding-school-turned-tribal-university, the HCCM is a pivotal site on campus that functions to pre-serve, negotiate, and interpret this history while also providing a place for students and community members to consider the legacy of colonialism that shapes the campus. This chapter works through what a consideration of legible sovereignties can demonstrate about how such a site works, tak-ing into account intertribal, multigenerational Native audiences as well as surrounding non-Native community members and visitors who wish to learn about Haskell's history. Unlike the Ziibiwing Center, with its specific tribal community roots and support, and unlike the NMAI, with its large

nationally and internationally visible platform, the HCCM pursues other goals, other desires in speaking sovereignty. First this chapter documents the HCCM's mission statement and its inaugural exhibit, *Honoring Our Children Through Seasons of Sacrifice, Survival, Change, and Celebration* (2002–present) as it opened in 2002 and as it had developed by the time I made my first visits in 2006 and 2007. Next I examine the rhetorical intent and rhetorical effects of the exhibit, and the challenges its curators and museum directors have encountered in the process of mounting and maintaining it. I then work through the state of affairs as of my visit in 2014, noting the changes that have been made and the HCCM's particular struggles to maintain its relevance and keep its doors open as part of a federally funded and controlled enterprise. Finally, the chapter concludes with a discussion of legible sovereignties within this space, and the particulars of making the HCCM's exhibits legible and relevant to both its Native campus audiences and its off-campus visitors under the current financial governance. My analysis shows the working tensions between the need to confront history and the need to affirm the accomplishments of the present, and the compounded difficulties of doing so under institutional constraints.

To Interpret History, and Archive the Process: The Founding of the HCCM

It must be recognized that Haskell Indian Nations University, as is perhaps revealed in part by its name, has a history rooted both in the colonial and assimilationist policies of the United States and in the contemporary reclamation of tribal intellectual sovereignty. Founded in 1884 as the United States Indian Industrial Training School, its original mission was part of the movement to educate Native students from multiple tribal backgrounds away from their home cultures and toward full assimilation into white society. This attitude is made most famous in Carlisle Indian School's founder Richard H. Pratt's declaration, "Kill the Indian in him, and save the man" (Pratt 1892), and Haskell was indeed modeled after Carlisle as a military-style boarding school for elementary school–age through teenage children. However, Haskell's history does not stop there, and across its 130 years the institution has shifted over time to expand into teacher education, then business and vocational training, and then to take shape as a junior college and now as a four-year university ("School History" 2015). It now serves more than one thousand Native students each semester in a variety

of fields, with a vision that recognizes "Haskell [as] a unique and diverse intertribal university committed to the advancement of sovereignty, self-determination, and the inherent rights of tribes" ("Vision Statement" 2015).

Until the founding of the HCCM, Haskell as a campus kept records but maintained no organized archives per se concerning its varied history and status as a historical landmark (Ranney 2001). Plans to build the HCCM were buoyed particularly by the American Indian College Fund ("Cultural Center" 2015), which in the late 1990s was supporting initiatives from tribal colleges and universities to build on-site museums and cultural centers. Haskell's unique status as the only intertribal Native American university in the United States made for a distinctive opportunity to create a space that documented the shared histories of Haskell students through their educational experiences. Furthermore, having a cultural center and museum would finally provide a site for creating and preserving more centralized records of, by, and for Haskell students and alumni as well as outside researchers.

The HCCM's vision statement has shifted over time, but in its early years its vision statement, in its entirety, read as follows:

> The Haskell Cultural Center and Museum is dedicated in remembrance of the first Haskell students in 1884, and to all students who have attended Haskell. The vision of the Haskell Cultural Center and Museum is to serve as a national center for the study of living American Indian traditions. The museum will provide present day and historical information regarding North American Indian/Alaska Native culture through exhibitions, educational programs, and research. Drawing upon the Sacred Circle as the foundation for the North American/Alaska Native philosophy, the Museum will also provide Haskell students with archives and museum classes and training that are focused on oral traditions and the spiritual dimension of objects of power needed to prepare them for careers in tribal archives and tribal museums. (King 2008)

In rhetorical terms, this early mission statement reinforces several key ideas. First, the vision statement underscores the connection to its past as a government boarding school and the collective memory of its

early students' legacy. Second, the vision statement highlights the HCCM's desire to serve as a site for the study of Indigenous cultures as living traditions, not cultures that are dead or frozen in time. Third, the stated goal for the HCCM is to use it as an educational site specifically for Native students to learn in culturally appropriate ways how to care for their own communities' objects and train them to support their own communities' collections and museums. In short, the HCCM is a site designed for making Haskell's history as a boarding school and its living cultures appropriately accessible and usable, particularly in support of its Native students and their education. Legible sovereignties at the HCCM were framed in terms of historical memory and care for and articulation of that memory, in multiple ways.

The primary grant-writer for the HCCM's creation and its first head director/curator, Bobbi Rahder, described the purpose of the museum in much these terms. Having begun her MA work with the Frank A. Rinehart photo collection—a photographic treasure now housed in the HCCM—Rahder knew how difficult research in Haskell's collections could be with no appropriate facilities to house or preserve them, and feared for the preservation of Haskell's history (interview 2014). In a 2001 interview with the *Lawrence Journal World*, Rahder says, "We want this to be a 'living' center. . . . We don't want it to be a storage facility that no one will use. We want it to be an active place" (Ranney 2001). At the time, Rahder hoped to see all Haskell records transferred to the new cultural center in order to centralize the archive of Haskell's history and give control of those records to Haskell staff and students. Furthermore, she anticipated the HCCM would provide greater access to Haskell's archives through digital means, including the scanning of all issues from 1887 to the present of the *Indian Leader*, Haskell's student newspaper and the oldest student-run American Indian newspaper in the United States (Ranney 2001). Perhaps even more important, Rahder saw the HCCM as a way to support Haskell students by providing "hands-on experience working with the Haskell Cultural Center's museum and archives collections. They can also participate in conducting and transcribing oral history interviews with tribal elders. Interns not only . . . get experience in learning how to handle and preserve historical records and artifacts, they get practical experience in grant writing, producing exhibits, and website development" (Rahder 2003, 8). Her stated goals for the HCCM correspond strongly with the initial vision statement, especially in terms of finding ways to make the resources at Haskell available and functional for Haskell students and researchers.

Rahder argues for making these resources accessible and therefore at least able-to-be-read, in first the service of Haskell and then the broader surrounding community. Legibility along with accessibility would be achieved in the careful archiving of the resources and their interpretation through exhibits, tours, and oral history projects.

The vision statement and Rahder's goals for the HCCM are embodied in the architecture, grounds, and inaugural exhibit, with the added dimension of supporting healing through confronting Haskell's history, not simply remembering it. The six-thousand-square-foot space was designed and currently stands as a two-level Florida cypress-log building surrounded by the Garden of Healing, a garden landscape growing native Kansan medicinal plants and bordered by the stones from some of the first buildings on the Haskell campus, including the dormitory barracks. The building stones invoke the children who lived and were often abused within those walls; a Peace Pole from the World Peace Prayer Society and the Tree of Peace offer the counterbalance (Love and Webster 2006, 1–2). In front of the Garden of Healing is also the Native Veteran's Memorial, which has as its centerpiece the bronze *War Mother* sculpture (by Barry Coffin, installed in 2005). The main entrance to the HCCM is a circular space designed as a site for purification before entering. Inside, the floor of the main display area contains a color tile reproduction of Haskell's Medicine Wheel, an earthwork on the south edge of the campus that students use for ceremonial purposes.[1] The building originally housed an exhibit of Haskell Indian Nations University history—the ongoing *Honoring Our Children* exhibition—and an exhibit dedicated to the Haskell veterans, as well as displays of Haskell student artwork. In addition, the HCCM accommodates the university's own collection of Native objects and artwork, the Frank A. Rinehart collection of glass-plate negatives of Native portraits from the Trans-Mississippi Exposition and Indian Congress of 1898, and the university archives (King 2008; "Haskell Cultural Center and Museum" 2015).

The rhetorical framing of the HCCM is, first, in terms of healing: quite literally so, as at its opening and through the present it was and is surrounded by structures, plants, and memorials all meant to support physical and mental well-being and to encourage productive encounters with past historical traumas. In this way, the assumed connection to Haskell's history is not a passive one, but rather a connection that already actively recognizes the negative effects of assimilationist policies that still resonate here:

Haskell would not exist without them. At the same time, the frame of healing also establishes a particular kind of relationship with that history, a relationship that suggests a way forward is possible, and that there is a way to honor the sacrifices of the first Haskell students while celebrating the thriving university of the present.

The inaugural exhibit at the HCCM, *Honoring Our Children Through Seasons of Sacrifice, Survival, Change, and Celebration*, continues this understanding and provides an example of how working through Haskell's history might be done through its own archives and collections, by its own students. Supervised by Rahder, a student curation team comprising students from Haskell's American Indian Studies BA program and from the University of Kansas' Indigenous Studies graduate student program, as well as supportive Haskell staff and alumni, researched and assembled *Honoring Our Children*. At the HCCM's opening, *Honoring Our Children* formed the core of the gallery space. As its title suggests, its materials were organized around the chronological themes of sacrifice, survival, change, and celebration in Haskell's history. An additional section honoring Native veterans was mounted at the back of the space, and provides its own timeline. Because the HCCM was imagined as a multipurpose space, the exhibit materials were mounted on metal mesh panels suspended from the ceiling to facilitate easy removal, travel, and reassembly, as it has traveled to other institutions on occasion, or has needed to be removed to make space for events hosted at the HCCM.

As it was initially installed, the exhibit was mounted around the center of the gallery and the tile replica of the Haskell Medicine Wheel embedded in the floor. Above the Medicine Wheel hung four semitransparent cloth banners, each with a black-and-white photo image from Haskell's history printed on it. Surrounding the Medicine Wheel and the photo banners, the exhibit panels created a rough circle along which a visitor could wander, in the rough thematic order listed above, and the veteran's section made up the back wall of the exhibit gallery. The material related to each theme was color-coded from the sections of the medicine wheel, with a colored border around most labels and images: "Sacrifice" materials were bordered in blue, "Survival" materials in red, "Change" materials in gray, and "Celebration" materials in green. The Native veterans also have a shade of red for their label borders, but because the veterans' section is clearly spatially separated from the rest of the exhibit and the Survival sections, there was little confusion.

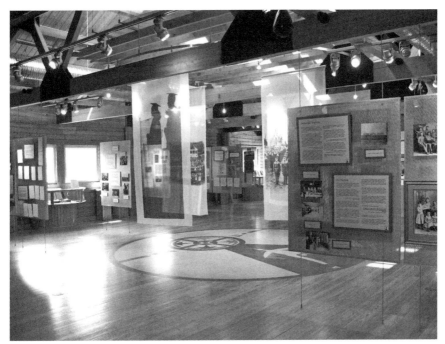

Fig. 7. Haskell Cultural Center and Museum. *Honoring Our Children* exhibit. October 2007. Photo courtesy of the author.

Given the materials and the historical narrative, the organization of the exhibit was therefore both thematic and chronological and traced Haskell's history from its inception as a government boarding school to its current status as an intertribal university. The accompanying brochure states the exhibit's purpose as "an exhibit that seeks to honor the first students at Haskell as well as all the students that attended boarding schools across the country. The exhibit celebrates the strength and resilience of the students and their contributions to what has become Haskell today. Additionally, the exhibit honors all of the Haskell men and women who have served in the U.S. Military services" (*Honoring Our Children* 2002). Following the map in the brochure, within Sacrifice a visitor would read about the arrival of the first Haskell students, their education, labor, diet, illnesses, and death rates from 1884 to 1887. The Survival section covered the introduction of military-style organization on campus designed to dissolve tribal affiliations and students' rearrangement, alliance, and resistance through extracurricular activities from 1887 to the 1930s. The Change section addressed Haskell's time of reorganization from 1925 to 1968 under new federal policy and a Native superintendent, and Haskell

students' continued adaptation and education, even under the 1945–1961 era of termination policy. Coming full circle, Celebration highlighted the decades between the 1970s and 2002, during which Haskell pushed toward self-determination, successes in the arts (for example the Thunderbird Theater and Haskell Band), and continued reorientation toward a Native culturally based curriculum in Haskell's evolution into a full-fledged university. Furthermore, the Honoring Our Native American Veterans section traced a timeline of Haskell students' military involvement, from the early military-style training implemented at Haskell in its early years, through World War I, World War II, the Korean War, the Vietnam War, the Persian Gulf War, and into recent military campaigns.

The primary materials used in the inaugural version of the *Honoring Our Children* exhibit were text and archival images, with a few selected objects contained in small cases along the east and west walls. The text consisted of archival materials (such as letters, newspaper clippings, records, and so on), excerpts from archival materials (including area newspapers, speeches, and Haskell's *Indian Leader* newspaper), image labels, and commentary from the exhibit curators and Haskell students. For example, one of the initial panels of the Sacrifice section contains archival images of some of Haskell's first students and the school's grounds. To the left of the grouping of images, a substantial text label that excerpts an 1887 Annual Report to the Commissioner of Indian Affairs and an 1889 report to the same describes the poor food and healthcare that these students endured during their time at the school. Within the images, a smaller label by student curator Johnnie Fields reads, "Not only did Haskell reflect the policy and ideology of the government boarding schools' ultimate goal to assimilate our children, we must never forget the many other boarding schools, day schools, and non-reservation schools that existed and still exist" (Fields, "Sacrifice Panel"). The image labels were not signed by the curators, and the many explanatory labels culled from archival resources only bore the citations of their sources, suggesting that these were meant to stand factually alone or at least were intended to be interpreted within the context of the sections' other texts. Other labels that provided narration or observations from Haskell students, as above, were attributed to their writers (with tribal affiliations acknowledged). The photographic images came directly from Haskell archives, beginning with the images of the first Haskell students in the Sacrifice section and continuing through the subsequent images of

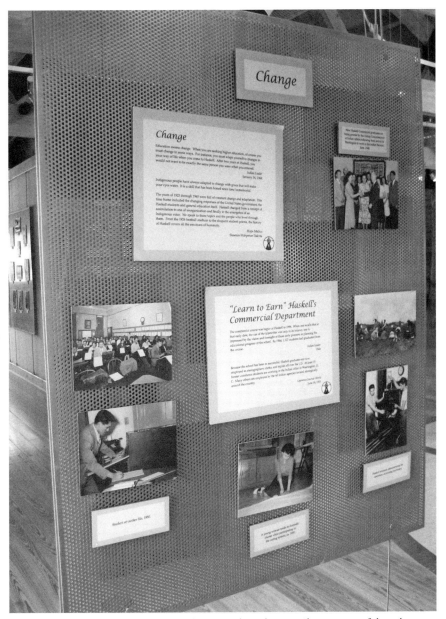

Fig. 8. Haskell Cultural Center and Museum. "Change" panel. October 2007. Photo courtesy of the author.

Haskell's student body through its history into the present. The curators followed this approach throughout the exhibit, and so for example the Change section displayed photographs of students in business, typing, and home economics courses, with a Change label from curator Hope Melius that described what change meant during the years between 1925

and 1965, along with a text label excerpting the *Haskell Indian Leader* and *Lawrence Journal World* from that era to explain the commercial and business courses developed at Haskell.

The objects selected for displays around the gallery supported the narrative, including a display case containing tools used by early Haskell students in their work, another containing a purple and yellow feather war bonnet (presumably belonging to the Haskell mascot), another containing silver jewelry made by Haskell students, and one dedicated to the athlete Billy Mills, one of Haskell's best-known graduates.

Across the back wall, the Honoring Our Native Veterans section of the exhibit traced a timeline of Haskell students' involvement in the armed forces. Images of student veterans and those killed in action were organized by war, drawing attention to the historically strong connection between many Native communities and military service to the United States.

In addition to the *Honoring Our Children* exhibit proper, two added alcove spaces deserve mention, as they, too, represented part of the HCCM's mission. First, in the northwest back corner of the gallery hall (to the left of the veteran's wall), a selection of the Rinehart photographs were on display as part of a small exhibit under the title of what became a book that honors them, *Beyond the Reach of Time and Change* (2005). As one of the best-known collections in the HCCM archives, the Rinehart photograph display provided a sampling of the HCCM's holdings and their significance. Similarly, the back northeast corner of the gallery hall (to the right of the veteran's wall) contained a display of Native art created by Haskell students and alumni, and thus linked current Haskell students' contributions to the larger narrative of *Honoring Our Children* while showcasing the talents of Native artists.

Overall, the creation and mounting of the *Honoring Our Children* exhibit attempted to put the vision statement into practice in tangible ways. In this space, the students themselves have had to work through Haskell's archives and translate Haskell's history in a way that leads the visitor through the consequences of colonial policies and celebration of Haskell students' resilience, generation after generation. The HCCM was the site of both production and protection of this narrative, and it opened the door, literally and figuratively, for further research on Haskell's history and for further support for its students to understand their place in it. There was little question about the importance of the HCCM as a site, or of the *Honoring Our Children* exhibit. A number of complications have

revealed themselves over the last decade, however—including a disjunction between initial intentions and actual effects, and the difficulty of maintaining the momentum begun by the opening of the HCCM—creating unique challenges for legible sovereignties.

Legible Sovereignties at the HCCM: Rhetorical Intentions, Rhetorical Effects

As the original HCCM vision statement articulates and the description of the *Honoring Our Children* exhibit helps illustrate, the HCCM wishes to be a site for remembering and preserving Haskell's history, a place of living cultural practices that provides students with the means to engage with this history. Whether visitors use the site to make sense of how they had found the "hard truths of colonialism" (Lonetree 2012) embodied in their own experiences or to encounter those truths for the first time, the HCCM was and is intended as a site of education and healing.

In anticipating who their visitors will be, the vision statement indicates quite clearly that the Haskell community is the first priority, and the non-Native public—while still important—is secondary. The HCCM is dedicated to all Haskell students and their histories and education, but it also seeks to be a national center for research. The "Cultural Center and Museum" section of the 2007 HCCM brochure underscores this prioritization, stating, "The Haskell Cultural Center and Museum provides a center for students, faculty, staff, and alumni, as well as the general public, to research and learn more about Haskell's history. The center is dedicated to the remembrance of the first Haskell students in 1884, and to all Haskell students who came after" (*Haskell Cultural Center and Museum* 2007). The audience for the HCCM, though it includes the general public, is mostly intended for the people (past and present) on Haskell's campus. More particularly, as Rahder observed in 2007, the HCCM in many ways functions as a welcome center on campus for incoming freshmen, who need a way to connect with Haskell and understand their roles as Native students who inherit Haskell's history (a history of suffering, survival, change, and celebration, as the *Honoring Our Children* exhibit suggests) (interview 2007). In the process, the HCCM also provides a place for remembering and healing, a place where students can come to feel safe (Rahder, interview 2007). Yet as Theresa Milk, one of the student curators involved in the creation of the permanent exhibit (and since an instructor on campus), also suggested, the

HCCM is there to teach everyone about the history of boarding schools and Haskell's evolution in particular (interview 2007). Both Rahder and Milk noted that area grade schools and other tour groups were also visitors to the HCCM.

To address multiple audiences while prioritizing the voices of Haskell students, the original rhetorical goals are multiple. Because the top priorities are the students and alumni of Haskell, the exhibit stands as a way to tell the story of previous Haskell students, their struggles, and their accomplishments to Haskell's present student body. In this way, the exhibit becomes a grounding point for new students, continuing students, and former students alike, as the exhibit is a touch point for remembering both the sacrifices of early students and the strength of those who made Haskell what it has become (Milk 2007). It is, as Milk puts it, in many ways a chronology of a healing process still in the making (2007). Furthermore, given the HCCM's existence as a kind of liaison point between Haskell and the greater Lawrence and Kansas City communities, the exhibit tells the history of Haskell for those who may not be familiar with the history of government boarding schools or that epoch of local and national history regarding Native peoples. As the initial panel of the exhibit states, the *Honoring Our Children* exhibit only addresses one of many schools that were a part of government assimilation policy, and while visitors will hear the story of only one, all should be remembered. In addition, the veterans' section of the exhibit, while perhaps thematically out of place at first glance, creates an additional narrative that runs, if not through the exhibit proper, then concurrently. As the exhibit brochure states, "Native Americans have been serving in the military before they were even given citizenship. In Native American cultures, being a warrior was one of the highest statuses to be obtained . . . [thus] proving their wisdom, courage, and endurance. We honor all who have served, survived, and died for the Honor of their Country" (*Honoring Our Children* 2002). In this way, the veterans' section, positioned between the Change and Celebration sections, endeavors to demonstrate the translation of Native values concerning service, honor, and the role of a warrior into contemporary times.

The spatial arrangement of the original mounting of the exhibit worked to balance the tensions between guiding visitors through the chronology of Haskell's history and providing enough flexibility to allow visitors to engage with the material in the way that makes the most sense to them. As I have already described, in the first years visitors were provided a

brochure for the exhibit that described each section of the display and pro-
vided a map of the intended path a visitor should take to see the exhibit in
chronological order, with the military installation along the back wall serv-
ing as an interlude between the Change and Celebration sections. While
the hanging mesh panels and banner images were practical in their use,
they also allowed for flexible visitor flow. Also, the space of the gallery was
and is not tremendously large—it takes up about half of the upper story
of the building, with the underground floor housing the archives—and so
the hanging panels and transparent banners allowed light and visitors to
move through the space without causing congestion. The flexibility of the
space also let visitors interested in particular eras of Haskell's history seek
those materials out immediately and relatively directly. The back alcoves
containing the Rinehart and art displays were loosely thematically linked
to the *Honoring Our Children* exhibit, but were also distinct enough to be
attractions on their own.

The immediate rhetorical effects of these efforts were strong and
largely positive, as demonstrated by the considerable excitement and atten-
dance at the HCCM's opening with the *Honoring Our Children* exhibit. The
local *Lawrence Journal World* had already run several pieces chronicling the
fund-raising and development of the HCCM (for example, Ranney 2000a,
2001, 2002; Ludwig 2001) as well as the *Topeka Capital-Journal* ("Archivist
Working" 1999; Eakins 2001; Albright 2001) and the *Kansas City Star* (Car-
roll 2002). Rather than being evaluative pieces or reviews, these articles for
the most part tell the story of the HCCM's creation and the hopes its sup-
porters had for what it could accomplish, and were aimed at the general
public. Furthermore, *Indian Country Today* picked up the story at the same
time (2001), and the same reporter, Mary Pierpoint, published a piece in
the *Tribal College: Journal of American Indian Higher Education* (2001), indicat-
ing a broader Native-oriented and academic audience.

On Haskell's campus, the HCCM opened to fanfare, concurrent with
the yearly Haskell Arts Market—which meant a large audience drawn from
Haskell students and alumni who were already there for the annual gather-
ing (Ranney 2002). Rahder and Milk both recounted the positive feedback
from Haskell community members who saw, for the first time, their
history (and frequently their families' histories) told through their experi-
ences at Haskell through the voices of Haskell students. Much of Haskell's
history had been written by outsiders, and so in many ways the *Honoring
Our Children* exhibition was groundbreaking in how it reclaimed Haskell's

history for Haskell's students. As a direct result of her work on the exhibit, Milk went on to research and write *Haskell Institute: 19th Century Stories of Sacrifice and Survival* (2010) in order to tell the previously ignored stories of some of Haskell's earliest students (interview 2007). Rahder, Milk, and Daniel Wildcat (professor of Indigenous and American Indian Studies at Haskell) all observed the influx of visitors from off campus, particularly researchers, students from area schools, and students from the nearby University of Kansas. The HCCM also served as a multipurpose meeting space for conferences and speakers (Wildcat, interview 2007) and thus underscored the need for the flexible and removable exhibition structure.

According to Rahder, the HCCM was at first used exactly as was envisioned: students had classes at the HCCM to learn about culturally appropriate collection preservation and archiving and first-year students were given a tour of the HCCM as part of their orientation to campus (interview 2007). The visitor book and anecdotal evidence from Rahder suggest that the HCCM was particularly popular with Haskell alumni, who appreciated the center both for its narration of Haskell's history in the *Honoring Our Children* exhibit and for its existence as a place to preserve that history and the objects that told it. Donations of letters, journals, memorabilia, and other items began to arrive from Haskell alumni so that the HCCM could help keep those students' experiences alive as part of the collections. From practically all accounts, the HCCM and its inaugural exhibit were a success.

At the same time, the initial energy of the opening might have had a significant rhetorical framing influence on the HCCM and on the *Honoring Our Children* exhibit, giving the exhibit in particular a meaning-making context from the ceremony that opened it. That is, the opening of the exhibit invoked community memory in a way that had not happened before, and could continue in strength so long as the witnessing community was largely intact—in this case, so long as the same faculty, staff, and students who made it and witnessed its opening were present or close by. They could continue to provide the narrative that made the most significant meaning for the exhibit and why its existence was important. Once the majority of that community was no longer present, maintaining that narrative would become more of a challenge, and the legibility of that space—and along with it, its sovereign declaration of history—would fade without reinforcement. That is not to say that strong efforts have not been made within the HCCM to maintain its momentum, though the rhetorical effect has faded

over time given the original exhibit's design, challenges with remounting it, and maintaining the HCCM's visibility overall.

Some of these challenges can be seen in basic maintenance of the exhibit. During my visit in 2007, *Honoring Our Children* had been remounted, having been taken down in order to act as a visiting exhibit at a different site. The rough organization was somewhat preserved, but the exhibit as it was remounted did not quite support the same clearly delineated approach as the original opening. It could be argued that because the gallery was designed to be open, regardless of the exhibition, arranged in a circular fashion and with no floor-to-ceiling partitions, it is questionable whether visitor flow was ever controlled to the extent the map suggests. While a visitor might eventually recognize the internal organization of color-coding and chronology within the exhibit materials, it was entirely possible for a visitor to go in the opposite direction (beginning with Sacrifice, moving counterclockwise to Celebration, then filling in the gaps), or to wander at will through the exhibit. Though a more structured narrative approach was the original goal, the spatial organization always allowed more flexibility for visitors as they made their way through, and hence suggests more flexibility and opportunity for narrative-making on the part of the visitor. Without the context of the opening, and with the complications from the remounting with the slight disorder of the original materials, meaning-making was on the shoulders of the visitor more than it had been before. At the same time, in 2007 the map and exhibit description were still available, thus lending some structure to visitor experience.

In terms of the language and images employed as exhibit materials, as already noted, much of what *Honoring Our Children* draws from were archival resources, excerpted as explication or support for the thematic sections and accompanied at times by further observations or interpretations of history by Haskell curators and students. While the plural first-person "we" was occasionally invoked, for the most part the narration provided by the curators remained in third person, or was absent, allowing the visitor to make her own sense of what she reads. It was not uncommon to find a label with quotations from historical sources whose major contextualization comes from its thematic organization or a cluster of ideas and images around a particular topic. Little explanation was made of the photo images presented, and the labels provided were minimal—perhaps a name or a location, and a date—and decoding the images' significance depended on their authority as archival sources, proximity to labeling and explanation

(which, after remounting, was not always proximate), and the visitors' associative observation. Once again, the curators had provided plenty of material, but left it up to visitors to make sense of what they saw; or alternatively, the contextual knowledge of Haskell's story was assumed, and the exhibit simply stood to document from the archives what visitors already knew. By the time of my visit in 2007, a few additions had also been made to the exhibit space since its opening, the largest of which was the clay sculpture version of the War Mother Memorial (by Barry Coffin) in front of the veterans' section of the exhibit inside, and the installation of the full-sized bronze sculpture outside. The exhibit was largely intact and some additions had been made, but the wear was beginning to show.

The HCCM had also come to a kind of rhetorical equilibrium off campus. The promotional materials available in 2007 demonstrated how the HCCM had enjoyed some promotion from outside Haskell, suggesting some recognition of its importance by other regional communities while at the same time, to an extent, remaining on the periphery. As we have already seen, in the lead-up to its opening, the major metropolitan newspapers had been periodically covering the HCCM's origins and development. By 2007, the HCCM had taken its place as the welcome center for Haskell's campus-as-tourist-attraction. The variety of publications available at the HCCM help-desk indicate the ways that Haskell, and by extension the HCCM, were located in the web of attractions in the Lawrence and Kansas City area. In 2007, the HCCM was distributing the 2005 Heritage League of Greater Kansas City's "History Map: Directory of Historical Sites and Organizations," on which Haskell was at least listed, though the HCCM was not. In the 2007–2008 *Douglas County Newcomers Guide*, Haskell receives mention as one of the area universities, and the HCCM is listed in the "Our Town" section among other galleries and arts attractions in Lawrence, though not promoted or highlighted in any particular way. Finally, the 2006 *Kansas Official Visitors Guide* mentions both Haskell and the HCCM, but only as listings in the "Kansas Trip Planner" section. Some cross-promotion could be expected as a result of this purposeful placement of Haskell and the HCCM in the network of area attractions, and the presence of the University of Kansas Lied Center seasonal program (2007–2008) demonstrates this phenomenon, in that there is no direct connection to Haskell in the program, and only a potential connection in audience as suggested in the promotion of a Native music performance at the Lied Center. Reading this networking rhetorically, Haskell and the HCCM, though they exist simply

as two of many, had at least to an extent become recognized as attractions on par with other galleries, museums, and Kansas history exhibitions.

More scholarly reception of the HCCM demonstrates its role as a touchstone for Native boarding school histories and as an example for how a cultural center/museum can serve Native communities, although the coverage has been intermittent. For example, in 2002, Loriene Roy and A. Arro Smith cite Haskell and the HCCM as one of the few tribal colleges that has a program to teach students tribal archiving, and Paul Resta, Mark Christal, and Loriene Roy cite the HCCM's efforts at digitizing the Rinehart collection of photographs as part of a broader movement to use digital technology in support of Native cultures and education (2004). The Rinehart collection has brought other attention to the HCCM, particularly in the publication of the book *Beyond the Reach of Time and Change* (2005), edited by Acoma poet and scholar Simon Ortiz and featuring a selection of prints from the Rinehart collection. The HCCM Healing Garden, especially as it has developed more fully, has served as an example of a different form of "archiving" and maintaining cultural resources; it received feature-article attention in a 2010 issue of *Native Peoples Magazine* for its work in connecting students with both the history of Haskell and Indigenous plant knowledge (Crupper 2010).

As its collections have grown and provided more details on Haskell's history, the HCCM has received further attention. Mary Annette Pember uses one of the donations to the HCCM, a photo album containing the only known photographs of Haskell's first students, as a beginning point for discussing her own family's history with boarding schools in "Ignorance, Is It Bliss?" (2011), and Laura Paskus cites the HCCM as an institution that documents the racism that frequently still needs to be addressed in educational systems (2011). A more recent feature story on a small pair of child-size handcuffs from the HCCM collections brought the HCCM into the spotlight again (Pember 2013), once more highlighting the roots of Haskell's founding and the history that students and visitors must grapple with.

All of these are positive examples, and point simultaneously to the impact that the HCCM's existence has made and also the struggle to keep it immediately relevant to Haskell and the broader communities over the course of time. Maintaining that initial momentum has gradually become difficult, both in physically maintaining the facilities and exhibit and in maintaining interest. Though the history of Haskell will never be irrelevant—for example, "commemorations" and not "celebrations" are a

regular part of Haskell's anniversary gatherings out of recognition for its beginnings (Pember 2009)—the Haskell community and the larger community are now seeking to know what other stories can be told. In reply to the statement, "We are still here," the HCCM now finds itself in a position to ask, "What else can we do?" Yet doing more, or just doing something different, also requires funding, and the arc of the last twelve years illustrates the difficulty in making more happen without the needed resources. Legible sovereignties, in very practical terms, needs all kinds of support, including the fiscal kind.

Keeping the Vision Alive: Maintaining the Mission and Meeting Rhetorical Needs at the HCCM

By the summer of 2014, twelve years after the opening of the HCCM, not a great deal had changed at the HCCM. Funding cuts from the BIA and the BIE have made routine budgetary obligations difficult to meet since 2008, and at a place like the HCCM, which has no actual budget line for a director (Rahder, 2014 interview), the struggle to maintain the HCCM is tangible. Further budgetary shortages have placed an uncomfortable spotlight on Haskell's previous decade of overall financial troubles; as Mike Hendricks and Mará Rose Williams observe, the university's relationship with and reliance on the federal government for support and funding "has limited [Haskell's] ability to grow and, at times, to take care of basic needs" (2015). Buildings are dilapidated, infrastructure needs repairs, and technology available to students is behind most universities' standards. The number of teaching faculty has fallen to about half of what it was thirty years ago, and federal funding regulations put extra red tape on outside funding initiatives and donations to Haskell that other universities do not have (Hendricks and Williams 2015). For example, any donations go into a larger federal fund instead of straight to Haskell, and so donors hesitate to give when what they give is not guaranteed to go to Haskell. This means that even donations made to Haskell and earmarked for the HCCM might not make it to the donors' intended destination. Finally, at the time of this writing (2016), the Haskell Foundation is undergoing a reboot after remaining inactive for nearly a decade after its director embezzled funds (Hendricks and Williams 2015).

As scholar Eric Cheyfitz observed in 2006 about Native education and the Institute for American Indian Art, Native intellectual sovereignty (and,

one could argue, financial sovereignty) was compromised because of its entanglement with the colonial agenda of the US government. "I would argue," he writes,

> that as long as the school exists within the colonial context of federal Indian law, it will not be able to conduct such an assessment [of its own colonial underpinnings], either because the ideological filters prevent it or because biting the hand that feeds it risks starvation even if the food is not in the final analysis nourishing." (2006, 152)

It seems that Haskell has a similar problem. It could be argued that in Haskell's case, its orientation to challenging its colonial-based history is quite clear—at least in terms of how it represents its story at the HCCM—and so it would appear that "biting the hand" has been the main concern. At this point Haskell looks poised to starve regardless, and serious consideration of alternatives is already under way (as I discuss in the concluding chapter).

What has this meant for the HCCM in the meantime? While still a living institution whose archives and collections are beyond value for the Haskell community and for researchers, the HCCM's major challenges in terms of sustaining legible sovereignties for its audiences lie primarily in efforts to keep its doors open regularly, to revitalize the space, and to support its continued relevance on campus. As the primary carrier and communicator of Haskell's story of revitalization, it would seem that university support for the HCCM should be a priority, but over the last decade the resources that supported it—including the museological and tribal archiving coursework that supported the creation of *Honoring Our Children* (HINU General Catalog 2015–2017)—have dwindled or disappeared altogether.[2] Particularly with the lack of a funded curator position from 2003 to 2009, and then again from 2011 to 2013 (Rahder 2014), the HCCM was not able to continue building from its initial momentum or develop in step with its audiences. At the same time, some efforts have been made to update the space and care for it as much as possible.

As of 2014, an updated vision statement on the HCCM's webpage read somewhat differently than the original, indicating a subtle shift in approach: "The vision of the Haskell Cultural Center and Museum is to respectfully serve as a steward of living Tribal materials, traditions and

cultural arts. The cultural Center provides present day and historical information regarding Haskell's history since 1884, Tribal cultural art, exhibitions, educational programs and research" ("Haskell Cultural Center and Museum: About Us" 2014; capitalization original). No longer explicitly dedicated as a memorial to the first students of Haskell, the HCCM has altered its vision to reflect a different emphasis, as a "steward" of living Native cultures and to provide educational opportunities for visitors and researchers. Also revised out of the vision statement is the emphasis on training Haskell students to care for their own tribal archives. The mission statement—an addition on the website that immediately follows the vision statement—further elaborates the current rhetorical framing of the HCCM's role:

> The Mission of the Haskell Cultural Center and Museum is to truthfully convey the story of Haskell's remarkable evolution from a government boarding school to its present day fully accredited University serving Tribal students. The Cultural Center celebrates the living heritage and culture of all tribal peoples today. It strives to continue the legacy of education through culturally based exhibitions, educational programs, traditional/cultural art classes and internships. It serves as a teaching facility for Haskell students, staff, faculty, alumni, researchers and general public. ("Haskell Cultural Center and Museum: About Us" 2014)

Several things are noteworthy here: the emphasis on evolution, not memorializing; the emphasis on education; and the explicit listing of its audiences and how those audiences are prioritized. First, the recasting of the HCCM as documenting Haskell's "evolution from a government boarding school to its present day fully accredited University" instead of "in remembrance" of the first students (King 2008) moves attention away from memorializing the first students and emphasizes Haskell's living change from that boarding school to a full-fledged university that serves Native students' needs instead of forcing them into nineteenth-century US government ideals of education. The connection to the inaugural *Honoring Our Children* exhibit is strong, insofar as the vision and mission statement now reflect the narrative that the first exhibit articulated so clearly.

Second, the emphasis on education supports the shift away from the potential of seeing the HCCM as a memorial and firmly toward the idea of a living cultural center that promotes and supports Native cultural traditions and practices. "Exhibitions," "education," "art," and "research" receive mention in both the vision and mission statements, emphasizing education in the present and less narrative of the past. It should also be noted that in terms of audience expectations, the HCCM now sounds more like a standard museum. Though it is uniquely situated at an intertribal university with a history as a boarding school, this narrative is now used as background to the work it does now; and that work, though situated in an intertribal context (as opposed to a private collection or non-Native museum), now sounds quite a bit like the kind of general—or even generic—work a museum does. While this may be a formulaic way to address all the educational work the HCCM does, including classes for Haskell students, this does connect in part to broader audience concerns.

The list of the HCCM's target audiences is suggestive in several respects, perhaps beginning with the shift away from the idea of "dedication" or "memorial" to a unique-but-recognizable cultural center/museum. Initially promoting Haskell's founding as a boarding school does directly and necessarily address the premise for celebrating Haskell's present accomplishments. There can be little understanding of the present scope of Haskell's achievements without knowing the complete about-face the institution has made since it first opened its doors. At the same time, foregrounding the boarding school narrative permanently as the rhetorical frame presents a problem: by prioritizing the past, the future gets short-changed. Milk's observations during the creation of the *Honoring Our Children* exhibit point out the concern she felt over spending too much time on the tragic parts of Haskell's history, insofar as it was necessary knowledge but not the end of the story. Healing could not take place without telling all of the story into the present; as she puts it, "Most scholarship focuses on the negative, and that's necessary, but in this place let's also acknowledge what has happened since then . . . dark and light, that we acknowledge the bad, but let's remember the good" (interview 2007). In the same way, revising the vision and mission statement to refer to the HCCM as a "steward" of this history and of Native cultures does not erase the boarding school history, but it does shift attention toward a long-term, active role for the HCCM that is present-oriented instead of memorializing. Remembering is certainly a part, but not the sole or first purpose, of the current HCCM.

This is significant in shaping audience perspectives in general, because the 2014 vision and mission statements no longer present the HCCM as a memorial for the students who perished, but rather as a living site. For students on campus, the HCCM is therefore cast as a means to work their way through this painful history and legacy and, as Milk observes, to recognize there is both "dark" and "light," and that arguably the light triumphs in how Haskell has changed. A memorial would be worth visiting once, or occasionally, but a cultural center/museum that has present relevance is a place worth visiting again and again, where "students, faculty, staff, and alumni" can come together to remember and to carry knowledge forward. The rhetorical change is important for researchers, in that the HCCM becomes more than an archive of a boarding school, as the HCCM's emphasis falls on living tradition and knowledges even more so than before. The general public, though last on the list, is also addressed in this change. A living institution has far more long-term appeal than a site that only documents the attempted assimilation of Native children and the crimes committed against them by a non-Native government. While non-Native audiences and their potential resistance to learning Haskell's history is not a top priority to be addressed, the general public is still explicitly acknowledged here as a welcome audience, as welcome witnesses to the current life of Haskell's achievements. Moving away from memorialization lessens both the potentially sensationalist appeal for some tourists and the fear that potential visitors might have in encountering the enormity of the boarding school history in such a direct way. The new vision and mission statements once again reaffirm "living heritage and culture," which avoids the potential misunderstanding of Haskell's tragedies as a selling point and routes the general public back toward the idea that Native peoples are alive and thriving. The movement toward listing its attractions as "exhibitions," "education," and "art" also make the HCCM sound more accessible to the outside community, in that these are things non-Native visitors know to expect, and so a conscientious non-Native visitor might feel less like they are treading where they are not welcome or where they do not belong.

The total rhetorical shift in the vision and mission statements point toward a shift in the HCCM itself, or at least how it presents itself: the *Honoring Our Children* exhibit's narrative has now been fully incorporated into the HCCM's sense of itself in how its self-narration has run the course of the "seasons of sacrifice, survival, change, and celebration" and now rests on "living heritage and culture." No longer starting with the dedication,

the HCCM now asserts its relevance as a keeper and supporter of Haskell's history, its students' legacies, and living cultural heritages. Such a change in the implicit argument for relevance marks a long-term vision for the HCCM, even more so than at its opening. In terms of legible sovereignties, such revisions mark the HCCM's own transformation and how it wishes to be understood by its various audiences.

Perspectives from the first and most recent directors help to illuminate this shift. Rahder, who was the first director/curator of the HCCM and was brought back periodically to do temporary contracted maintenance work for storage, collections, and inventory until 2013, observes that while the goals of the HCCM are still similar to the stated mission at its opening, now the HCCM is in the process of addressing shifting audience needs. Both Native and non-Native visitors were invested in hearing the story of Haskell's origins and transformation, especially given that that story had not yet been fully told from a student perspective. However, twelve years later, visitors want to see more of what the HCCM has to offer: not just the *Honoring Our Children* exhibit, but also other collections, lectures, and the revolving gallery space in the back that showcases local Native artists' work (Rahder interview 2014). "People do like the boarding school story, as a permanent story, but there also needs to be new things," Rahder asserts (2014).

Jancita Warrington, the most recent HCCM coordinator (beginning in summer 2014) and Haskell alumna, asserts that the "concept of healing" that framed the original founding of the HCCM needs additional support, past the *Honoring Our Children* exhibit. Based on student comments, Warrington observes that "students say the exhibit makes them angry, mad, sad, a lot of negative energy, but [there's] not the healing" (Warrington interview 2014). Therefore, she sees her job, and the job of the HCCM, as one that better frames Haskell's history to help them work through the trauma and points them more effectively toward positive action and healing: the HCCM "is trying to communicate this history to visitors, but since the Cultural Center and museum is for the students, it also should represent progression of the university, created as a space of empowerment" (2014). Warrington additionally notes that, for non-Native visitors, there is still a considerable educational wall to be broken down. She says, "Haskell is special in that if people don't feel comfortable going to a tribal center, they will come here and get this history . . . though they still often think that Haskell is like a reservation. It's good for them to come here and

see that Indian people are human people, too"—though the strength of the HCCM, she says, is that it "doesn't sugar-coat the history" (2014). Relevance in this case has to do with humanizing the history that non-Native visitors might not know or have kept at a distance. At the same time, Warrington makes the same observation as Rahder, that the HCCM needs to expand past that initial story to do more with the HCCM's archives and collections and to tell stories that support students toward leadership roles on campus and in their own communities.

What becomes clear about the frame for legible sovereignties at the HCCM is that its creation, opening, and inaugural exhibit were all pivotal in creating a public face for Haskell's history that was Native-told, using Haskell's own archives—no small thing, given that the school is still operated by the federal Bureau of Indian Affairs and Bureau of Indian Education. It was and is a powerful exercise in critiquing the very system that still influences Haskell and funds it. The HCCM provided a place to discuss this history and critique, and the means to explore it and to recognize the positive transformations that have occurred. That was a distinct act of rhetorical sovereignty. At the same time, audience needs have changed, and the very work that the HCCM did then now renders the HCCM out of step with its own audiences; now that the historical narrative has been self-told, publicly displayed, and its presence accepted, "What next?" becomes the foremost question. According to Rahder and Warrington, this slow stagnation has not been for lack of people wanting to do more with the HCCM, but rather for lack of permanent resources and steady support. This was especially apparent in the state of the HCCM during my 2014 visit.

As of the summer of 2014, the HCCM was open only twice or three times per week instead of its initial daily opening hours, and was primarily staffed by student workers. A misunderstanding by a temporary staff member about the contents and importance of the nationally recognized Garden of Healing had caused its beds to be partially ripped out, which had not yet been replanted. Most of the guiding pamphlets and literature were no longer present in the vestibule, so visitors had to ask for a tour or wander through themselves. Yet the HCCM is still trying to keep itself available to students and other visitors, and Rahder's work and Warrington's efforts to do something new are evident.

In June of 2014, the *Honoring Our Children* exhibit was still on display, and clear efforts have been made to update its contents in keeping with the uptick in donations to the Haskell archives since the HCCM's opening. For

example, with the donation of some rare photographs of Haskell's first students during one of her contract periods from 2009 to 2011, Rahder was able to add to the initial panel of the *Honoring Our Children* exhibit. It now includes images of those first young children, a valuable glimpse into Haskell's origins that enhances the Sacrifice section. Seven new photographs in a wooden case (with two other photos having slipped behind the others) depict student portraits from 1884 to 1885. The caption with the case reads,

> They came in the mail from Pennsylvania, encased in a leather photo album—carte de visites and cabinet cards of the first Haskell students from 1884. Obviously the album was put together by an early Haskell teacher who identified each of the Native students with their name and tribe. They are wearing stiff wool and heavy silk clothing typical of Western culture at that time, except for a few students who are still wearing their own moccasins. We will always remember them.

Other donations and loans that arrived during Rahder's brief return have enhanced the space, including a sample padlock from Haskell's earliest days (also in the Sacrifice section), a display case that provides a look at one former Haskell student's experience through her memorabilia from the early 1900s, and a large powwow drum on loan (which visitors are encouraged to touch).

At the same time, there is some confusion in the organization of the exhibit. As Rahder indicated, over the course of the life of the exhibit it has been removed and reinstalled multiple times in order to allow it to travel to other sites or so that the gallery space could be used for gatherings. At the time of my visit during regular hours, a meeting that was held the day before meant that hanging fabric panels were still wrapped and tucked into the rafters, the projection screen covered part of the Veteran's Wall, chairs were stacked in front of the Rinehart photographs, and the War Mother sculpture in its case had been moved to the side. It also meant that the panels had not been fully rehung, leaving some of the labels and images from the exhibit propped on the floor next to the metal panels, and some had been mixed up from their original positions in the exhibit. The color-coding of the sections helped alleviate the problem of reinstallation to an extent, but within sections the panels were not always entirely coherent.

For example, the Change panel was now mixed with images from the same era, and some of the photographs—the one of the class typing, specifically—were now missing or placed elsewhere. The Change label itself no longer framed the panel's interpretation and appeared elsewhere in the exhibit, though the Learn to Earn label was intact. A different text that discussed termination policy during 1953–1968 was now affixed among the images, and an alternate photograph depicting "Haskell students skillfully displaying their marionettes to Smithsonian officials. June 3, 1936" was included in the mix. (What this has to do with learning to earn is not explained.)

One could argue that this is merely a temporary problem, but the limited hours that the HCCM was open and the shortage of staff meant that this situation was not entirely uncommon, especially since the staff were (and currently are) not the original curators or students who created the exhibit. For the non-Native tourist family who came into the exhibit that morning, it meant that their first encounter with *Honoring Our Children* was not quite as powerful as it could have been, and the lack of pamphlets, brochures, or supporting material meant there was nothing tangible for them to take with them. Warrington's presence to guide them mitigated some of the problems, but the unclear organization of the exhibit still presented complications. Because of the chairs, the Rinehart photographs were more or less inaccessible in the back alcove, the Veteran's Wall was partially covered, and items were missing from the cases in the artists' section that had not yet been replaced. In short, the museum's struggle to maintain itself and the lack of resources showed.

At the same time, visitors are still grateful for what they can see at the HCCM, pointing to the dearth of information the public sees about boarding school histories and the valuable work that the HCCM does. A perusal of the comment book next to the door demonstrated that in those months, even with budget cuts and closings, the HCCM provided a narrative that resonates with its audiences. The signatures from the last year alone indicated a local audience from Lawrence, from the surrounding region, from multiple states in the United States, and even a few international visitors. Students from the KU School of Social Work and several Kansas City universities had visited as part of diversity initiatives. Alumni of Haskell and their children had come for a look and remarked on how wonderful it is to see the stories told. One signature even shyly included the note "Might come to Haskell" and is signed with a heart. Over and over the words

"informative," "beautiful," "awesome," and "sad" emerge in describing the exhibit content, but the overwhelming sense is one of thanks: thanks that the story is told, thanks that the HCCM exists, thanks that the opportunity to learn is there. As local historian Katie Armitage aptly observes, "It is a unique experience and an underused jewel" (Carr 2012).

More than a decade after its opening, the HCCM is still making an impact and provides an important resource for the region and for the Haskell student and faculty community and all the tribal nations they represent. Yet the evidence of its struggle to maintain the momentum it had when it first opened was visible and tangible in 2014. Even as it was shifting its direction toward a present and future-oriented narrative, as its vision and mission statements indicate, it struggled to update the story that still stands in *Honoring Our Children*. Legible sovereignties, in this space, point to the need to follow through with what *Honoring Our Children* began, to continue making Haskell's history and the heritages of its students accessible to students and the wider public. It means continuing the example set by using past and present Haskell student voices to tell the story and maintain the established rhetorical sovereignty, even as the HCCM creates new ways to deepen visitor understanding of the histories it tells.

The First of Major Changes: The Woodland Exhibit at the HCCM

Changes at the HCCM are already under way, and in 2015 Warrington was hired on a more permanent basis as director. During her time at the HCCM in the summer of 2014, Warrington had been formulating plans for what she would like to do to begin the process of updating and creating new exhibits (Warrington 2014). Warrington noted that the new president of the university, Dr. Venida Chenault, had voiced an interest in expanding the HCCM's physical space to include a new wing that could house a permanent exhibit on Haskell's history—presumably based on the work already done in *Honoring Our Children*—and perhaps a second wing that could stand as a changing exhibit space. With such expansions, Warrington said, the present gallery space could be used for gatherings, for classwork, and as a community space (2014). In the meantime, Warrington said short-term goals included condensing the *Honoring Our Children* exhibit to make room in the existing gallery for some new exhibits, in particular one that would honor the new president at the time of her inauguration that fall.

Fig. 9. Haskell Cultural Center and Museum. *Woodland Exhibit* banner. November 2014. Photo courtesy of Lara Mann.

This final goal was realized in September 2014 with the *Woodland Exhibit: Honoring Haskell's 7th President, Dr. Venida Chenault*. On display until June 2015, the exhibit marked Dr. Chenault's inauguration, the first time a former Haskell student has become a Haskell president, and draws

from Chenault's Prairie Band Potawatomi Nation heritage. The exhibit was mounted by Warrington, Hattie Mitchell (the cultural preservation officer and tribal treasurer for the Prairie Band Potawatomi), and other members of the Prairie Band Potawatomi, and a tour of the exhibit was included as part of the inauguration festivities ("Venida Chenault Inaugurated" 2014).

At the time of opening, the *Honoring Our Children* exhibit had not been entirely removed, and Warrington's work to condense the exhibit so that other work could be displayed in that space was well under way. The fabric photograph banners had not been removed, but rather tied and bundled into the rafters to allow for the central gallery space to be more accessible. The Veteran's Wall had been condensed as well, and some of the recent artwork that had been on display in the back northeastern alcove was hung on the right side of the Veteran's Wall. The central gallery space was then occupied by a display of Woodland regalia as interpreted through Prairie Band Potawatomi tradition, arranged on top of the medicine wheel in the center of gallery underneath the tucked banners, and an additional display of Prairie Band regalia replaced the materials in the back northeastern alcove. Explanatory labels illustrate the items and link historical Prairie Band traditions with Dr. Chenault's present success as a leader at Haskell.

The total effect of the new exhibit in this shared space was perhaps an uncertain one that endeavored to extend the display by placing the *Woodland* exhibit in the center without removing all of *Honoring Our Children*. To be sure, this was the first new exhibit in some time, and it celebrated the legacy of a tribal community with a strong leadership at the university, which was largely its rhetorical intent. Yet the question remains: With the limited space, what happens rhetorically when the *Honoring Our Children* exhibit is condensed or only partially removed? Does it give a new or updated vision of Haskell, or does the narrative become disjointed in the shared space and with the removal of parts of the *Honoring Our Children* exhibit? Physically and metaphorically, the story of Haskell surrounded the Prairie Band exhibit and Chenault's inauguration, but actual visitor flow was more difficult to predict than ever. That is, the resonance of the two exhibits together was somewhat uncertain. Certainly Haskell students could visit now and see the symbolic legacy of a former student come to fruition, and that perhaps enhances the idea of celebration, assuming that the sequence of *Honoring Our Children* was intact enough to provide that frame.

Additionally—and audience reaction is the best way to gauge this—
the new exhibit raised questions about being inadvertently exclusionary in
its featuring of one Native community over all others. While it certainly
does make sense to create an exhibit in honor of Haskell's new president
and the occasion of an alumna taking office, there is the potential to read
the privileging of Prairie Band Potawatomi heritage over all others present
at the university. Given the intertribal nature of its primary audience, the
HCCM may run some risks in mounting an exhibit that highlights only
a fraction of its campus audience instead of maintaining the intertribal
emphasis. On the other hand, the short duration of the exhibit and its
nature as a changing exhibit perhaps ameliorates this reading, particularly
because of the auspicious occasion that it marked.

Public reaction was relatively quiet. The student-run *Indian Leader* on
campus mentioned the existence of the exhibit only in passing as part of
the inauguration ceremonies for Dr. Chenault, but nothing else (Hassel-
man 2014). Understandably, the Prairie Band Potawatomi Nation ran a spe-
cial feature on their website that highlighted both Chenault's inauguration
and the exhibit that represents and celebrates their heritage and Chenault's
inauguration. The *Lawrence Journal World* article on her inauguration does
not mention the HCCM at all (Shepherd 2014a). At this writing, the exhibit
has now run its course and been closed without further overt attention
or features in campus or local press coverage. The relative silence appears
to speak to the temporary and limited nature of the exhibit: it served the
purpose of celebrating Chenault's inauguration, and then need and inter-
est dropped.

What can be said, however, for the *Woodland* exhibit is that it was the
first major sign of change toward the new vision and mission of Haskell,
using the resources available. It also seems to suggest an alternative model
of support, one that asks for Native nations whose students attend Haskell
to take more of a direct interest in helping tell the connected history of
Haskell as an institution, and its students and alumni. The Prairie Band Po-
tawatomi Nation is relatively nearby, and so geography and occasion made
its participation easier to facilitate in both coordinating the exhibit space
and augmenting Haskell's collections. But it does also provide a model
whereby a Native nation contributes back to Haskell and circumvents the
need for federal funding, thereby reinforcing the presence of Native voices
on campus and in the exhibits. Whether such an approach will meet the
criticism of exclusion that can come with selectively highlighting particular

tribal nations (and thus excluding others) or is viable as an alternative model during funding droughts remains to be seen.

Conclusions from the HCCM's First Decade

By following the *Honoring Our Children* exhibit and the HCCM's development, we see that the HCCM serves multiple audiences, and that the information in the inaugural exhibit/permanent exhibit is invaluable as a documentation of Haskell's transformation from boarding school to culturally supportive university, through Haskell students' eyes and archives. Haskell students and alumni visit to witness to this history, and outside visitors come to learn. Both the creation of the HCCM and the mounting of the *Honoring Our Children* exhibit were pivotal acts of rhetorical sovereignty, and even if the visitor flow has slowed to a trickle, the place and the exhibit still speak to everyone who visits. Yet it cannot be denied that the rhetorical impact of the HCCM and *Honoring Our Children* has eroded from lack of physical and fiscal support.

Using legible sovereignties as a frame, several ideas emerge. The HCCM has already shifted to keep itself and its statements of rhetorical sovereignty legible, particularly in its revision of its vision and mission statements. Clearly, the emphasis has moved from memorializing/dedication to stewardship. This was accomplished in part through the work done on the *Honoring Our Children* exhibit, which traces the arc from sacrifice to celebration. The HCCM has now incorporated that narrative of progression fully into the mission frame. This change assists in the legibility of its mission in how "stewardship" does not forget Haskell's founding traumas but keeps them even as it moves visitors forward from that narrative. For students and staff, this is a place to begin making sense of Haskell's full legacy; for outside visitors and researchers, the HCCM is a resource for foregrounding these histories and learning from them.

The actual enactment of this renewed and revised mission, however, provides specific challenges for legible sovereignties. First, the upkeep of the *Honoring Our Children* exhibit as part of the necessary contextual frame for Haskell's success stories creates an ongoing puzzle. Though the exhibit was initially intended to be the inaugural exhibit, the first of many, the work that it does to lay out the history of Haskell has made it essential to understanding anything else that comes after it. As Warrington's own plans indicated, the exhibit probably should only be condensed, not removed,

and the president's hopes include a new space that could permanently house such an exhibit so that visitors would always have it as a context to work from. In the meantime, any new material mounted will always have to be framed within the existing exhibit, and how to do that well without damaging the impact of the *Honoring Our Children* displays will be a consistent consideration.

Second—though connected to the first point—there does need to be more done with the exhibit space to provide new stories and new material to keep visitor interest and better facilitate student understanding, past their initial anger and sadness at Haskell's beginnings and the colonial legacy those beginnings represent. *Honoring Our Children* cannot be the endpoint for the HCCM's statement of rhetorical sovereignty, and Warrington has already attempted to extend the HCCM's exhibits in a different direction. At the same time, as already argued above, the context, without a sugar-coating, is important to maintain, and so any new exhibits will have to make overt their connections to Haskell's history and legacy in order to create coherence.

Finally, if a rhetorically sovereign statement is made but no one is there to hear it, is it actually sovereign? That is, in the case of the HCCM, if it exists to make a powerful statement about Native students reclaiming their history at a place such as Haskell, if few people ever get to see it, is it effective? Rhetorical legibility has to do with access to concepts and actual spaces, and without consistent funding and staffing, the HCCM will struggle to maintain itself as legibly sovereign. While the problems of funding are larger than I can address here (for this or any institution), they remain a strong factor. Without stewards and resources, there can be no stewardship.

Because of its situating at Haskell, the HCCM is obligated to address the difficult history of boarding schools; unlike the Ziibiwing Center, the boarding school narrative has to be placed front and center, because it is Haskell's beginning. The history of the site must be addressed as part of its work. As a smaller institution serving an intertribal community with a shared legacy of education under or influenced by the US federal policy regarding Native peoples, the HCCM's unique position allows it to address this legacy. Haskell's own transformation has created the occasion and means for Native voices to tell this history themselves. In point of fact, it would not make sense for anyone else to tell this history at Haskell, and so the HCCM is a powerful reclamation of rhetorical sovereignty.

Yet legible sovereignties, as they continue to develop here, will b to take into account how to keep Haskell's story as part of the context, as part of the practice of orientation and healing for students, even as HCCM seeks to provide new stories from Haskell's past and present: conceptually, physically in the available space, and fiscally. The HCCM demonstrates that the practice of legible sovereignties takes considerable resources on all these fronts, especially as it plans for the future.

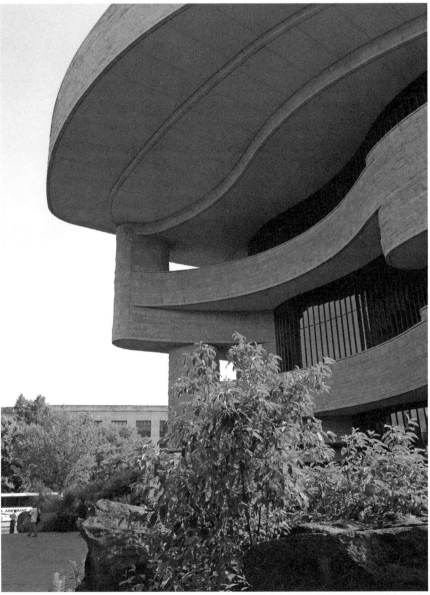

Fig. 10. The National Museum of the American Indian, Washington, DC. July 2014. Photo courtesy of the author.

3

Challenging Perception, Educating a Non-Native Public
The National Museum of the American Indian

Planted right next to the US Capitol building, the National Museum of the American Indian (NMAI) is one of the most visible Indigenously oriented museums in the United States. The Washington, DC, location is technically part of a three-branch arm of the Smithsonian Institution that includes the George Gustav Heye Center in New York (opened 1994) and the Cultural Resources Center in Suitland, Maryland (opened 1999), but the DC National Mall location is the most prominent of the three. It opened its doors in September of 2004 to fanfare and celebration, the final installation of the 1989 National Museum of the American Indian Act.

The NMAI is a sweeping Kasota limestone structure, built to look more like a rippling cliff face than a neoclassical marble dome, and the architectural contrast to its surroundings was part of its endeavor to reclaim a Native space at the nation's capital. In the decade since its opening, the surrounding woodland and garden features have grown up around it, emphasizing its connections to the natural environment in ways that set it apart from the standard landscaping on the Mall. The contrast at the NMAI was not meant to be merely in appearances, however. In every way, from its architecture to its curation, from its exhibits and activities to its collaboration practices, the NMAI desired to redefine the relationships that a major museological institution could have with the Indigenous communities it ostensibly represents. The challenge was far greater than anticipated, in some respects, as breaking a mold is easier than constructing a new shape the museum could use to attain its goals.

In this chapter, I continue the discussion of legible sovereignties: what it means and what it reveals within a large, national institution. As discussed in the introduction, there are particular rhetorical challenges for Native and Indigenous peoples using communicative structures such as museums that have historically been used to erase them. By using the NMAI as the final site for analysis, I demonstrate the ways in which the NMAI attempted to break the stereotypical museum mold to create a space for Native and Indigenous voices. Unlike the Ziibiwing Center or the HCCM, the NMAI operates from an already-established museological structure, through the Smithsonian, and the museum has had to strategize how to deal with that historical and rhetorical burden since its inception. Instead of working from a direct roots-up approach, like the Ziibiwing Center or the HCCM, the NMAI has struggled with working from the institution outward to Native communities while still meeting audience needs. Following a synopsis of its first efforts, I discuss the ways it has had to alter its approaches when those first attempts yielded unexpected reactions and results. The analysis shows that though the NMAI's inaugural exhibits worked very hard to privilege Native voices and cocurators, those exhibits simultaneously went too far in thwarting visitor's expectations and assumed too much background knowledge, resulting in an assertion of rhetorical sovereignty that was not fully legible. As a result, the NMAI has been rethinking its practices, and its latest efforts combine an effort to support Native voices and to meet audiences where they are in order to establish the relevance and rhetorical-historical context for those Native voices.

To understand this, first we work through the NMAI's mission statement a the time of opening and provide a description of the three inaugural exhibits, *Our Peoples, Our Universes*, and *Our Lives,* as I experienced them during my visits around the time of opening and again in 2007. Together, the mission statement and inaugural exhibits establish the conceptual and physical framework for rhetorical action and show the NMAI's challenges to the traditional museum's display of Indigenous peoples. Next I provide an analysis of the rhetorical intentions of the exhibit spaces and the rhetorical effect of the exhibits in terms of reactions, praise, and backlash. Furthermore, I address the rhetorical significance of audience struggle with making-meaning—that is, the audiences' struggles with discovering holes in their expectations or knowledge, finding the exhibits legible or accessible, and listening to Native voices on their own merit in the context of

the Smithsonian. The final part of the chapter discusses the current state of affairs, highlighting the revisions that have been made in the decade since the opening, and the new attempt at legible sovereignties as *Our Peoples* has been replaced with the *Nation to Nation* exhibit.

Breaking the Mold, Seeking a New Ideal: The Shape of the NMAI

When the NMAI opened on the National Mall in 2004, it foregrounded Native voices in every exhibition it had. It was understood to stand in contrast to the museums that had come before it and to the kinds of depictions of the vanishing Indian, frozen in time, that were so damaging to Indigenous self-representation and contemporary life. Even as thousands gathered on the Mall grounds to celebrate the NMAI's opening, the National Museum of Natural History had its own problematic dioramas featuring Native peoples still accessible and open to the public. Quite literally, one could go into the National Museum of Natural History, tour the stereotypical ethnographic depictions of Native peoples, walk back out into a throng of living Native people from across two continents, and then walk into the NMAI's visions of the past and present of Native Americas.

That vision is captured in part through the NMAI's mission statement, which for my purposes here is particularly important for establishing rhetorical intent. Its guiding vision reflects in part its connection with the Native American Graves Protection and Repatriation Act, which foregrounded Native rights to their own bodies, remains, and material culture (Trope 2013). The public NMAI mission statement from the website in 2004 read,

> The National Museum of the American Indian shall recognize and affirm to Native communities and the non-Native public the historical and contemporary culture and cultural achievements of the Natives of the Western Hemisphere by advancing—in consultation, collaboration, and cooperation with Natives— knowledge and understanding of Native cultures, including art, history, and language, and by recognizing the museum's special responsibility, through innovative public programming, research and collections, to protect, support, and enhance the development, maintenance, and perpetuation of Native culture and community. (As quoted in Atalay 2008)

During approximately that same time, the "About" section on the NMAI website said,

> [The NMAI] is the first national museum dedicated to the pres-
> ervation, study, and exhibition of the life, languages, literature,
> history, and arts of Native Americans. . . . The museum works
> in collaboration with the Native peoples of the Western Hemi-
> sphere to protect and foster their cultures by reaffirming tradi-
> tions and beliefs, encouraging contemporary artistic expres-
> sion, and empowering the Indian voice. ("About the National
> Museum" 2007)

What is important to note about both these statements is the emphasis on "partnership" and "collaboration," the acknowledgment of "present and future" and "contemporary" in addition to the standard "past" or "tradi-tion," and the concepts of "perpetuation" and "continuance of culture" and "reaffirming traditions and beliefs" in order to "empow[er] the Indian voice." Rather than acting as a repository of scientific knowledge—though "preservation" and "study" are also in there—the larger goals of the NMAI had to do with collaborating with Native and Indigenous peoples, com-munities, and living cultures in the present for the sake of the future in order to benefit those peoples, communities, and cultures and "empower" them to speak. While this arguably does follow the new museology turn in museum studies that privileges community involvement, the NMAI was the first such institution in the United States to attempt consistent partnership and collaboration on this scale as part of the museum's reason for existing. For working toward a legible statement of sovereignty or self-determination, the mission statement is crucial in how it frames the goals of the NMAI, at least in theory, as a stage from which Indigenous communities and artists may speak.

The founding director of the NMAI, W. Richard West, echoes these sentiments, but adds something more. In a 2005 interview with Amanda J. Cobb, he described what he understood to be the goals of the museum, and that, first and foremost, it was intended to be an "international institu-tion of living cultures." Second, he wanted the NMAI to be a place where Native communities would "bring to bear . . . their own views, voices, sets of eyes. . . . Native peoples themselves have authentic and authoritative voices to bring to their own representation." Third, he desired that the

NMAI marshal the resources it had to "bring them to Indian Country, recognizing that only a tiny fraction of Native America . . . will ever set foot in Washington, D.C." and that the consultation process that went into the exhibits was a way to connect communities to the NMAI. Yet the NMAI also represents something else, West argues: "It's not just a cultural destination; it really is a civic space, . . . public space that transcends its being a museum to become a meeting ground where this connection between the cultural origins of this hemisphere and everything that came after it finally come together in a way where some kind of real understanding can occur that sets the stage for cultural reconciliation over a long haul" (West and Cobb 2005). His first three points line up with the officially stated mission, but his additional desire that the NMAI become a "meeting ground" of "real understanding" is an outwardly directed statement that includes not only the Native peoples speaking and representing, but also the visitors who come to listen and see.

The official mission and much of West's intentions were reflected in the architectural space as it was arranged in 2004 and in the three inaugural exhibits, *Our Peoples*, *Our Universes*, and *Our Lives*. The NMAI's exterior is limestone, meant to mimic a natural landscape; based on consultation with representatives from multiple Native communities, its architecture also incorporates significant symbolic concepts, as do the botanical features outside (*Map and Guide* 2004). Within, the visitor entered into a four-story-high sky-lit atrium, with a performance space called "The Potomac" as the center. The visitor had the choice of entering into the Chesapeake Museum Store, a carrier of high-end Native art by individual Native artists, following the curve of the building all the way back to the Rasmuson Theater and the Mitsitam Café, or going up the first flight of stairs to the upper levels. The second floor contained the Roanoke Museum Store, with books, T-shirts, Pendleton products and other souvenirs, a smaller temporary exhibition space, and the *Return to a Native Place* exhibit next to the elevators. The third floor housed the resource center, a large rotating exhibit gallery, and the *Our Lives* exhibit. Finally—designed in the hopes that visitors would begin at the top and work their way down—the fourth floor housed the Lelawi Theater and its introduction to the exhibits, as well as the *Our Peoples* and *Our Universes* exhibits.

Though the architecture of the museum makes a visual and symbolic argument about Native presence on a National Mall full of marble columns and neoclassical architecture, the three inaugural exhibit galleries[1]

at the NMAI were the centerpieces for the initial expression of what the NMAI was supposed to be about, an introduction to what Indigenous self-representation in this space would look like. Each exhibit gallery was designed with its own thematic structure and internal organization, but what they had in common was that each had a group of eight Native communities (for twenty-four total communities) contributing their stories and viewpoints under the thematic umbrella provided by the NMAI curators, as well as recognizable genre features such as labels, images, and objects. The Indigenous community spaces were constructed as part of a years-long process of collaboration between community representatives and NMAI curators; in many ways they were the first of their kind to be constructed on that scale (McMullen 2007). Each exhibit space was also taken as an opportunity to reappropriate display techniques in terms of the mission statement.

Our Peoples: Giving Voice to Our Histories provided the historical framework for the rest of the museum, as it worked to establish an overall contact narrative from an Indigenous point of view that culminated in the histories and stories of survival from eight Native communities: the Seminole Tribe of Florida (USA), Tapirapé (Mato Grosso, Brazil), Kiowa Tribe of Oklahoma (USA), Tohono O'odham Nation (Arizona, USA), Eastern Band of the Cherokee Nation (North Carolina, USA), Nahua (Guerrero, Mexico), Ka'apor (Maranhão, Brazil), and Wixaritari (also known as Huichol, from Durango, Mexico).[2] The spatial arrangement was designed to be a "gently destabilizing" experience (Smith 2005, 5), full of curving walls and alcoves that a visitor must explore (as opposed to a highly sequenced arrangement). The backbone narrative, called "Evidence" by its curators Paul Chaat Smith, Dr. Jolene Rickard, and Dr. Ann McMullen, curved in sections through the center of the gallery space from entrance to exit, and surrounding it were eight semicircular, room-size alcoves, each devoted to Native community. An additional alcove, called "Making History," sat to one side.

Visitors entering the exhibit space encountered the "Evidence" narrative as it was displayed through a technique that the curators called "repetition with difference" (Smith 2005, 7): presenting many similar objects together that are at the same time distinct and providing conceptual labels to guide the narrative rather than individual labels for individual objects. As it was originally mounted, and when I was there, visitors entering the exhibit space at the intended entrance were greeted by a glowing blue wall

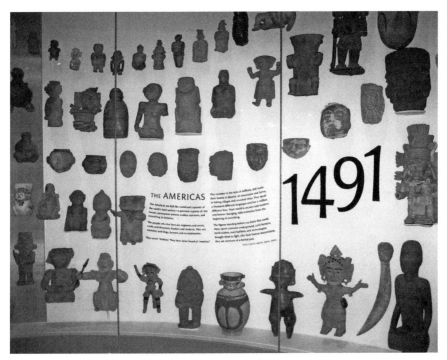

Fig. 11. NMAI. *Our Peoples* exhibit. "1491." June 12, 2007. Photo courtesy of the author.

with various objects embedded in it, with the word "EVIDENCE" set in the center. To the right, the exhibit curved into a display wall of hundreds of unlabeled figurines, titled "1491," with an explanatory label concerning the diversity of peoples in the precontact Americas. This display curved into another, called "Gold," also a collection of unmarked gold ornaments and ears of corn, that bore a conceptual label explaining the wealth of the Americas and preparing the visitor for the neighboring "Contact" and "Invasion" sections by framing Native history as a story of "wealth and dispossession" (Smith 2005, 7). The Contact display was one of swords and gold artifacts, connected to the Gold wall and explaining the transfer of American wealth to Spain; to the left was a free-standing display setting forth the exhibit's thesis, and across from that was the display wall called "Invasion," detailing both the pandemics of disease brought by Europeans to Native peoples and the incursion of European conquerors and settlers into Native homelands.

Toward the center of the exhibit space, three walls curved to form a broken circle, called "The Storm," and on these walls visitors read about three major forces that shaped Native histories with the coming of

Europeans—guns, bibles, and governments—with accompanying labels explaining the curators' choice of emphasis. In the "Coiled Dragons" section, one followed a curved wall of guns, from several centuries old to the present, and read about the impact on and adaptation of European weapons in Native hunting, trade, and warfare. Following the circle around, the "God's Work: Churches as Instruments of Dispossession and Resilience" section displayed statuary, crucifixes, and Christian scriptures and hymnals in European languages and translations in Native tongues, with labels explaining the conceptual and historical impact of Christianity on Native societies. Finally, in the "Stated Intentions" section, visitors viewed samples of the hundreds of treaties signed by Native leaders, colonial powers, and the US government that document Native relationships to government and sovereignty (and labels that explain this relationship). Within the center of this circle was a work of conceptual art by artist Edward Poitras, called *Eye of the Storm*, which symbolized the regeneration of Native peoples and "evidence of Native survivance"[3] (Smith 2003a).

As mentioned before, the individual Native community displays surrounded the Contact and Storm narrative displays, within which each community voiced its own history in a narrative they co-wrote with the NMAI curators and with objects they chose from the NMAI collections. While significantly smaller than an exhibit in a place like the Ziibiwing Center, each community space was prominently titled with the community's name and a subtitle for the display, a panel where the community, its geographic location, and its contributing "community curators" were introduced via text and photographs. These displays were heavily language-text based, but also integrated artwork, photos, video monitors, and artifacts into the experience. Within these displays, each community told its history as its contributing community curators had decided to tell it, including creation stories, major historical events, and perspectives on contemporary life.

Perhaps the most important section, although not centrally located or attractive by size, was the Making History alcove, in which visitors encountered a curved wall full of George Catlin portraits of Native leaders—a literal assembly of colonial-made images of Native peoples—facing a wall with a single portrait on it: that of George Gustav Heye, the collector whose massive collection of Native objects forms the foundation of the NMAI. Next to Heye's portrait was a section of the wall bearing the title of the alcove, and in an explanatory label, curators Paul Chaat Smith and Ann McMullen described who Heye and Catlin were as collectors.

Furthermore, Smith and McMullen suggest that history itself "is always about who is telling the stories, who the storyteller is speaking to, and how both understand their present circumstances" (Smith and McMullen 2003, "Making History" panel). Simultaneously, a video monitor embedded among the Catlin portraits played a video depicting Floyd Favel, a Plains Cree playwright, directly confronting the past depictions of Native peoples, especially in museums, and offering the

> self-told histories of selected Native communities. Other communities, other perspectives, would have produced different results. We present evidence to support our belief that our survival, the original people of this hemisphere, is one of the most extraordinary stories in human history. . . . Explore this gallery. Encounter it. Reflect on it. Argue with it. (*Narration* 2003)

This narration appeared also as a text panel for visitors to read.

After winding through the roughly structured but spatially flexible exhibit, visitors exited—at least according to original intentions—after viewing the *Eye of the Storm* installation, next to a large projected white-on-black word cloud containing the name of every Indigenous nation affected by colonization, with the statement "We Are the EVIDENCE" in the center.

On the same floor and across the hallway, the *Our Universes* exhibit provided a philosophical framework through which to understand the representative Indigenous communities, and used the lens of continuity of belief and practice as an alternative and addition to the narrative of contact in *Our Peoples*. *Our Universes: Traditional Knowledge Shapes Our World* presented another eight Native communities, in this case with the goal of explaining how each community spiritually and epistemologically frames the world. According to the primary curator for *Our Universes*, Emil Her Many Horses, the communities selected were those who had a communal ceremony and established structure from which their traditional community philosophy could be articulated (Her Many Horses 2007). Communities that participated in the original exhibit are the Pueblo of Santa Clara (Espanola, New Mexico, USA), Anishinaabe (Hollow Water and Sagkeeng Bands, Manitoba, Canada),[4] Lakota (Pine Ridge Reservation, South Dakota, USA), Quechua (Communidad de Phaqchanta, Cusco, Peru), Hupa (Hoopa Valley, California, USA), Q'eq'chi' Maya (Cobán, Guatemala),

Mapuche (Temuco, Chile), and Yup'ik (Yukon-Kuskokwim Delta, Alaska, USA). The exhibit also covered three pan-Indigenous events: the Denver March Powwow, the North American Indigenous Games, and the Day of the Dead.

The exhibit space was organized as the "passage of a solar year," with star constellations marked overhead in the ceiling and the end of the exhibit marked with the phases of the moon. Upon entering the exhibit—and *Our Universes* had a distinct entry and exit point, unlike *Our Peoples*—visitors encountered a yellow wall with the title of the exhibit, with an introductory label by Her Many Horses:

> In this gallery, you'll discover how Native people understand their place in the universe and order their daily lives. Our philosophies of life come from our ancestors. They taught us to live in harmony with the animals, plants, spirit world, and the people around us. In *Our Universes*, you'll encounter Native people from the Western Hemisphere who continue to express this wisdom in ceremonies, celebrations, languages, arts, religions, and daily life. It is our duty to pass these teachings on to succeeding generations. For that is the way to keep our traditions alive. (2003)

Accompanying the label was a contemporary glass sculpture of a raven's head, its beak grasping a glowing red ball, titled *Raven Steals the Sun*.[5]

The exhibit alcoves for each community were arranged in a roughly circular pattern according to the passage of the solar year, though each community's space was shaped by the site or ceremony they wished to be portrayed. For example, the Pueblo of Santa Clara had their space designed roughly in the shape of a kiva, with the four cardinal directions also representing the four colors of corn and the four stages of life; the Hupa space evoked the shape and feeling of their traditional cedar plank houses, where much of their ceremonial life takes place. Photographs of people participating in ceremonial life were frequently included, as were symbolic images, artwork, and artifacts and occasionally video clips chosen by the community curators. The entrance to each community's space was marked by a tall blue panel, with the name of the community appearing vertically down the left side, and the top of the panel depicting a symbolic representation of that community's guiding philosophy. For example, the

Lakota panel included a medicine wheel marked with the four cardinal directions and their names in Lakota. Beneath the symbol was a brief introduction to the community's philosophy and a short explanation of what the symbol means to the community, and this explanation comes from and was signed by the community curator(s). At the end of each community section, a long panel introduced the visitor to the community curators who were the primary consultants for each section, providing the names and photographs of the community curators, and sometimes a description of their roles in their respective communities. This panel also included a map to show the geographic location of each Native community. The exhibit itself ends with a glass *Raven Steals the Moon*[6] sculpture as a complement to the *Raven Steals the Sun* sculpture at the beginning, and there was also an alcove with carpeted benches designed for visitors to sit and listen to and watch a video animated presentation of one of the Pacific Northwest Raven stories, emphasizing the teaching of stories and cultural philosophies to new generations.

Placed a floor below the *Our Peoples* and *Our Universes* exhibit galleries (and so potentially the first visitors would see in their ascent up the stairs), the *Our Lives: Contemporary Life and Identities* exhibit gallery drew together the historical narrative and the acknowledgment of traditional cultural philosophies in its exploration of present-day Native lives and identities. The organizational theme for this exhibit gallery was explicitly "survivance" and identity, both in terms of general questions surrounding Native survival, resistance, and identification, and in the specific terms of eight contributing Native communities. The original Native communities involved in this exhibit gallery were the Campo Band of Kumeyaay Indians (California, USA), Urban Indian Community of Chicago (Illinois, USA), Yakama Nation (Washington State, USA), Igloolik (Nunavut, Canada), Kahnawake (Quebec, Canada), Saint-Laurent Metis (Manitoba, Canada), Kalinago (Carib Territory, Dominica), and Pamunkey tribe (Virginia, USA).

As the organizational backbone of this exhibit, Gerald Vizenor's concept of "survivance" received explicit treatment across multiple themes. The introductory panel/wall that visitors found when they entered was called "Faces of Native America," and presented more than sixty photo portraits of people who identify as "Native." Meant as a challenge to the stereotypical images that historical portraits—such as the Catlin collection in *Our Peoples*—now evoke, this section introduced the idea of "survivance"

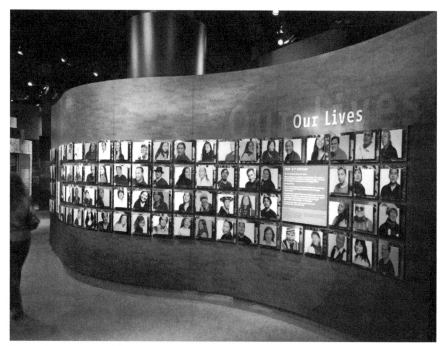

Fig. 12. NMAI. *Our Lives* exhibit entrance. July 2014. Photo courtesy of the author.

in more detail, and asked visitors to consider what it means to be "Fully Native" by questioning whether blood quantum is the primary identifying trait of Native people. Curved like the panels in *Our Peoples*, the "Faces of Native America" connected around into a section called "Body and Soul," which continued the discussion concerning questions of who is "Native" and who is not and provided some historical context for US government policy regarding blood quantum, Native bodies as artifacts and quantifiable objects, and BIA governance and identity. In this way, the concept of "definition" was connected as part of "survivance."

Other themes, such as language, place, self-determination, social and political awareness, economic choices, and traditional and contemporary arts, were examined in separate sections that curved through the center of the gallery and were also interspersed in between the community spaces that were set around the circumference. Within each section, objects, images, and linguistic text were interwoven for larger effect; within the traditional arts section, for example, four large wall panels were emblazoned with floor-to-ceiling images of a traditional mask, basket, moccasins, and eagle feather war bonnet, and these images were provided small explanatory labels with culture of origin and approximate age of the objects. Set

within each image, however, was a glass case that displayed a contemporary Native artist's work that, while invoking the traditional image around it, also brought the art form into the twenty-first century with innovation and parody: the contemporary mask was made from metal and kitchen utensils,[7] the basket was woven from 35-millimeter film strips,[8] the "moccasins" were actually beaded Converse sneakers,[9] and the "war bonnet" sported rows of baby bottle nipples instead of feathers.[10] Explanatory labels beneath the displayed objects provided contextual information and the artists' names, and some audio context was also provided. In another example, the section on social political awareness presented a collage of objects from the 1960s and 1970s, from handmade dolls to album covers featuring Native musicians, from Red Power merchandise to books by Native scholars. The surrounding wall was a collage of photographs of Native protesters. The label next to it read (in part): "Survivance means doing what you can to keep your culture alive. Survivance is found in everything made by Native hands, from beadwork to political action. . . . The things that we make, also make us" (Rickard and Tayac 2004).

The eight community sections of the exhibit also provided contemporary Native peoples an opportunity for explaining how they define themselves as "Native," including a mixed-nation urban Native community (Chicago), a mixed European-Native community (Saint-Laurent Metis), and a Native community that (at the time) was not officially recognized by the US government (Pamunkey). Like *Our Peoples* and *Our Universes*, each community section was created with the help of a group of community curators. Each section was titled with the name of the community, then a subtitle (sometimes with the official name of the community instead of the commonly known one, sometimes with a further description), and then an introductory statement about that community from its curators. Nearby was a map so that visitors might find each community's geographic location, and an introduction and photo of the community curators was also provided. Within each space, each community described what it holds most important—language, culture, land/environment, food, sovereignty,[11] and so on—and how change has happened, and how those things it values are enacted and supported today. The great majority of labels within these alcoves were written and signed by the community curators, and the images (most often photos and photo collages of community members and community spaces) and objects (hard hats, sports equipment, language keys, and so on) were also selected by those community curators.

In total, the three exhibits, *Our Peoples*, *Our Universes*, and *Our Lives*, demonstrated a concerted effort to break from the typical—or stereotypical—methods for mounting exhibitions about Native peoples and to affirm Native participation and voice in the process and result. Intent, however, does not always translate into understanding.

Legible Sovereignties at the NMAI: Rhetorical Intentions, Rhetorical Effects

As I observed in the introduction, Carole Blair (1999) and Eilean Hooper-Greenhill (2000) both argue that memorial or museum displays are never transparent in their meaning, and whatever the designers or builders intend is always countered by what visitors bring to the table. Eilean Hooper-Greenhill is blunt on this point: meaning-making is something that can be influenced, but not completely determined (2000, 4). Visitors have interpretive lenses of their own through which to understand what they encounter. This is not to argue that guiding visitor perception in regard to interpreting displays is a futile effort; if anything, such an effort underscores the importance of how the histories and narratives told by exhibitions are constructed and, thus, in the end are highly rhetorical.

In the case of the NMAI, curator and designer intentions were grounded in the mission statement's goals of "collaboration," "partnership," "continuance of culture," "reaffirming traditions and beliefs," and the "empow[erment of] the Indian voice." All three of the inaugural exhibitions featured an open interpretive design that allowed visitors to move and construct narratives as they pleased, with a guiding thematic "spine" for each gallery; each highlighted eight Indigenous communities from across the Americas to tell their own stories along this thematic backbone; and each emphasized Native voices and Native interpretations of history, worldview, and identity through panels that identified the community curators and put a named source to each piece of label text. All these choices were intended to upend the tradition of the monolithic museum-as-Truth and the habitual treatment of Indigenous peoples as objects under study. Given their content, each inaugural exhibit took a slightly different approach in centering Native voices and rethinking how exhibit spaces ought to function.

The rhetorical goals of *Our Peoples* included undermining the linear structure of a history exhibit and providing visitors both an illustration

of knowledge- and history-making and an opportunity for their participation in it. Rather than producing an exhibit gallery full of artifacts labeled in archeological or anthropological language by material, time period, and cultural category, curator Paul Chaat Smith argues that the *Our Peoples* exhibit was intended to make a space in which "the anthropological gaze, previously one that showed Indians on display, trapped in an ideological prison, would be returned by Indian people" (Smith 2005, 3). More specifically, the *Our Peoples* gallery strove to overturn the notion of monolithic museum history itself, especially in its Making History alcove. According to the text from the Making History space, museums visitors were literally challenged to interact with and question what they see instead of passively absorbing it. As already observed, the label quite directly asked visitors to "Explore this gallery. Encounter it. Reflect on it. Argue with it." This was a space of confrontation, whether it is George Gustav Heye's portrait facing off with those of Native leaders, or visitors confronting the legacy of colonization through displayed clusters of guns, treaties, and bibles that shaped Indigenous subjugation to European control. The spatial organization, while it provided a loose narrative of contact and destruction, could physically be encountered from two directions (so the "beginning" was not necessarily where a visitor started) and encouraged visitors to piece together what they saw in their own fashion.

Complementing the larger narrative of contact, the eight Native community spaces emphasized that living Native cultures still thrive, in spite of everything depicted in the Evidence narrative, and showcased the multiple ways they characterize their histories coming out of the contact narrative. For instance, the Kiowa Tribe of Oklahoma's alcove, titled "Kiowa: Our Songs and Our Ceremonies Enable Us to Carry On," used a large background panel depicting historical figures from the Kiowa Nation, overlaid with large text images from treaty documents; highlighted in large letters are the terms "Confederation" and "United States of America." Four wall-mounted glass cases formed the center of the object exhibit set on top of the text and under the photographic images, and they contained a pipe with its beaded bag and a number of historical documents (treaties, letters, a map) the community curators chose to represent Kiowa history. The explanatory panel that introduced the section, by community curators Juanita M. Ahtone, Fred Tsoodle, Mary Ruth Tsoodle, and Emily Satepauhoodle (Cold Weather Kiowa), read,

The earliest oral history of the Kiowa people places us in Canada. As we have been told, the Kiowa people then migrated into what is now the Yellowstone area of present-day Wyoming, and then onto the southern Plains. Our ancestors took directly from the world around them. Our traditions were formed from their relationship with other forms of life. Before us and before all was the center of reality, the Great Mystery that gave our people life, words, and song. To this day, our people continue this relationship by passing on this knowledge to our younger generation.

Photographs of the curators vertically lined the left side of this label. The sum total of the exhibit therefore captured Kiowa choices (or at least these curators' choices) in how they wished to tell the public their story, grounding it in history but bringing it into the present. Likewise, other labels in the Evidence sections provided a historical, conceptual orientation rather than a specific archeological or anthropological orientation, and the narratives of the Native communities displayed linguistic and imagistic snapshots of living communities as they were coconstructed with NMAI curators and designers. Again, all labels were signed with the contributor's name (as demonstrated above with the Kiowa label), further adding a nameable source and accountability to the insights the exhibit provided.

Like the *Our Peoples* exhibit, the goal in *Our Universes* (the only exhibit of the three presently remaining, projected to run through 2019) was to take the explanation and display of Native and Indigenous cultural and ceremonial philosophies out of the traditional archeological and anthropological frameworks so often used in museums and allow the included communities to explain their philosophies as they best saw fit. The curators and designers involved still provided an organizational backbone—the solar and lunar calendars, introductory and closing panels, and the choice of ceremonies still practiced by living cultures—but the content of the individual community spaces was largely chosen and negotiated by the community curators (Her Many Horses 2007). Furthermore, the great majority of the explanatory labels within each community space were written in first person (sometimes singular, more often plural) and signed by the community curator or curators in the same manner as *Our Peoples*.

Experientially, each community space in *Our Universes* was unique, and demanded the active attention of the visitor to interpret what each

community had presented. In terms of spatial organization, regardless of whether or not a visitor is aware of the solar and lunar organization, the consistent introductory and closing materials for each community space created a sense of content organization. A visitor could discern that a tall blue panel means an entrance into a new community's space, and could expect to find something about ceremonial life inside, and to find out something about who the community curators are and where they are from when one exits that space. Within each community space, a visitor had to reorient and do a little bit of exploring every time, for no two spaces were alike in how the community curators chose to portray their ceremonies or philosophies (and entering a symbolic kiva space is much different than entering a cedar plank house space).

However, unlike the *Our Peoples* exhibit, the larger historical narrative was not of primary concern, and rather than discussing survivance or adaptation, the strongest emphasis within the *Our Universes* gallery was on continuing tradition with minimal orientation toward linear history. While the individual community sections demanded exploration on the part of the visitor, the general organization of *Our Universes* was far more structured than *Our Peoples*, and nowhere were visitors asked to "argue" with what they saw and heard, as in the Making History section of *Our Peoples*. If anything, the rhetorical framing of *Our Universes* appeared in terms of respect, as the opening panel spoke of "teachings" passed down from "ancestors" to "succeeding generations" and encouraged a different kind of participation from visitors, one in which they were asked to explore in order to understand (and be taught), and listen in order to understand (and be taught), but not necessarily to challenge what they found there.

The primary goal of *Our Lives* was to underscore the notion of "survivance," to demonstrate that change in the lives of Native peoples and communities has not led to erasure, but instead a complicated and varied sense of what "Native" is in a contemporary world. That it was employed in this gallery as a major thematic structure suggests a framework for resisting the established and often stereotypical discourses of Native identity, in order to actively acknowledge Native peoples' survival and resistance in a multitude of ways. As an introductory panel stated,

> We are not just survivors; we are the architects of our *survivance*. We carry our ancient philosophies into an ever-changing modern world. We work hard to remain Native in circumstances

that sometimes challenge or threaten our survival. *Our Lives* is about our stories of *survivance*, but it belongs to anyone who has fought extermination, discrimination, or stereotypes. (Jolene Rickard, Cynthia L. Chavez, Gabrielle Tayac, 2004, "Now: 21st Century" label)

By invoking Vizenor's concept of survivance as the conceptual frame for the exhibit, all encounters within it were supposed to be understood in terms of both "survival" and "resistance," challenging those historical narratives that understand Native communities as dead, now impure (culturally or racially tainted), or fully assimilated. By naming the Native and Indigenous communities the "architects of [their] survivance," the label also asserted agency on the part of these communities in what the visitor would see, rather than passivity.

How those encounters within the exhibit would occur, however, was left largely up to the visitor, for aside from the opening text panel on survivance embedded in the photo portraits of the Faces of Native America display, the organization of the exhibit was open to exploration. The thematic framework of the exhibit—social and political awareness, language, arts, and so on—tended to curve through the center of the gallery in intermittent pieces or lie interspersed with the community sections, which were also curved and created smaller alcoves around the perimeter. A visitor had no map of the display, and so had to explore the individual community or thematic displays to create a coherent sense of what "survivance" meant here. The only real point of visitor flow control was the single entrance/exit to the gallery, and so no matter how one chose to walk through it, the "Faces" of contemporary Native people were the first and the last images that visitors saw.

As they were originally conceived, the fluidity of these three exhibits' structures, the attention required of a visitor to actively participate in meaning-making, and the reliance on Indigenous voices to ground the content of the exhibits all made for a challenging series of encounters that, as Smith (2005) articulated, was meant to reverse the gaze of the museum and put the responsibility for understanding back in the hands of the visitor. It was intended to be a strong statement of rhetorical sovereignty in the sense of creating a museum space that served the voices of Native and Indigenous peoples, their histories, and their cultures: here, as in no Smithsonian museum before it, substantial portions of the means to

self-represent were put in the hands of Indigenous communities, under the influence of both Native curators (both in the community and at the NMAI) and non-Native curators. Reactions to the inaugural exhibits, however, showcased a wide variety in visitor expectations and the actual demands visitors made on these spaces.

The initial audience reactions varied in substantial ways, frequently depending on how each visitor expected the museum to function and how it met or failed to meet those expectations. The positive reviews cited the novelty of the NMAI as a "museum different," the way it finally provided recognition of North and South America's First Peoples on the National Mall, and the joy (and sometimes surprise) of finding Native and Indigenous peoples still alive, culturally vital, and speaking for themselves in this space. For example, Johanna Neuman's *LA Times* review of the museum was generally positive, citing the educational "irony" of having a Native museum on the Capitol's doorstep and the planners' desire for "a validation of history but also a recognition of vibrancy" (Neuman 2004). Edward Epstein's review observed a turn away from the typical practice of artifacts in glass cases toward "a place of living, varied culture" (Epstein 2004), and Michael Kilian's *Chicago Tribune* review is largely pleased with the challenge to stereotypes of Native peoples (though he himself does end up using both "noble" and "savage" as sincere descriptors in his review) (Kilian 2004). Impressed by the pageantry of the NMAI's opening, surprised at the thousands of Native people who attended, and fascinated with the exhibits and the Mitsitam Café's thematically consistent offerings, many reviewers grasped at least the general idea of "we are still here." Native reviewers of the museums such as Mark Trahant and Mary Annette Pember voiced their support for the museum; Trahant wrote that "this was the right way to shift the narrative [of history] going forward . . . a story of hope, of complexity, and of the future" (Trahant 2004), while Pember stated that with the NMAI "Indians are stepping out from behind the museum glass to offer this country important and vital knowledge. My great hope is that American will hear it" (Pember 2004).

Not everyone was happy though, and not everyone heard it. The worst reviews of the NMAI's opening are now well documented and near legendary in their recounting. Edward Rothstein's *New York Times* review skewered the NMAI, and though he said he understood that "we are still here" was the intended message, he was more concerned with what he perceived as a "studious avoidance of scholarship" in favor of erasing

detail and reinforcing a "pastoral romance about the Indian." He openly wishes the National Museum of Natural History had simply received funding to revamp its exhibits instead of having the "self-celebratory" NMAI (Rothstein 2004). Paul Richard's "Shards of Many Untold Stories" in the *Washington Post* was no better, arguing the museum and its exhibits lacked "the glue of thought" to create a coherent narrative, and in short, "the museum doesn't nourish thought" because it wasn't rigorous enough and didn't show enough of the collections (Richard 2004). Marc Fisher's review in the *Washington Post* lamented in similar ways that the museum's lovely architecture was a façade for "intellectual timidity and a sorry abrogation of the Smithsonian's obligation to explore America's history and culture" (2004). One might chalk such reviews up to a museum-reviewer as a caricature of an indignant white, male, *Frasier*-like character; however, Native reviewers were not uniformly positive, either. Tim Giago's review voiced a desire to see both "the bad along with the good," pointing out the irony of a museum meant to serve Native peoples and the fact that many of those communities' members will never be able to afford to visit the very museum meant to honor them (Giago 2004). Furthermore, Sam Lewin documents representatives from the American Indian Movement that criticize the NMAI for not addressing "America's holocaust" against Native peoples. As Lewin writes, "By highlighting the good and downplaying the bad, the museum may help people celebrate, but it doesn't necessarily help them understand" (Lewin 2004).

Likewise, scholarly reviews of the museum and its inaugural exhibits varied. As noted in the introduction, the journal *American Indian Quarterly* devoted two special issues to documenting and discussing scholarly reaction to the NMAI in 2005 and 2006, culminating in an edited collection in 2008 (*The National Museum of the American Indian: Critical Conversations*). An entire section of the collection concerns "Interpretations and Response." Elizabeth Archuleta's reading of the museum as a literary text likens it to Leslie Marmon Silko's oft-cited metaphor of Pueblo story as a spiderweb—a series of interconnections, not a linear narrative—that "should not spoon-feed information to an audience" and should rather "offer enough information that sparks our curiosity, invoking in us a sense of response-ability" (Archuleta 2008, 204). In "'Indian Country' on the National Mall," Aldona Jonaitis and Janet Catherine Berlo expand on their initial *Museum Anthropology* review of the NMAI, suggesting that the highly negative reviews of the museum stemmed from an inability

of those reviewers to examine the museum that existed rather than the museum they desired or expected to see, and that the NMAI was in fact "the museum different" that broke standing paradigms of what a museum could do in a postcolonial world (2008). Gwyneira Isaac's essay, "What Are Our Expectations Telling Us?," tackles what she calls "genres of expectancy"[12] to explain how different expectations of what exhibits should do will lead to different interpretations of the exhibits and, in the case of the NMAI, how clashes in interpretation occurred (Isaac 2008). Sonya Atalay's piece "No Sense of the Struggle" articulates the problem of having little historical context with which to frame the discussion of survivance and also how the exhibits, while promising, need to do more to contextualize why the celebration of survivance is significant for both Native and non-Native audiences (2008). Myla Vicenti Carpio echoes a similar concern in "(Un)disturbing Exhibitions," in which she expresses frustration at both a lack of historical contextualization and an implicit linear telling of Indigenous story when, in fact, she argues for a cyclical understanding of Indigenous healing and transformation (2008). Finally, Amy Lonetree's "Acknowledging the Truth of History" works through the "missed opportunities" she sees at the NMAI and offers an analysis of how avoiding a discussion of the devastation Indigenous peoples have endured through colonization actually compromises the impact of Indigenous survivance and the ability to decolonize museum spaces. Lonetree's critiques took fuller form in her monograph *Decolonizing Museums*, which reinforces her analysis of the NMAI in more detail and calls for the telling of these "hard truths" (2012).

Since then, Jennifer A. Shannon's monograph *Our Lives: Collaboration, Native Voice, and the Making of the National Museum of the American Indian* (2014) confirms much of the above concerning overall reception of the inaugural exhibits. Her work with the collaboration processes for, construction of, and reception to the *Our Lives* exhibit reveal the ways that Indigenous peoples were generally accepted by the public as symbols of but not authorities on Indigenous cultures and histories (176), which points to a significant problem with understanding the exhibits as legitimate displays of knowledge. A visitor survey completed a year after the NMAI's opening furthermore showed audience confusion over the open exhibit structures and indicated that, while visitors understood the message of "we are still here," they still sought traditional, chronological histories and background information that could contextualize that statement (171).

In short, audience reactions to the NMAI—at least as far as we can grasp them from newspaper reviews and a collection of established scholarship—were tremendously varied, and demonstrate the ways in which museum visitors bring their own expectations with them and form their own narratives based on generic expectations of museums and what they already know (or don't) about Native and Indigenous communities. My own reading of the exhibits in terms of rhetorical sovereignty elaborates further on their multivalent qualities.

As suggested above, the rhetorical goal of the *Our Peoples* exhibit was to turn the anthropological gaze back on the visitor (Smith 2005) and provide a more conceptually oriented approach to history and contact that supported Native voices and challenged visitors to think of history in dialogic terms. Perhaps this isn't a locked-into-place narrative. However, given that this exhibit, as a genre, strives to overturn what traditional museum exhibits have done in the past—arranging Native objects by regional grouping or evolutionary groupings, or narrating with dioramas, without any or with little consultation from the Native communities who are the subject—it also may have thwarted its "readers" expectations in counterproductive ways, making a legible rhetorical sovereignty difficult. For example, the use of "survivance" as a key word that appears in label text is significant, in that the use of Vizenor's neologism for "survival" and "resistance" asserts a desire in this context to both resist the way Native histories have been told and allow the histories Native peoples have constructed to be heard. Yet the concept was not explained within the exhibit and therefore would likely have caused confusion among those who do not already recognize it. Smith acknowledges that the curatorial team understood that in general the exhibit they were constructing would likely produce "cognitive dissonance"[13] in how it would tell stories and histories that visitors had never encountered before (Smith 2005, 5). In addition to that, I would argue that the exhibit structure itself, in its efforts to undermine museological knowledge-making authority, had the potential to create cognitive dissonance in terms of how visitors expect to approach an exhibit in the first place—thereby occluding legibility. Either of these results has the potential for epiphany or backlash (or a combination of the two): on one hand, a visitor may be able to work with the challenging narrative, or on the other, she may reject it out of hand because it does not fit what she expected. Dr. Ann McMullen, the senior curator for the NMAI, acknowledged in my 2007 interview with her that most visitors are imagined as

impatient tourists, as viewers who will not spend more than two minutes looking at any given object or label and who arrive at the Smithsonian fully expecting to be told what to believe (2007). The intentions of the *Our Peoples* exhibit were fairly clear, but whether or not visitors are willing to participate in the history-making process is not, especially if they greet the purposeful undermining of their expectations as unwelcome and prefer to fall back on more traditional—and often passive—ways to approaching a museum exhibit.

As the longest-standing of the three exhibits, the *Our Universes* exhibit, as already noted, was designed to rely on more traditional museum display approaches in that it has a more definitive, linear layout and does not invite visitors to argue with the content of the alcoves or the spine of the exhibit. It spends little time on history, even that history of suppression or eradication of the practices and philosophies depicted. Though these philosophies and practices are arguably an embodiment of survivance, adaptation, and/or cultural revival, they are not depicted in this way. Instead, even if the individual community sections demand exploration on the part of the visitor, the general organization of *Our Universes* is far more structured than that of *Our Peoples*. If anything, the rhetorical framing of *Our Universes* is in terms of respect. Hearing and reading about "teachings" passed down from "ancestors" to "succeeding generations" suggests a different kind of participation to visitors, one in which they are encouraged to participate in order to learn something but not necessarily to challenge what they hear or see. There is a fine narrative line that potentially positions the non-Native visitor as both an invited guest who may learn and also an outsider observing the practices of Native communities—the second of which invokes the older frame of passive observing or even voyeurism again. While these Native communities may understand their actions as a kind of rhetorical sovereignty and an invitation to museumgoers to actively receive these stories and philosophies as a kind of rhetorical sovereignty, there is the distinct shadow of exhibit-practices-past that allows for the non-Native visitor to overlook that rhetorical sovereignty and peruse *Our Universes* again as a gallery of curiosities. One could argue that cognitive dissonance is also supported here in the sheer scope and variety of what is covered if the visitor is looking for "the" Indian, and yet that dissonance is already eased (perhaps too much) in the structure and potentially passive role approach *Our Universes* creates for visitors.

The *Our Lives* exhibit posed challenges of its own in how audiences approached it and what they did with it. That same openness and reliance on the visitor to make meaning that was attempted by *Our Peoples* also created potential difficulties for *Our Lives*. Unlike *Our Peoples*, which began with at least a somewhat familiar historical narrative of contact, or *Our Universes*, which provides an explicit explanation and organization of what visitors will see, *Our Lives* described a rhetorical discourse of survivance/self-determination/sovereignty that visitors from outside Indian Country will likely find unfamiliar, and depicted Native community realities that challenged what visitors may believe. This kind of education is a good thing, without question. Yet since the declaration of survivance was combined with the openness of the exhibit itself and the refusal to create a new prime narrative, there was always the potential that non-Native visitors might actually balk at it specifically because they did not know how to make sense of what they saw. Legibility might not function because many visitors did not know how to read the narrative presented here. Though the thematic framework for survivance was there, and the community spaces were to an extent self-contained and self-explanatory with a repeating pattern in their introductory materials, the degree to which a visitor might come to understand survivance as the intended tie to bind them all—or accept it, once recognized—remains a question. On the other hand, like the *Our Peoples* exhibit, such a layout encouraged dialogue between exhibit and visitor, and so one may understand the goal of this exhibit as, if not outright persuasion, at least provoking discussion—and that, too, is a kind of rhetorical sovereignty, or at least a start.

Considering the initial stated goals of the NMAI, the inaugural exhibits demonstrated both the desire to remake museum paradigms of consultation and display to meet the needs and support the voices of the Indigenous communities whose cultures were on display and the desire to challenge larger misconceptions about Indigenous communities and educate visitors, while illustrating the wide variety of readings and meanings visitors could derive from such a project. The three exhibits provided three distinct approaches to presenting Native nations' perspectives on history, philosophy, and contemporary life, although what they all had in common was the pervasive and persistent push to present Native and Indigenous perspectives first instead of the exclusive European American scientific or anthropological perspectives as they have been previously embodied in the

museum exhibit genre. This reversed prioritization is an act of rhetorical sovereignty.

At the same time, that rhetorical sovereignty hasn't always been legible, and the variety of reviews and scholarly reaction only touched on here demonstrate the potential problems inherent in the endeavor to articulate rhetorical sovereignty to multiple audiences that may or may not react favorably to the cognitive dissonance potentially created by the exhibits or the mixture of traditional and innovative display techniques. Depending on how it is deployed, that combination simultaneously creates the opportunity for rhetorical sovereignty and the opportunity for gaps in non-Native visitors' understanding to interfere with that articulated sovereignty. For instance, the mandate to discuss and interact with exhibits that visitors may expect to passively peruse as concrete "Truth" is not a part of the larger Smithsonian approach—at least not in its history with presenting Native peoples. Consequently, such exhibits may also cause frustration in visitors whose generic museum expectations have been thwarted and who have not yet found a way to comprehend what they do see, as demonstrated by the initial unfavorable reviews. In fact, taking those new exhibits in relationship to the larger structure of the NMAI, they were still surrounded by the conventional trappings of a museum and flanked by conventional object-driven displays in the hallways that fall back on previous exhibit models. As a result, visitors to NMAI in its first few years had to make the awkward negotiation between the exhibits they were most comfortable with (likely the cases full of tomahawks and beadwork) and the inaugural exhibits that upended that comfort. Those Native voices from the inaugural exhibits ended up competing with more conventional versions of museum exhibits and audience expectations. Such positioning might have inadvertently distanced and objectified those voices and the three inaugural exhibits by association, or placed the traditional exhibits and the inaugural exhibits in competition with one another for narrative status.

Compounding that potential ambiguity is the fact that non-Native visitors will also likely not encounter the "Indian" they expect to see in the inaugural exhibits. This is in many respects precisely the point of these exhibits and cause for celebration, but, rhetorically speaking, combining major changes in both the communicative framework and what it speaks can create a less-than-optimal distance between the speaker and the listener. A purposeful cognitive dissonance may be produced, but how well

that dissonance is put to constructive use within the inaugural exhibits is another question, leaving room for discussion about how speaking sovereignty in these spaces might be accomplished more effectively.

Clarifying the Vision: Maintaining the Mission and Meeting Rhetorical Needs at the NMAI

Since its opening in 2004, the NMAI has not been unconscious of the ambiguities and controversies the inaugural exhibits provoked and has made it a point to engage in self-reflexive analysis in order to better serve both the Native communities it represents and the predominantly non-Native visitors that come through its doors. Through various processes of reevaluation and new attempts to address the questions raised about what the museum should be doing and how it should do it, the NMAI has adjusted the way it approaches creating exhibits and, arguably, enacting rhetorical sovereignty, with the goal of making it more understandable to its non-Native visitors. The original statement of "we are still here" was unmistakable, and even the harshest critics understood, at minimum, the NMAI's desire to communicate that much, even if they did not like how it was communicated. Yet, since its opening, the NMAI has realized that its goal cannot be merely asserting presence, but also making that presence relevant: in short, making Native voices not just hearable but understandable, and making the exhibits not just purposefully beautiful or disorienting but also clear in their goals. The NMAI has now turned its energy to making itself legible.

This is not to say that they intend to create a new monolithic Native museum and a new master narrative—though this is certainly something that curators, designers, and staff have struggled with. Such a temptation is part of the inherited generic structure of the museum. To an extent the spirit of the Making Histories alcove in the *Our Peoples* exhibit is still present, and the possibility of co-making meaning with visitors has not been shut down (and it couldn't be, Hooper-Greenhill would say, even if they tried). If anything, the NMAI is attempting to take visitors' critiques into account to better serve them. What might be more accurate to say is the museum has been seeking new models of how to simultaneously support Native self-representation and provide the necessary guidance to visitors who do not have much more than the lens of stereotype through which to understand what they encounter. To meet this challenge, the NMAI has

shifted in approach toward legible sovereignties from 2004 to 2014, culminating in the new *Nation to Nation* exhibit, which was the first to replace an inaugural exhibit and now stands where *Our Peoples* once was.

In 2007, Kevin Gover replaced W. Richard West as director of the NMAI, and if West's job was to help bring the mission of the NMAI to fruition, Gover's work has been to maintain and refine the mission's and the museum's approach. The current mission statement reads,

> The National Museum of the American Indian (NMAI) is committed to the advancing of knowledge and understanding of the Native cultures of the Western Hemisphere—past, present, and future—through partnership with Native people and others. The museum works to support the continuance of culture, traditional values, and transitions in contemporary Native life. ("Mission Statement" 2014)

This streamlined version of the first mission statement is noteworthy for where its rhetorical emphasis now falls, for though it still speaks of a "partnership" with Native peoples "to support the continuance of culture" and so on, the stated reason for doing so is to "advance knowledge and understanding" of these Native cultures. Whose understanding? One can assume that Native visitors have plenty to learn about other Indigenous cultures in the Western Hemisphere and that the museum might even have something to share with them about their own cultures. But given that 95 percent of visitors are non-Native, the subtle shift in the mission has moved toward balancing the advancing of "knowledge and understanding *of*" with the support of continued culture and contemporary life. This shift was well under way in 2007, as the 2007–2008 *Programs and Services Guide* mission statement already contained the most recent wording ("Appendix A: Profile and Mission Statement" 2007).

Gover's recent anniversary post on the NMAI blog further articulates what the museum sees itself doing in the coming years, and marks the shift in emphasis. Targeting "citizens, policymakers, and policy influencers" over the next twenty-five years, he writes,

> Most Americans have been taught a limited—and often mistaken—version of Native American history. I still remember the stereotypes that defined my childhood: Indians were figures of

the past. . . . The true story of our heritage is so much more nu-
anced, complex, and fascinating. Understanding this complexity
can help us understand our present and prepare for our future
as a multicultural nation. (2014)

In terms of rhetorical appeals, this is a call for a broad audience to engage,
and one that subtly underscores the framing of Native voices and Indigenous
cultures as relevant to everyone, not just Native communities. The original
message of the NMAI—"we are still here"—is implicit in that Native peoples
are not "figures of the past," but Gover's goal is an education that addresses
the potential reply of "so what" to this message—the relevance for everyone
of Native presence and continued cultural and political life.

Some critics might argue that this shift is a sacrifice of the emphasis
on Indigenous voice, as quite clearly the wording from the original mission
statement that highlighted "Native voices" is gone. To an extent this critique
has some merit, at least on the surface, and the idea of a "multicultural
nation" is surprising, given the potential ease of erasing Indigenous cultural
and political sovereignty under the heading of "multiculturalism." Yet the
omission of "Native voices" in the mission statement does not necessarily
indicate an omission of Native voices in the museum or its exhibits, and
points to a rhetorical strategy that intends to highlight relationship with—
or, "partnership," at least—and support for Native communities while
providing education to all. This shift has to do in part with visitor reception
and the frustrated reviews of 2004 that claimed the museum had ceded its
authority. Now supervisory museum curator for the NMAI, Ann McMullen
suggests that in the course of the last ten years, the museum has recognized
a need to "meet museum visitors where they are" instead of assuming visi-
tors have background knowledge of Native peoples or understand shifts in
museum practice. For example, and specific to perceptions of Native voices,
McMullen observes that the tactic of signing the exhibit labels through all
the inaugural exhibits (as discussed above) was intended to indicate taking
responsibility for those words and sharing the responsibility of explaining
ideas. However, because audiences were not accustomed to that change in
practice—and this is where generic expectations matter—McMullen says
that visitors treated the signed labels not as truthful, authoritative informa-
tion to be taken seriously, as one would a newspaper article (her metaphor),
but rather as an "op-ed piece" that a reader could dismiss or ignore (inter-
view 2014). Native voices were therefore categorized as mere opinion, and

thus their authority was undermined through unorthodox presentation. The shift in the mission statement therefore has a great deal to do with setting the frame to help visitors understand the importance of what they will see: in educating the public to hear and understand Native and Indigenous voices, the NMAI sees itself as serving Native and Indigenous communities, albeit in a more roundabout way.

Whether that intention will play itself out effectively is another question, and one the museum is endeavoring to answer through its understanding of the NMAI audience. As former director of education and a contributing curator at the NMAI during the time of its opening, and now in the post of historian there, Gabrielle Tayac observes that the platform of the NMAI as part of the Smithsonian lends it a visibility that most other Indigenously oriented museums do not have, and so visitors treat it as an authority on Native cultures and peoples (Tayac 2014). At its opening, however, and in subsequent years (and beyond the harsh reviews), it became clear that visitors were having trouble connecting to the exhibits. As Tayac observes, relevance was hard to articulate to museum visitors, and they did not engage with the exhibits as was hoped. Ninety-five percent of visitors were, and still are, non-Native, and they do not come with a background in Native histories or cultures. The average K–12 education does not provide visitors with the vocabulary to engage with the exhibits, and many visitors have felt lost; Native visitors who did not find themselves immediately represented have wondered where they fit.

In thinking through the future of the exhibits and programming, Tayac asserts that "we want people to feel part of the story, we want them to know how it effects them, [and] rather than looking at the exoticized other, I think we're really interested in seeing what's the shared legacy point" (interview 2014). There is a movement toward contextualization, she says, from understanding the NMAI as an "ethnic museum" to more of a "national museum" (interview 2014). This is not, as she puts it, an "assimilationist project," and the mission to support Native communities still stands. She argues instead that in addition to Native community-based projects, the combination of more traditional museological voices in archaeology and history with Native voices in oral and community-based scholarship can provide a broader narrative, and that

> if we do this right, what we can end up with is a much more informed public, and when it comes time for them to think

about how to think about Indians . . . the idea is that if you can transmit the idea and teach people how to look at the material and make them care about and help them realize this has impacted them, then they're going to be able to grasp other pieces [of history and policy]. (interview 2014)

McMullen's account of the general visitor surveys conducted by the Smithsonian's Office of Policy and Analysis is also revealing, in that the Smithsonian hypothesized that their target audiences comprised two major groups: those who came to museums to see art or objects, and those who were attracted to museums to seek out the ideas presented there. What the surveys discovered was a third kind of visitor, one who seemed to be attracted by people: photos, voices, and images of people. The challenge—and one of many—is to "flip" one kind of visitor to another, to help them begin with their initial reasons for being there and then become interested in the other features: from interest in objects to ideas and people, from ideas to objects and people, and from people to objects and ideas (Pekarik and Mogel 2010; McMullen 2014). Based on this, exhibit design now tries to tap all of these features, though given the initial reactions and complaints about the NMAI, she still sees a basic tension in place: "How do we do idea-based exhibits when people mostly come [to the NMAI] to see the collections?" (McMullen 2014).

Gover, Tayac, and McMullen's observations and articulation of the NMAI's goals all point to similar audiences needs and working tensions between what the NMAI wants to accomplish in asserting Native presence and its relevance to everyone, and what audiences expect from a museum and from "Indians." This is the NMAI's particular context to work in as it establishes the possibility for legible sovereignties in the museum's structure and in each exhibit space as the inaugural exhibits are dismantled and replaced.

The immediate structural differences that have been made through the last decade have been the significant reduction of the Chesapeake Museum Store, the expansion of the Mitsitam Café, and the replacement of the resource center with a children's education and play area called "imagi-Nations Activity Center." As noted above, the Chesapeake Museum Store was on the entry-level floor, and one of the first things a visitor would see to the right. It was a carrier of "fine art" objects advertised by individual Native and Indigenous artists and, rhetorically speaking, was oddly out of

place in a museum meant to tell broader stories and histories for tour-
ists. In terms of price and specialized knowledge about Native art, it was
not accessible to the average visitor. That space has since been converted
to create an extension of the Mitsitam Café's seating area; as one of the
consistently lauded and now award-winning parts of the museum because
of its thematic consistency with the rest of the museum and well-reviewed
cuisine, the café has received additional support through this expansion.
The Chesapeake Museum Store is now the Chesapeake Gallery Store, and
has been reduced to a long counter adjoining a coffee stand, just off the
Potomac on the first floor but in the hallway toward the entrance to the
downstairs auditorium.

Perhaps the most striking of the changes, however, is the conver-
sion of the resource center and its kiosks of computers to the brightly
colored imagiNations Activity Center. It directly addresses the general
K–12 dearth of education concerning Indigenous peoples, and provides
an interactive educational play space for children that was not part of the
original design of the NMAI. Through the bilingual English and Span-
ish space, children go on a journey that "will take you to Native nations
across the Americas. You'll meet people who are like you in many ways.
But they also have their own foods, clothing, homes, and ways of living"
("Welcome" panel 2014). Even in the opening welcome, the orientation is
clear: these are Native nations, they are like you, but they are also uniquely
themselves. The panel illustrates clearly the shift the NMAI is making in
how it seeks direct engagement between visitors and the material and fills
in conceptual gaps.

The inaugural exhibits, too, are slowly on their way out, though the
process of figuring out the best ways to remedy the issues raised in the last
decade has been a series of careful experiments. Recognizing the need to
address conceptual issues and to build historical context into the discussion,
to connect non-Native visitors to unfamiliar material, to reestablish narra-
tive authority in a way visitors could understand, and to use more of the
collections to satisfy visitor expectations, the staff at the NMAI have been
rethinking their approaches. Budget was and is also a significant constraint:
while the galleries for individual Native communities marked an important
turn in museological practice, in that Native community members had un-
precedented (for the Smithsonian) control over content and display, it was a
time-consuming and extremely expensive process. Only a handful of com-
munity displays were rotated out, and the hopes for regularly rotating the

individual galleries to represent other Native communities were eventually dashed as it became apparent the model was unsustainable at the NMAI (Tayac 2014; McMullen 2014). Given that this model of consultation was a significant part of giving Native and Indigenous communities voices at the NMAI and one of the most visible markers of the "museum different," and also given the complaints from unrepresented Native communities from the beginning and the conceptual confusion invoked with visitors, it was important to find alternatives that still supported Native voices but that also answered questions of legibility and budget.

McMullen explains that since the opening, the staff has used the changing exhibit gallery as a way to begin experimenting with adapted exhibition techniques to create more accessible but still accountable exhibits (2014). In what ways could Native and Indigenous community consultation still be kept as a centerpiece? In what ways could this be turned both to meet and challenge visitors? According to McMullen, one of first changing exhibits that appears to have met the criteria successfully so far was the Northwest Coast–based exhibit *Listening to Our Ancestors: The Art of Native Life Along the North Pacific Coast* that ran in Washington, DC, from February 2006 to January 2007. The exhibit included four hundred objects from the NMAI collections, as selected by representatives from eleven Indigenous North Pacific Coast communities, including the Coast Salish (Skoskomish), Makah, Nuu-chah-nulth, Kwakwaka'wakw, Heiltsuk, Nuxalk, Tsimshian, Nisga'a, Gitxsan, Haida, and Tlingit peoples (*Listening to Our Ancestors* 2007). Cast as a "series of community self-portraits," the exhibit displays both the objects and the discussions of "the ways in which these masterpieces, as well as everyday tools and utensils from the museum's collections, connect them [the communities] with their forebears and enrich their world today" (*Listening to Our Ancestors* 2007). McMullen notes that reviews were generally positive, and Aldona Jonaitis's review of the exhibit in *Museum Anthropology* reveals her own sense of the contrast between the inaugural exhibits and this one:

> "*Listening to Our Ancestors* looks different from the inaugural exhibits of the NMAI. It is more refined, easier to navigate, and clearer in content. For those anxious to acquire information on Indians, they will be pleased by the good ethnographic documentation of objects. . . . Those visitors who want to spend time among beautiful creations will appreciate the exhibitions artistry. (2006, 131)

The exhibit, at least according to her, meets both the desire for ethnographic content and for aesthetically pleasing objects. However, she continues,

> But for those who take a little more time to actually read and absorb the messages each group issues forth, there might be other realizations. One, that even a region that appears on the surface to be uniform is in fact composed to distinct people who cannot be represented as versions of each other. Two, that the exhibit expresses several powerful political statements. And three, that the 11 Northwest Coast tribes represented in this exhibit all share the message that lies at the heart of the NMAI: "we are still here." (2006, 131)

Jonaitis's assertions are significant in several ways. First, in terms of genre expectations, she points out how the *Listening to Our Ancestors* exhibit better fits what audiences are likely looking for and, if anything, hits the nail on the head according to what McMullen described—there is something for the object-oriented visitor, for the ideas-oriented visitor, and for the people-oriented visitor. In terms of the genre of the exhibit, it works because it is clearer (and more direct in its message) and lines up better with what visitors expect a museum to do. Second, the exhibit is also in line with Tayac's observations about the direction the museum is going in, especially in the blend of ethnographic research and community voices. In particular, the section of the exhibit devoted to explaining the actual process of consultation reveals the cooperation in the meaning-making process in a way digestible to the same kind of audience that balked at the idea of the Making History alcove in the *Our Peoples* exhibit. Both exhibits demonstrate meaning as co-made, but *Listening to Our Ancestors* appears to work less with outright cognitive dissonance and tries to meet visitors where they are by demonstrating how such meaning is made rather than simply challenging visitors to do it. Finally, Jonaitis argues that the assertion of "we are still here" successfully resonates throughout the exhibit, and thus the intent of the original mission has been maintained. Whether the visitors actively engaged with the material on a personal level is still a question; while Jonaitis observes that the contemporary political statements several of the Native communities made might provide more depth for visitors who stop to consider, there is also the distinct possibility of visitors opting out of engaging the tougher material in favor of seeking out parts of

the exhibit for their aesthetic appeal. But perhaps the point is that the option to engage—the opening—is there.

As an additional example, McMullen also pointed to a recent exhibit on display in the NMAI's changing gallery: *Cerámica de los Ancestros: Central America's Past Revealed*, displayed from March 2013 to February 2015. The exhibit included 160 objects from the Central American collections of the NMAI, and sought to "illuminate . . . complex civilizations, each with unique, sophisticated ways of life, value systems and arts. The ceramics these diverse communities left behind, combined with recent archaeological discoveries, help tell the stories of these cultures and their achievements" ("Ceramics Provide a View" 2013). Including objects from the areas that are now Belize, Guatemala, Honduras, El Salvador, Nicaragua, Costa Rica, and Panama, the exhibit was the NMAI's first major bilingual exhibition, in English and Spanish. McMullen has observed that one of the challenges with the NMAI's vast collection is using its Latin American items, insofar as many visitors do not recognize Latin America's Indigenous heritages and misperceive the mission of the museum as focusing only on Native peoples within the geopolitical boundaries of the United States. To those visitors, anything to do with Native communities outside those boundaries is confusing.

The rhetorical goals of *Cerámica de los Ancestros* therefore included complicating visitors' understanding of "American Indian" to include all Indigenous peoples in the Americas and, in this case, highlighting cultural contributions from Central American Indigenous communities. Like the *Listening to Our Ancestors* exhibit, *Cerámica de los Ancestros* attempted to blend the expected scholarly voices with Indigenous representations and to connect the collections with past and present Native communities, although the differences in collections created basic differences in display. *Cerámica de los Ancestros* began with a general explanation of what a visitor would see, the importance of ceramics as archeological and historical objects, theories about their use, and a large panel primer of animal figures and photographs of actual animals to help a visitor decipher what they would see. During my 2014 visit, I observed the exhibit had a fairly clear path through the space, coded by geographic region and culture, informed by both Native and non-Native specialists in archaeology, anthropology, and the history of collecting these objects. A "Gallery Guide for Young People and Their Families" (2013) was available in both English and Spanish, and each page contained the sections "Make a Connection," "Fun Fact," "Find [a specific object] and Discuss," and "Key Words," to orient visitors

(ostensibly children, but really anyone who seeks a basic understanding) to the ideas the exhibit wished to impart. The effort to engage non-Native audiences in the educational endeavor was clear.

The exhibit also functioned to connect with the Central American population in the Washington, DC, area and, in McMullen's words, sought "to give them a sense of patrimony" over the collections on display. Anecdotally, she has observed that these visitors seemed happy with the exhibit, though she was skeptical about the degree to which they feel connected to or represented by the NMAI (2014). Unlike *Listening to Our Ancestors*, this exhibit is not, as Jonaitis described above, a series of community self-portraits, and instead relies quite a bit on the traditional museological authority invested in archaeology and anthropology. While non-US archeologists' and anthropologists' voices are present in the exhibit, the focus on the ancient objects and the lack of the kind of community curatorship found in *Listening to Our Ancestors* draw more attention to the past, and thus could do less to communicate that these Indigenous communities are still present as significant political and cultural entities and more to emphasize this is important cultural history to these present-day countries. McMullen notes that the tension between nationalism and Indigenous identity was present in the exhibit—even if it is not precisely addressed, for that is a topic for discussion in itself—and because of that tension she was uncertain whether or in what ways visitors understood the exhibit past an interesting display of objects. As McMullen puts it, "If the inaugural exhibitions were not entirely successful, . . . was it a good message, and we executed it poorly? . . . If we can't afford to do community consultation [on the same scale], and we stop doing that and do more object-based exhibits, did we lose the baby with the bathwater? These are hard questions" (2014). In the meantime, *Cerámica de los Ancestros* continued the effort to find different ways to meet audiences and communicate to them, and the contrast in display, in part a result of the objects and subject material, demonstrates the new challenge each exhibit presents for creating legible sovereignties.

The *Listening to Our Ancestors* and *Cerámica de los Ancestros* exhibits each illustrate the difficulties in shifting direction and the flexibility in rhetorical approach necessary for creating legible sovereignties. They share some similarities in approach and rhetorical strategy with clearer, more linear layouts and a more didactic approach, with traditional museum authority used for support. However, what the brief descriptions above also make clear is that each set of objects, each community or country involved,

each story that could be included or excluded presents a range of rhetorical choices that, in combination, will produce unique exhibits with different rhetorical resonances. Though that may seem like a statement of the obvious, it deserves some consideration: rhetorical sovereignty will look different depending on the rhetorical situation and the materials and audiences one works with. The *Cerámica de los Ancestros* exhibit could not—and, given the material and its origins, should not—use the same template as *Listening to Our Ancestors*. This means the execution of the NMAI's mission and its communicative goals will find a different rhetorical filter in each exhibit mounted, and therefore making the communication work, making it legible, will take new consideration each time. Each new collection of objects and the stories that come with them will prompt a rethinking of how to meet the needs of the Native and Indigenous communities involved, of the visitors who come to the exhibits, and of the institution at large, producing a new iteration of legible sovereignty each time.

The First of Major Changes for the Inaugural Exhibit Spaces: Nation to Nation

As of this writing and my follow-up visit in the fall of 2014, the replacement plans for the inaugural exhibits have long been under way, and *Our Peoples* has now been removed and replaced with the new *Nation to Nation: Treaties Between the United States and American Indian Nations*. Opened on September 21, 2014, and set to run through spring 2020, *Nation to Nation* attempts once more, on a larger scale than the changing exhibits, to assert "we are still here" in a way that uses the experiences and feedback since the NMAI's opening to better reach NMAI audiences and thereby assert legible sovereignties. Here we examine how the *Nation to Nation* exhibit illuminates the current approach to seeking legible sovereignties in how it tries to answer the NMAI's past critics in a meaningful way.

 In an interview with Fred Hiatt of the *Washington Post*, Gover describes the exhibit as a corrective to the problems in education about American Indian peoples, reflecting the sentiments of his anniversary essay on the NMAI's website. This idea also finds articulation in the official exhibit description on the NMAI website:

> From a young age, most Americans learn about the Founding
> Fathers, but are told very little about equally important and

influential Native diplomats and leaders of Indian nations. Trea-
ties lie at the heart of the relationship between Indian Nations
and the United States, and *Nation to Nation: Treaties Between the
United States and American Indian Nations* is the story of that
relationship, including the history and legacy of U.S.–American
Indian diplomacy from the colonial period through the present.
("Nation to Nation" 2014)

This statement subtly but directly addresses some of the major
critiques of the inaugural exhibits. First, by taking treaties as the "heart"
of the exhibit and the histories it tells, it makes a strong link between
many visitors and the material: whether you are Native or a non-Native
American, treaties affect policy, which in turn affects you. Relevance is
established from the beginning. Second, the kind of relevance created will
differ according to the viewer, and in making it clear that it is "nation to
nation," not United States to tribes, the language of the exhibit affirms not
only "we are still here" for Native communities but also "we are a force to
be reckoned with." Relevance for the non-Native viewer is also constructed
through the framing of education, in that potential viewers' interest may
be piqued by the idea that in this space they can have access to stories that
their education failed to tell them. What goes unstated, at least on the
website, are the ways that the uglier chapters and difficult truths of history
will be considered, in ways the inaugural exhibits did not.

Curated by scholar and activist Suzan Shown Harjo, *Nation to Nation*
is organized in five sections: "Introduction to Treaties," "Serious Diplo-
macy," "Bad Acts, Bad Paper," "Great Nations Keep Their Word," and
"The Future of Treaties." The historical arc first introduces the visitor
to the history of the treaties and a sampling of the treaties themselves;
then takes the visitor through the darker history of how the treaties were
used, misused, and broken in order to deprive Native nations of their
lands; and finally, explains contemporary Native nations' life and contin-
ued existence. The 125 exhibited selections from the NMAI collections,
National Archives, and tribal archives include actual historical documents,
images, maps, wampum belts, peace medals, pipes and pipe bags, and
other objects that illuminate the treaty-making process between distinct
cultures. Initially, the exhibit featured the Treaty of Canandaigua of 1794
between the Haudenosaunee and the United States, which was rotated
out to focus on eight other major treaties through the life of the exhibit.

Overall, the exhibit features thirty-seven tribes from the United States and Canada ("Fact Sheet" 2014). Labels chronicle the history of the treaties, strategically providing both Native and non-Native viewpoints on the land in question, what the stakes were, who was negotiating, and what the outcome for each treaty was. The sources for the exhibit include input from Native and non-Native experts in law and history, in addition to archival materials.

The educational strategy of the exhibit differs from others that have been mounted in that it is neither trying to invoke complete cognitive dissonance, in the sense of the Making History alcove from *Our Peoples*, nor wishing to fall back into a pedantic explanatory voice. Instead, NMAI education expert Ed Schupman explains, they decided on a technique already well-known: "inquiry-based learning" (Schupman 2014). If the NMAI learned a hard lesson about too much flexibility with visitors who did not know enough to make much of the inaugural exhibits—and if, as Schupman puts it, "the 'telling' approach is not the most effective educational strategy and often results in something my mother used to characterize as 'going in one ear and coming out the other'"—then a third way is necessary. Schupman writes, "Inquiry-based learning begins with something that is compelling—for example, an image, a question, an object, or a

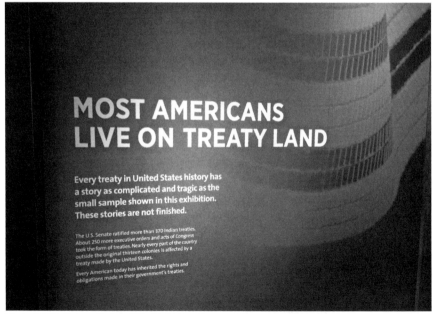

Fig. 13. NMAI. *Nation to Nation* exhibit label. November 2014. Photo courtesy of the author.

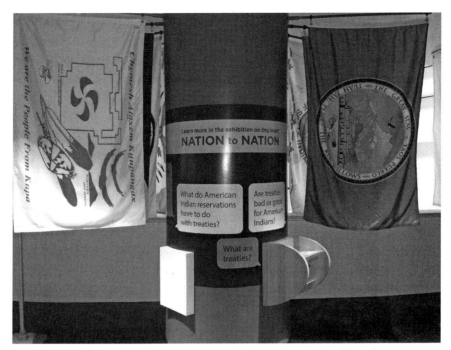

Fig. 14. NMAI. *Nation to Nation* exhibit teaser kiosk. November 2014. Photo courtesy of the author.

combination thereof—then encourages people to explore it." In the case of *Nation to Nation*, this means putting teaser stations around the museum to draw visitors into the exhibit itself, an important technique, given that the main exhibit galleries are upstairs on the third and fourth floors and not near the entry. Within the exhibit, in addition to the object displays, this means creating stations that pose questions that visitors might have and then providing several ideas or images that help the viewer think through them (Schupman 2014).

Nation to Nation does take a distinctly different tack from the inaugural exhibits and reflects Gover's, Tayac's, and McMullen's observations. The teaser stations begin with questions such as "Are treaties still valid?" or "Do American Indians have special rights?" to entice visitors with questions they already have, even as the stations are framed by the national flags of multiple Native nations as a kind of statement, an affirmation of presence that witnesses these questions. Gover wishes to educate the broader public, and the exhibit in many ways is a basic yet intense "Treaty 101" course to introduce visitors to historical narratives on foundational treaties, and the processes of making and upholding them, that visitors do not know, especially from Native perspectives. It attempts to meet the

non-Native public where the NMAI now estimates it to be. The exhibit also contains a mixture of "expert" and Indigenous perspectives in an effort to create the museological authority that so many visitors found missing from the inaugural exhibits, thus fulfilling genre expectations of voice within the exhibit and potentially making the information more palatable and accessible. The information is also patterned carefully in its presentation, to routinely clarify the land in question for each treaty example, who was involved, what the stakes were, who the negotiators were, and what the outcome of the treaty ultimately was. For instance, the Lenape Treaty of 1682 is featured in the first section of the exhibit, and its panels organize its material by "Land," "Negotiators," "Treaty," and "Aftermath." In each of these panels, the voices of each party are labeled by "Viewpoint," and so readers are encouraged to see the negotiations of the featured treaty from multiple perspectives at each step. The labels are accompanied by maps of the land in question and objects that help represent the spotlighted Indigenous cultural heritage and/or the treaty-making process itself; in this exhibit, for example, there are two wampum belts that preserve the event of the 1682 land agreement with William Penn. In this way, objects are frequently part of the narrative, satisfying the general desire to see more objects from the collections in context. The rest of the exhibits are structured similarly. Even if a visitor does not read every label for every treaty, the larger narrative pattern emerges as a visitor moves through the exhibit space. There is some confusion over where one is supposed to start the exhibit—the *Nation to Nation* exhibit now occupies the space that *Our Peoples* did—though the clear historical progression of *Nation to Nation* does quickly make it obvious if one is going the wrong way.

So far, published public reaction demonstrates greater visitor satisfaction. Philip Kennicott's *Washington Post* review for *Nation to Nation* was broadly positive, and made a direct comparison to the inaugural exhibits and what he perceives as the NMAI's achievements in avoiding the problems those exhibits had (2014). Rather than creating "the ultimate postmodern museum experience, with no central narrative, no omniscient voice and no absolute appeals to the voice of science and history" as he puts it, the *Nation to Nation* exhibit "falls squarely in the mainstream of exhibit design"—and he very much likes it. From where he stands as a visitor and a critic, *Nation to Nation* provides a "clear and compelling argument"

with appropriate historical and object-based support that leads a visitor to consider the "intriguing and often maddening details of history" (2014). He finds the contrasting viewpoints in the labels and the addressing of tragedy satisfying, though he does wish that "posing the obvious hard questions that non-Native visitors should contemplate" had occurred more directly, and he calls the final section a "feel-good" celebration that is a "holdover" from the previous exhibits. Yet even as he is praising the general clarity of the exhibit, he voices concern at the end that perhaps "the fundamental perspective is now much closer to the master-narrative style of Western intellectual discourse; the spoken word gives way to text-dense written panels. With the introduction of a standard museological approach into the NMAI, one begins to miss the old multivalent style of the exhibitions a decade ago" (2014).

Rothstein has also contributed a review of *Nation to Nation* for the *New York Times*, and finds more to laud in this exhibit than the inaugural exhibits that he still refers to as an "intellectual catastrophe" (Rothstein 2014). He appreciates *Nation to Nation* as what he calls "the first histori-cally serious chronicle to be mounted at this museum," though he is still concerned that it doesn't go into enough complexity on the subject of treaties or do enough to address what he perceives as the treaties' "ben-efits" to Native nations. All in all, however, he demonstrates at least a degree of appreciation for the direction he sees the NMAI taking.

It might be easy to throw up one's hands in frustration—there appar-ently is no way to completely please the critics—and both reviews provide criticisms that in some ways contradict each other. This may say more about the critics than about the exhibit and, in rhetorical terms, about the difficulties that still exist in reaching a variety of audiences. In this case, Kennicott represents the visitor who wants a clear narrative but more of Native voices, while Rothstein stands in for traditionalists who still do not grasp Indigenous peoples as having legitimate perspectives that are just as significant as accepted historians or anthropologists. Kennicott's review, too, points to the working tension that the NMAI faces every time it mounts an exhibit: how to balance the articulation of Native voices with the expectations of a non-Native audience. What both reviews help dem-onstrate, and what my own reading of the exhibit shows, is that *Nation to Nation* further reveals some of the strategic rhetorical consequences for understanding legible sovereignties in action.

Conclusions from the NMAI's First Ten Years

Regardless of critical reaction, we can safely say that what the NMAI attempted in 2004 was revolutionary given the history of museological depiction of Native and Indigenous peoples. However, in tracing the rhetorical arc of the NMAI's first decade, what becomes clear is that it is not sufficient to make a site as "Native" or true to its contents' community of origin as possible. While it is a good and necessary start, articulating "we are still here" is not enough. Curators and staff at the NMAI knew their work was only beginning with the mounting of the three inaugural exhibits *Our Peoples*, *Our Universes*, and *Our Lives*, and ten years later the work is ongoing. *Nation to Nation* exemplifies this effort, though at the same time there are no laurels to rest on, nor will there be. Each new idea to be taught or exhibit to be mounted requires a new iteration of rhetorical sovereignty and new strategies to make it legible given the time and place, the target audience, what has come before, and what is now.

Thinking in terms of legible sovereignties through the NMAI's first decade yields a number of observations. First, the NMAI has no choice but to work with museum visitors' expectations. Cognitive dissonance is an effective teaching tool, to a point, but in hindsight *Our Peoples* may have gone too far. The inquiry-based learning provides a direction, goals, opportunities, but allows for visitor choice for how to engage: this means directed choice for how to co-make meaning. Providing more guidance and context leads to more effective goal-oriented learning, and ultimately makes the exhibit and its Native voices more legible. *Listening to Our Ancestors* has been roundly considered a successful exhibit in part because its narrative and direction were clearer, and so far *Nation to Nation* appears to be received positively because it follows similar ideas.

Second, using objects does not have to be capitulation to audience expectation, and when displayed and contextualized well they will assist in learning. This process was begun in the inaugural exhibits through the extensive consultation process, but lacking a narrative to follow, visitors could not grasp the significance of what they saw. In *Listening to Our Ancestors*, the NMAI demonstrated that smaller-scale consultation with object selection could indeed lead to an exhibit that successfully rests on Native and Indigenous voices and satisfies visitor curiosity about objects. *Cerámica de los Ancestros* was perhaps less effective in this respect, given the ancient origins of much of the collection, but it could still use the

objects to link the past to discussions in the present. In *Nation to Nation*, demonstrating how wampum belts and other objects of diplomacy are significant in treaty meaning and not merely decorative helps support the goals of this particular exhibit (in ways that might not exactly work in others).

Third, the NMAI has to meet visitors where they are. If celebration has no impact without historical context, neither will a Native holocaust museum. Because of the clear dearth in US and worldwide education about the Indigenous peoples of the Americas, any museum dealing with Native subject material will have to provide context for discussion. Again, the cognitive dissonance approach assumes that, in some ways, people need to be nudged out of their comfort zones, and to an extent I agree; but, drop someone in the water with little knowledge of swimming, and the odds of him making it back to solid ground are rather slim. When exposing visitors to new and controversial material, they will need some guidance—a contextual, narrative life raft. The contrasting-viewpoints approach in *Nation to Nation* is notable here in how it provides an opportunity to see/hear Native and non-Native voices side by side, to see the dialogue on these subjects played out.

Fourth, as Tayac and others have observed, it does not automatically compromise Native voices to be set side by side with the traditional experts and museological voices. Yes, it may look more like "Western intellectual discourse," as Kennicott calls it, but thinking of it in those terms creates a false dichotomy between "Indians" and everyone else and erases the work of Native curators, Native anthropologists, Native historians, and non-Native allies in these fields. Furthermore, in terms of rhetorical approach, using other "experts" can leverage acceptability. McMullen's metaphor of the op-ed piece versus the regular news sharply reveals visitor perception of Native voices by themselves as just another "opinion." If non-Native visitors are not accustomed to thinking of Native voices as having authority, using Native voices by themselves looks like that "capitulation" to "revisionist history" that does demonstrate the ignorance of the viewer but does little in the end to bridge it. By putting Native voices side by side with voices of authority as central to the discussion but not excluding all others—at least, as appropriate—the rhetorical effect is to elevate Native voices in non-Native visitors' eyes. The question of whether we should wish for such elevation is entirely relevant, but place is also a factor here: at the Smithsonian, can it be done any differently? Are there things that

tribal museums can do, and that visitors might even expect there, that the Smithsonian and the NMAI cannot?

Finally, if Kennicott's reaction is any indication, addressing the controversy and pain of history is important. Done well and brought full circle, it will enhance visitor understanding of history and the significance of Indigenous peoples' lasting and continued presence. *Listening to Our Ancestors* had some of this woven through it, as individual communities chose to address the effects of colonization and the outlawing of the potlatch ceremonies on their communities, but also brought their narratives into the present. Likewise, *Nation to Nation* endeavors to take on the larger narrative of treaties and injustice in the United States and does so directly through the series of displayed treaty histories and Native nations' efforts, then and now, to establish themselves as entities to be taken seriously.

It is possible to argue that the NMAI is going backward with the more direct exhibits that appeal to more authoritative voices, and it is reasonable to expect limits on what the NMAI can actually do as a federally owned museum. At the same time, believing the NMAI to be just another government museum is also erroneous. Scott Richard Lyons's work in *X-Marks* (2010) points out that an "x-mark" on a treaty is a sign of assent, of actively making a choice even in bad circumstances. To even use the communicative structure of a museum as a means to speak can be perceived as a capitulation, a form of assimilation. But understood in this way—that the NMAI is an x-mark at the Smithsonian—may help set realistic expectations for what it can actually do without dismissing what significant changes it can make.

Perhaps a better understanding of what the NMAI has accomplished and continues to work toward is as a form of rhetorical sovereignty that deliberately seeks to engage non-Native audiences, to indigenize a form of communication that does have its limits but that, by virtue of its familiarity to those audiences, makes itself more legible to them. By its very nature and its rhetorical situating, the NMAI's rhetorical goals must be different than those of a tribal museum or a smaller local museum. At the same time, the NMAI continues to refine its approach to become more effective in the situation it is in; the *Nation to Nation* exhibit is already doing courageous work that was not yet possible ten years ago, when "sovereignty" wasn't even a topic considered by the exhibits except as individual communities insisted on using the word. Legible sovereignty

will not happen all at once; it will be a progression, development over time, education in the long haul, and an ongoing process of meeting the needs of the moment, the audiences of the time, with the materials at hand.

Conclusion
Openings for Legible Sovereignties

There is for me always a sense of both contentment and regret when I leave one of these museums or cultural centers: contentment in having borne witness to frequently beautiful acts of self-representation, however terrible the truths they speak; regret in knowing that I have to leave and knowing that it will change behind me. When I go back next it will not be the same. Yet as a matter of course, it shouldn't be. In this way, it is strange to write a conclusion here, particularly because, as I write, each of the sites discussed here is already moving along, doing more, and continuing to refine their practices in articulating legible sovereignties.

It might be better to think of this as a resting place to consider, in sum, what a rhetorical analysis of the past ten years can show us (the scholars, the community members, the visitors) about how enacting legible sovereignties shifts over time and space in response to community and audience needs. This rhetorical analysis has attempted to reveal the nuances between speaker-display and its audiences through stated intentions and actual effects, the institutions' reactions to audience feedback, and their continued work. The advantage of a rhetorical analysis like this is that it can provide not just theoretical justification for Native and Indigenous self-representation, but also on-the-ground analysis of how it happens and how it must strategically shape and reshape itself. To illustrate this further, in the following I provide a brief comparative look at what the Ziibiwing Center, the HCCM, and the NMAI have accomplished and where they have struggled, and an update on what each of them is now doing at the time of this writing.

In the introduction, I outlined the key ideas for a framework that supports the legible representation of rhetorical sovereignty, with the proviso that what "rhetorical sovereignty" will look like and what needs to be done for the sake of legibility will change according to the time and the museum or cultural center site. What works for one place will not function well for another; what a set of audiences need at one site will be different for the next site. However, there is some unity in the process of shaping rhetorically sovereign communication. To recap, in thinking through legible sovereignties as a framework for rhetorical action, we can

1. take Indigenous self-determination in communication first and foremost as the primary goal;

2. understand and examine the communicative intent of a given act or display in support of the represented Indigenous communities;

3. observe how the communicative act functions in reality—that is, assume it does generate multiple meanings for different audiences and take those multiple meanings into consideration of its total effect;

4. analyze the tensions between the communicative intent and the multiple meanings generated; and

5. provide constructive rhetorical critique toward eliminating disconnects and strengthening communicative alliances between communicative goals (and the community they represent) and audiences.

The Goal Is Indigenous Self-Determination, The Intention Is to Speak

At each of the sites covered here and in each of their major exhibits, each institution is attempting to make a rhetorically sovereign statement about the community it serves or represents. What is quickly clear, however, is that the context—the site itself, the time in which it speaks, the reasons for speaking in that time and place—all influence how rhetorical sovereignty becomes embodied in the exhibits. For example, at the Ziibiwing Center, long-standing community desire and immediate post-NAGPRA need were primary driving forces in the creation of the Ziibiwing Center. As a result, the articulation of rhetorical sovereignty came directly from the Saginaw Chippewa Indian Tribe, and the goals of the Ziibiwing Center and *Diba Jimooyung* are to maintain local Anishinabe knowledge and history and

educate the home community about them. Outside audiences are welcome to join, and it is the hope that, through this education, tribal members, other Anishinabek people, and area communities will come to recognize the value and importance of Saginaw Chippewa history, culture, and place. Particularly because the Isabella Reservation has been a site of contested histories and ownership, the Ziibiwing Center's existence and goals seek to firmly establish Saginaw Chippewa voices within the discussion and on that land.

Meanwhile, at the HCCM, a historical institution representing 150 tribal nations found itself in need of a way to trace and preserve its history. The HCCM now houses and protects the Haskell archives, and the *Honoring Our Children* exhibit captured that desire for retrospection from Haskell's origins as a boarding school to its support of Native cultures and students today. More than only a repository or site for display of history, though, the HCCM stands as a space intended to encourage students to confront the boarding school histories that still resonate for many Native families and communities. The articulation of rhetorical sovereignty therefore comes in part from the desire to remember and document this history, but then also show how Haskell students over time have turned the purpose of school to serve them and their communities. Additionally, the HCCM was intended to stand as a bridge between the past and the present and between the Haskell community and the Lawrence and Kansas City–area audiences.

On the national and international stage, the NMAI attempts to represent the voices of two continents and an entire hemisphere of Indigenous peoples and nations. Its ambitious attempts at reforming museological practices on such a scale have resulted in both praise and criticism from multiple camps, Indigenous and non-Indigenous, pointing to the necessity of reevaluating goals, techniques, and audience needs in order to best represent the Indigenous communities it works with. The three inaugural exhibits, *Our Peoples*, *Our Universes*, and *Our Lives*, were far from failures, but they revealed the complex ways that self-representation finds expression and the need for self-reflexivity when that expression does not resonate with—or is not even legible to—its audiences. *Nation to Nation* represents the first large-scale attempt to rearticulate legible sovereignties with the understanding gleaned from reactions to the inaugural exhibits, and its successes reflect both the rhetorical progress being made in articulating legible sovereignties and the need to keep reassessing what constituent communities and audiences need.

A brief cross-comparison of these three institutions with regard to legible sovereignties helps illustrate how much the context, site, and differing needs of communities influence the different forms a legibly sovereign statement will take. With regard to taking Indigenous self-determination in communication as the primary goal, it can be safely said that each of these institutions does this. At the same time, context requires that it happen in different ways. At the Ziibiwing Center, a community-oriented approach grown from the community's long-expressed desire to articulate its own history among many Saginaw Chippewa has shaped the path of *Diba Jimooyung*. The center's location, alongside the town of Mount Pleasant and within the long history of conflict and discrimination there, highlights the need for a functioning site of public outreach and makes the Ziibiwing Center's message and mission relevant for the present and the future for the sake of staking Saginaw Chippewa claims to existence, to culture, and at times even to sovereignty under the law.

At the HCCM, self-determination takes the shape of narrating Haskell's evolution from boarding school to a unique pan-tribal, Native-supporting institution of higher education. The need to speak here is closely tied to preserving that history and articulating it for students, faculty, and surrounding communities so that it can be remembered and not forgotten. But more than simply preserving history, the process of mounting and maintaining *Honoring Our Children* has provided the means for students and faculty to come to grips with that history; in speaking it, the exhibit has the potential to provide a site for healing and motivation. For the wider surrounding community, the exhibit stands as a reminder of a history that is all-too-often sidelined in favor of more palatable narratives about the region.

At the NMAI, the need to self-represent is situated on the National Mall in the United States' capital city, among the long-standing historical narratives that freeze or erase Native peoples in time, at the epicenter of legislative power. It is also a tourist city that attracts millions of visitors a year, and thus is both a national and global platform for Native and Indigenous voices. The NMAI's initial goals were therefore to purposefully overturn traditional museological practices in that space in order to support Native voices in as many ways as possible. In this way, self-determination was meant to be the driving force in the inaugural exhibits, even as the NMAI fought its inherited legacy from other major museological institutions and the concomitant expectations of visitors.

In connection with taking Indigenous self-representation as the primary goal, the second point—concerning how we examine the communicative intent of a display in support of Indigenous communities— directs our attention to how self-determination happens through these communicative acts. At the Ziibiwing Center, *Diba Jimooyung* is a focused, community-based telling of Anishinabek migration and settlement in the area, as well as the events from the last century. By taking control of the historical narrative and using the exhibit as a place to exhibit land and legal sovereignty, the exhibit functions as a way to make a very specific rhetorically sovereign statement aimed at educating visitors from a Saginaw Chippewa perspective. Similarly, the *Honoring Our Children* exhibit at the HCCM draws from its own archives and collections to tell its own story on a site that once was meant to erase Native voices, at least Native voices that challenge the narrative of assimilation. The HCCM also becomes a space for students to interpret for other students, and opens the possibility for celebration of survivance in the face of the assimilation narrative. The NMAI, in part because of its more visible platform and national/international orientation, meant to stage a challenge to the national historical narrative about the Indigenous peoples of the Western hemisphere in order to support Native communities' voices and collaborative narration of history. By calling into question what visitors desired of museums and then opening the space for collaboration with multiple Indigenous communities, it desired to illustrate self-determination within the museum on a wide scale.

From the first two points, from the frame above, we can see that there may be broad shared conceptual goals—of self-determination and the support of Native voices—but how that takes shape will be heavily determined by local contexts, local histories, and the specific goals that sites produce. Rhetorical legibility must be considered within those particular elements, and self-determination will shape-shift accordingly.

Reactions and Tensions

While intentions may be good, and the goal of self-determination an admirable one, the previous chapters have illustrated that stated rhetorical intentions and actual rhetorical effects do not always align—sometimes in unanticipated ways. At the same time, these effects are often learning opportunities that can help an institution understand more about its visitors

and their needs in order to make exhibits, displays, or the museum/cultural center as a whole more legible.

At the Ziibiwing Center, *Diba Jimooyung* functions well for tribal members to support their education, and museum programming is consistent with that educational goal. The awards and recognition at the state and national level reinforce the sense that Ziibiwing is doing well, and tourists from out of town leave positive remarks and reviews for other travelers. At the same time, the discrimination study and the ongoing work at Central Michigan University illustrate that local communities in the area, and particularly Mount Pleasant, still do not always have the educational resources they need to fully understand their Saginaw Chippewa neighbors' history, culture, and ongoing presence. At the HCCM, the initial impact of the exhibit was positive in part because of its novelty: as the first of its kind, it was doing groundbreaking work for the university community as well as the local and regional audiences, and was celebrated accordingly. Over time, however, the *Honoring Our Children* exhibit appears to have led visitors to consider the problems and sadness of Haskell's initial decades quite effectively but, from director accounts, has not consistently led to healing or resolution for the students who see it. Furthermore, the exhibit seems to have lost its immediate currency, and its story has fallen into physical and rhetorical neglect. Meanwhile, as was amply documented, the NMAI's initial efforts with the inaugural exhibits were met simultaneously with celebration and strong critique for multiple reasons, as detailed in chapter 3. The large national and international stage was both an asset and a challenge in that there were so many more audiences to take into account: participating Native and Indigenous communities, observing Native communities who were not included in the exhibit, activist groups, scholars, non-Native reviewers, and non-Native visitors.

It would be an accurate observation that a given museum cannot be all things to all people all of the time, yet I would argue that a museum can always be doing more to make its exhibits more accessible—more legible—over time, to respond to audience needs in a given moment in time. Identifying and analyzing the rhetorical tensions at a given site can help reveal strategic ways to respond and adjust the statement of self-representation for a museum's audiences. At the Ziibiwing Center, the disconnect between the Saginaw Chippewa community and Mount Pleasant was abundantly illustrated by the discrimination study

and by the legal case contesting the Isabella Reservation's borders. The narratives of colonial rights and dominance are still present, and while Ziibiwing's existence provides a tangible counter-narrative, drawing local non-Native visitors to consider that narrative remains a challenge. Similarly, incidents on CMU's campus over the last ten years indicate an ongoing need for cross-cultural education, which the Ziibiwing Center is uniquely positioned to support.

At the HCCM, the tensions emerge from student struggles to process the grief and horror of Haskell's founding, challenges to maintaining the HCCM's relevance in the present, and practical difficulties in funding for the maintenance of the exhibit and supporting programs. Without promotion, maintenance, and funding to add new exhibits, the HCCM and *Honoring Our Children* have both suffered in the past years, and therefore for a time were unable to sustain a profile as consistently usable and relevant as a gathering site and attraction on campus.

For the NMAI, trying to simultaneously challenge traditional museological practices (and the attendant expectations cultivated in audiences) while foregrounding Native and Indigenous voices created an unevenness to the inaugural exhibits that ultimately caused confusion, celebration, and outrage, or a combination. It was an ambitious project, but one that in many ways was covering new ground without a precedent to follow on that scale. As a result, the discord in the range of responses can be understood as a result of an experiment that was in part successful (in that it did lay a foundation for new work to be done) but also in part ineffective.

In sum, audience reactions over time and the resulting tensions between exhibits and audiences provide new insight into the process of meaning-making and the relative legibility of a given exhibit. What all these institutions demonstrate in their attempts to mount and maintain legible exhibits is the difficulty in being able to estimate what will speak to multiple audiences and how it will resonate with them. At times only some audiences' needs are met, or an exhibit may meet with initial success only to find its relevance fade as audience needs change over time. Additionally, the uniqueness of each site and the very different tensions generated in each context point to the ways in which rhetorical legibility, and therefore rhetorical self-determination, is a highly localized act. What works at one site will not transfer well to another, and problems that arise in one place will not necessarily be an issue elsewhere. Much depends on

the context, history, and needs of the constituent community (or communities) and the visitors.

Constructive Critique toward Legibility and Alliances

The tensions arising from audience/visitor feedback can be understood as a potential positive when they are used to generative effect, as each of these institutions demonstrates. Over the course of their first decade, they have all had to adjust, or at least plan for adjustments, to make Native and Indigenous self-determination legible and relevant to target audiences. Rather than conceptualizing a museum and its exhibits as an entity on a linear trajectory, with hurdles to overcome and obstacles to surmount toward a single goal, it is more productive to think of them as living institutions that are constantly learning and responding to new situations and new constellations of factors.

The Ziibiwing Center, for example, could not have anticipated the role it would play in settling the legal dispute over the reservation's borders, but found itself and its archives becoming crucial in protecting Saginaw Chippewa land sovereignty. The *Diba Jimooyung* exhibit, while generally successful, still seeks local visitors who could benefit from the narrative it provides, and so its surrounding programming has needed some adjustment to serve both the Saginaw Chippewa and regional Anishinabek communities as well as draw in more local audiences from Mount Pleasant and the university by reaching out. At the HCCM, the *Woodland* exhibit was a first major step in doing something new with the exhibit space that did not downplay the importance of the history encapsulated in *Honoring Our Children*. While it was not large or permanent, the *Woodland* exhibit did mark a new occasion—that of a Haskell alumna taking on the university's highest leadership position—and drew attention to the successes of the present and the long-term positive legacy of Haskell. At the NMAI, the *Nation to Nation* exhibit and the techniques used to construct it reflected the museum staff's attention to the feedback and critique generated from the inaugural exhibits. By providing more physical and rhetorical guidance to visitors, by addressing the context of history in many of its hard truths, and by making the story told relevant to non-Native visitors through making their history a part of the narrative, *Nation to Nation* stands as an example of how responding to audience critique can lead to greater rhetorical legibility and therefore better self-representation.

What can generally be said across these three sites is that, as frustrating as critique can be, it takes a first attempt at creation to be able to enter the conversation and promote Native voices at all. The job of the museum is then to respond to audience reaction at the moment of opening, but then also, over time, to support the rhetorical legibility of its exhibits and goals. The Ziibiwing Center has not lost its importance for the Saginaw Chippewa community, but because of its successes for its first priority community, it can now turn its attention to other forms of outreach for other communities. The HCCM and *Honoring Our Children* represented milestones in Haskell's self-telling of its history, and while that history is still important, the students need a fuller understanding of that history, as it endeavors to do now. The NMAI's ambitious first attempts toward large-scale museological and historical change could be dismissed as a partial failure, and yet the very presence of those attempts did still create visibility and they have created the space to do even better work.

Through the frame of legible sovereignties, these institutions' decade of work reveals the various factors involved in the successful communication of Native and Indigenous self-representation to multiple audiences at the same time. Communicative tensions will always exist; even if an exhibit could meet all audiences' needs on the first go and open in a state of rhetorical perfection, audience needs would change over time and the exhibit or museum would have to adapt. Meaning-making will vary down to the level of the individual visitor, and the curator and exhibit designer cannot control how visitors will interpret what they see. For Native and Indigenous communities using museums and cultural centers as stages from which to speak, this means that the act of articulating sovereign self-representations will involve a recognition of living in this state of rhetorical flux. It means the evaluation and reevaluation not just of how they wish to represent themselves, but also of how to make this work for the audiences whose eyes, ears, and engagement they seek. For the Ziibiwing Center, it means finding ways across the deeply ingrained racism and ignorance that so often blocks communication or even recognition of Saginaw Chippewa people as Native people with rights. For the HCCM, it means discovering again what students need now, and making the site a priority for the enhancement of student life on campus, then for the larger regional community. For the NMAI, it means making local, continental, and hemispheric Indigenous narratives clear, accessible, and significant to a large set of audiences. For all these sites, moving in a spirit of both rhetorical

sovereignty and outreach toward audiences over time appears to make the difference in creating legibly sovereign self-representations.

New Work and Legible Futures

The work is never done. This study has attempted to capture in a ten-year span what the Ziibiwing Center, the HCCM, and the NMAI have accomplished toward legible sovereignties, in their own ways, for their own contexts. Yet even as I write they make plans for new ways to speak, and further changes, challenges, and endeavors are in the works.

The Ziibiwing Center plans to continue with the programming that has made the most impact and find ways to enhance that influence in the region and beyond. For *Diba Jimooyung*, as already noted in chapter 1, the maintenance work and updates will continue. Two of the three cradleboards for the Blood Memory section are finished and will soon be installed, and other small repairs and enhancements are in the works to keep the exhibit on the cutting edge of display and to support its ongoing relevance as a history-keeper for the community.

With the Saginaw Chippewa acquisition of the Mount Pleasant Indian Industrial Boarding School (MPIIBS) grounds, work will continue on that site to document the school's history and the ongoing ramifications for the Saginaw Chippewa, regional Native, and Mount Pleasant communities. As a place that represents tough and at times tragic stories that involve all of these communities, it will be a continued site for education and dialogue. The *Debwewin/Truth* changing exhibit was the beginning step in bringing the MPIIBS materials into the public eye, though clearly more will be done. Since 2009 there has been an annual day of remembrance to honor those stories, and at the most recent gatherings, the anniversary of the closing of the school has been marked by a public ceremony and tours of the site. The day is sponsored in part by the Saginaw Chippewa community and the Ziibiwing Center, but has included sponsors from CMU and Mount Pleasant (Sowmick 2015; "Honoring, Healing, and Remembering" 2015). Further plans are in development, but it appears that the MPIIBS already serves as a kind of common ground on which several communities may meet to recognize the difficult history there and its present consequences.

The changing exhibit space at the Ziibiwing Center has since housed the *Great Lakes Native American Collection* exhibit, which showcased objects

from the Cranbrook Institute of Science's anthropological collections. By allying with a Michigan museum of natural history, such an exhibit builds a partnership with another museum that has participated in colonial collecting practices and, more importantly, brings the objects into a Native context for interpretation and display. Within the Ziibiwing Center and adjacent to *Diba Jimooyung*, the objects have a better chance of being framed as part of living memory and culture rather than anthropological curiosities. At the same time, by borrowing the accepted rhetorical authority of the Cranbrook Institute, the Ziibiwing Center can strategically raise its profile in non-Native communities that may perceive it as a place only for Native visitors or as a space that does not have the same educational value as a non-Native museum. Additionally, this space has recently hosted the *Walking With Our Sisters* traveling bundle and memorial, which honors missing and murdered Indigenous women in Canada and the United States and stands as a strategic call to action ("Ziibiwing Centre" [*sic*] 2016; "Walking With Our Sisters" 2016). This traveling memorial and its loving display has garnered much praise and attention as a community-based project that raises public awareness of the current crisis in the rate of abuse and death of Indigenous women through the display of nearly two thousand pairs of donated moccasin vamps. As the only US institution to host *Walking With Our Sisters* to date, Ziibiwing strengthens its ties to, and continues its work as part of, a larger Indigenous network across northern North America. Through the *WWOS* bundle's visit, Ziibiwing found yet another new way to carry out its goals for community healing, local education, and self-representation. In total, the changing exhibit space and the acquisition of the MPIIBS grounds create a potential for a constellation of programs and exhibits that appeal to multiple audiences in a variety of ways that all support the Ziibiwing Center's mission and educational goals as well as cross-community alliance-building. Each new offering is a new invitation to these communities to come and learn together.

At Haskell, the HCCM and its funding struggles have become part of a larger conversation about the future of the university itself and its relationship to the federal government. Haskell students, families, and faculty were shocked when the administration announced the need to cancel the 2015 football season and several other athletic programs because of funding problems (Tait 2015). In October of 2015, the subject of severing ties with the federal government altogether was broached, and the *Kansas City Star* reported that the option was actively being investigated by the

university administration. Because Haskell is a ward of the federal government and subject to its jurisdiction, as with other federal agencies, the university is also subject to the same funding cuts and red tape for fund-raising (Hendricks and Williams 2015; Rahder 2014). For example, while Haskell's neighbor, the University of Kansas, saw a 15 percent increase in its funding over the past four academic years because of its fund-raising campaigns and endowments, Haskell saw a mere half of 1 percent increase because of federal restrictions on its ability to raise extra funds. The Haskell Foundation, once defunct, was revived in 2014 and has been working to regain public trust to ease some of the university's financial pain (Shepherd 2014b). The foundation now has its website up and running, and its mission is explicitly to "assist with unmet needs of the university that are beyond appropriate funds provided by the Bureau of Indian Education" ("Haskell Foundation" 2015). Whether or not severing ties with the federal government will be pursued is another matter, though the BIE has to this point been supportive of at least discussing it. Such a move would also need to find support with the Kansas congressional delegation, which may provide further obstacles (Hendricks and Williams 2015).

For the HCCM, Warrington's steady presence has meant a slow revitalization of the space and its activities, even in an atmosphere of institutional uncertainty. Through her efforts on campus, art classes have been offered again at the HCCM (Hasselman 2015), and the HCCM has been developing better promotion through a consistent social media presence that highlights materials from the archives (see the "Haskell Cultural Center and Museum" Facebook page). Even better, Warrington has continued developing new exhibit materials, and in the summer of 2016 mounted a new exhibit celebrating the anniversary of one of Haskell's most important landmarks, the Haskell Arch and Stadium. By all appearances, Warrington's vision to extend the consideration of Haskell's history beyond—but without forgetting—*Honoring Our Children* is well under way. For now, its supporters continue to find ways to keep it functioning on campus, and hints for its future can perhaps be read in the latest (as of December 2015) version of its mission statement:

> The Mission of the Haskell Cultural Center and Museum is to provide Tribal students and communities with programs and exhibitions that enhance the understanding and appreciation of the unique history of Haskell Indian Nations University. The

Cultural Center serves as the leading institution of holistic edu-
cation and intellectual prominence of Indigenous culture and
fine arts, . . . providing the resources for academic research to
faculty and tribal communities. ("About Us" December 2015)

Even more than the previous version of the mission statement dis-
cussed in chapter 2, and consistent with Warrington's work, this articu-
lation of the HCCM's vision projects Haskell as a place with a "unique
history" that deserves preservation but is not the end of the HCCM's
purpose. This particular version also sounds less like the standard museum
statement of its preceding form, and foregrounds the HCCM as an "in-
stitution of holistic education" that is the home and educational site for
recognizing the "intellectual prominence of Indigenous culture and fine
arts." Deleted from this version are references to classes or internships,
though the "resources for academic research" remain. The stated target
audiences are students and faculty, though the Vision Statement maintains
the additional orientation to the general public.

Overall, the HCCM's future is not yet secure, though its value is
unquestioned. These gradual changes—the *Woodland* exhibit, the updates
to the website, and Warrington's hire—indicate that the HCCM is still a
rhetorically viable and important site on campus. The Haskell Foundation
has the power to take earmarked contributions for the HCCM, as indicated
on the HCCM's updated website, and so with successful fund-raising more
opportunities may come. For now, the HCCM keeps its head above water
and does the best it can to recover.

The NMAI continues its work on the national and international stage
as it replaces the second of its inaugural exhibits. The newest large-scale
exhibit, *The Great Inka Road: Engineering and Empire*, takes the place of *Our
Lives* and examines the Inka Road as "one of the monumental engineering
achievements in history" that connects peoples and cultures over space
and time. The online exhibit description frames the exhibit as one that
"explores the foundations of the Inka Road in earlier Andean cultures,
technologies that made building the road possible, the cosmology and
political organization of the Inka world, and the legacy of the Inka Empire
during the colonial period and in the present day" ("Exhibitions: The Great
Inka Road" 2015). One can see the inheritance of previous NMAI exhibi-
tions in this exhibit, as well as what has been learned from them. On the
one hand, *The Great Inka Road* is careful to narrate the cultures that gave

rise to the Inka Empire, the spiritual and cultural significance of the road, the empire's successes, but also the narrative of European invasion, the impact of it, and how Indigenous communities along the road maintain it today; in this respect, techniques and themes developed in the *Our Peoples*, *Our Universes*, and *Our Lives* exhibits remain present ("Exhibition Website" 2015). On the other hand, the stronger orientation to visitor needs, which includes significant background information, explicit discussion of invasion, the inclusion of 140 objects, the interactive multimedia stations, and the blending of academic and Indigenous voices (often in the same person, as with the curators Ramiro Matos [Quechua] and José Barreiro [Taíno]) ("Fact Sheet" 2015), reflects the adjustments that *Nation to Nation* made in the NMAI's approach.

This new exhibit makes contributions in its own right, as well. While *Cerámica de los Ancestros* was the first bilingual exhibit that the NMAI had mounted, *The Great Inka Road* is the first semipermanent exhibit that is in both English and Spanish. The exhibit also includes some vocabulary in Quechua, which orients visitors to precontact languages. As McMullen observed of the previous ceramics exhibit, part of what the NMAI is trying to accomplish is a larger sense of what "Indigenous" means, and *The Great Inka Road* illustrates the largest effort yet to stretch visitors' understanding past the typical North American Plains peoples they likely imagine when they think of "Indian." In a different respect, the exhibit also challenges the notion of the "primitive" Indigenous in how it describes the Inka Road explicitly as a feat of engineering and an accomplishment that rivals anything accomplished in Europe or elsewhere. By covering the science and engineering aspects of the road and its maintenance even today, the exhibit seeks to establish the Inka Empire and the peoples who were a part of it as users and creators of technology that we have yet to replicate today.

Media coverage (other than the Smithsonian's regular promotional articles) of *The Great Inka Road* so far has been largely positive, though the coverage has served primarily as further promotion, and few reviews of the exhibit itself have been published in major outlets. Most pieces simply describe the contents of the exhibit in the same way they might any other exhibit at another museum, sometimes in past tense ("Smithsonian Exploring" 2015) but often in terms of a "great engineering feat" (Dingfelder 2015; "Inka Road Still a Monumental Achievement" 2015). Some science and engineering blogs have covered the opening of the exhibit, again emphasizing the appeal to visitors not just in terms of culture and

history (M. Anderson 2015; "Inka Road Still a Monumental Achievement" 2015; Pittman 2015). North American Native news sources have not given the exhibit much coverage, with the exception of a positive promotional article in *Indian Country Today* ("20 Stunning Views" 2015).

Given a complete lack of critique or backlash such as what happened after the inaugural exhibits were unveiled, one could assume that, because the exhibit so far meets audience expectations, there is nothing to make a visitor feel uncomfortable. The relative distance from the subject material—this is about a different continent, after all—may also lower the perceived threat to visitors' preconceptions of Indigenous peoples. Yet that distance may also create rhetorical opportunities in that, when the threat level is low, visitors are better able to engage with the materials. The education that visitors can receive about Indigenous technological accomplishments and the variety of Indigenous peoples across two continents may require creating more accessible contents even as it reinforces these histories from Indigenous perspectives. Overall, *The Great Inka Road* showcases techniques that may become part of standard rhetorical procedure that the NMAI follows as it mounts new exhibitions.

For the Future

In sum, legible sovereignties as an analytical frame enhances rhetorical analyses of how exhibits function in Indigenous museums. It reveals how the communication from a museum to the public is constantly evolving and still frequently entangled with colonialism. Each articulation of purpose or mounting of an exhibit reads differently depending on context; it is affected by resources, and it has to be continuously revised in order to meet audience needs and maintain relevance. This may seem obvious, but it is not quite so transparent in practice; of course we look to see what other institutions do, but legible rhetorical sovereignty will generally be rooted in place and intention, requiring close attention not just during the process of writing a mission statement or designing an exhibit, but through the process and afterwards. Procedure cannot be taken for granted, and self-reflexive rhetorical analysis with attention to audiences and the desires of the Indigenous communities involved will yield the most effective self-representations. Simply speaking or displaying does not mean the rhetor will be understood. Legibility requires an understanding of the communicative need of the moment, the context, the place; it will need to represent

the involved Native community the way it wishes to be understood; it will have to work with the constraints of the audiences that community wishes to target.

Yet these constraints also offer opportunities. This rhetorical analysis from the past ten years reveals the representational workings within these institutions' exhibits and how they support Indigenous rhetorical sovereignty while also revealing the distinct differences in how each site makes its stories accessible to multiple audiences. The next decade will be telling for the Ziibiwing Center, the HCCM, and the NMAI, as each continues to maintain its relevance and make itself legible to as many of its audiences as possible. Their work also lays the foundation for further questions about where legible sovereignties go from here: for example, what happens when these exhibits travel, if they can? How does a museum outside of the Americas handle a collection indigenous to the Americas in a responsible way for the constituent communities and the local non-Native audiences? In what ways can technology—websites for exhibits, online teaching resources, digital archival collections—enhance access to and legibility of Native self-representation? And what are the limits of museums? If the institution itself builds in expectations for visitors, how far can a museum thwart those expectations, and what other means of self-representation might be more effective or support a given exhibit?

The promising thing about all three of the sites covered in this study is that they are young, and in many respects each represents a new beginning and a new attempt at legible sovereignties that continues to reshape how we think about Native and Indigenous self-representation to multiple audiences. While it would be nice to have a one-size-fits-all solution, or a statement of sovereignty so clear and thorough that it solves the problem of Indigenous self-representation permanently, the rhetorical reality is that each community, each audience, across time, will need something different in order to understand. To be truthful, any form of self-representation, not just museum exhibits, involves a consideration of rhetorical legibility and the ways in which rhetorical sovereignty can be enhanced. The efforts made at each of these sites illustrates one kind of approach (the exhibit), but they are part of a larger rhetorical network of communications across Indian Country and beyond. They demonstrate what kind of work has already been done, and they give us hints for what works and what does not. As they and other museums learn, so can other Native and Indigenous communities and other museums learn from their example—in their

successes, their miscalculations, their reorientations, and their follow-up efforts. They teach us about the rhetorical and educational power of exhibits and the museums and cultural centers that house them. They teach us about the rhetorical processes of communication across communities and audiences in often-tension-filled situations and hard histories. And they teach us about Native and Indigenous peoples' power to self-represent. As a process of negotiation in this complex constellation, the work of making Native and Indigenous self-representation legible is never finished, and so in the coming decades we will continue to see how they evolve to meet the new exigencies that will inevitably arise. If the impact they have made so far is any indication, then the future will be a challenge, but that future is full of potential for articulating legible sovereignties.

Notes

INTRODUCTION

1 A note on terminology: I use tribal affiliations wherever possible, but in general discussions of communities within the United States, I use "Native" or "Native American," and for broader discussions that move beyond the United States I use "Indigenous." However within chapter 3, because the NMAI uses "Native" and "Indigenous" interchangeably, I do the same. "Communities" is also a term of choice here to refer to all the ways in which Native peoples are organized, whether they are federally recognized, state recognized, seeking recognition, resisting categorization, urban, mixed, and so on. Where appropriate, I refer to communities by name. All emphases in quotations are original unless otherwise noted.

2 I use the term "constellation" here and elsewhere in this text as a purposeful metaphor that sets ideas and disciplines in multidimensional relationship to each other rather than as "intersections" that imply single moments of meeting or crossing. See "Our Story Begins Here: Constellating Cultural Rhetorics," by Malea Powell, Daisy Levy, Andrea Riley-Mukavetz, Marilee Brooks-Gillies, Maria Novotny, and Jennifer Fisch-Ferguson, in the October 25, 2014, issue of *Enculturation*, at http://www.enculturation.net/our-story-begins-here.

CHAPTER 1

1 It should be noted that, through historical circumstance, part of the city of Mount Pleasant is technically on the Isabella Reservation, but it is predominantly white. Outside of Mount Pleasant is generally perceived to be "Indian territory."

CHAPTER 2

1 The installation of the medicine wheel in the HCCM was recommended by Kiowa elder Marilyn Bread to "balance the campus," with a medicine wheel on its south and then north sides.

2 To Rahder's knowledge, the tribal archives and museum management courses ceased for the most part when she left Haskell in 2003; the Records Management course she designed with Dan Wildcat in 2004 is still being taught in the AMS program by an adjunct faculty member in conjunction with the national Archives Records Administration in Kansas City and the American Indian Records Repository in Lenexa, Kansas.

CHAPTER 3

1 Technically the fourth permanent installation, called *Return to a Native Place*, is in a small series of kiosks on the second floor, next to the elevator. It exists to document the history of the NMAI site as a Native space with a Native history; however, because of its comparatively small size, and the lack of emphasis on maps and publicity literature, the focus of this chapter remains on the three major inaugural NMAI exhibits.

2 This is the original grouping of Native communities at the NMAI site; between May 2007 and the exhibit's closing, two new communities, the Blackfeet Nation (Browning, Montana, USA), and the Chiricahua Apache (Mescalero, New Mexico, USA) were rotated into the exhibit space. ("Exhibitions: Our Peoples: Giving Voice to Our Histories," http://nmai.si.edu/explore/exhibitions/item/?id=828.)

3 The term "survivance," from *Manifest Manners* is key to Gerald Vizenor's understanding of how *"indian"* simulations are overturned; however, the term is not defined or attributed to him within the exhibit.

4 Orthography is not entirely consistent across Anishinabemowin-speaking communities, so both "Anishinaabe" and "Anishinabe" appear in this text, as preferred by the named groups.

5 By Preston Singletary (Tlingit), 2003.

6 By Ed Archie Noise Cat (Salish), 2003.

7 By Larry Beck (Chnagmiut Eskimo), 1972.

8 By Gail Tremblay (Onondaga/ Mi'kmaq), 2000.

9 By Teri Greeves (Kiowa), 2004.

10 By George Longfish (Seneca/Tuscarora), 1981.

11 Though the labels written by the NMAI curators do not address "sovereignty" specifically—instead, "self-determination" is most often the term of

choice—the word and idea of "sovereignty" does appear in labels written by some community curators, most overtly in the Kahnawake section.

12 Isaac's "genres of expectancy" should not be confused with rhetorical genre theory, which is a developed line of inquiry in rhetoric studies, as discussed in the introduction. Rather, she uses her own term in quotation marks to indicate "preferred ways of doing things and which are easily recognized by an intended audience" (2008, 243). In terms of rhetorical genre theory, this would be the genre knowledge leading to generic expectations about museums that a visitor would bring with them—that knowledge is not a genre in itself, as Isaac seems to frame it, and instead is part of the functioning of the genre.

13 By Smith's definition, "cognitive dissonance" is "defined as a psychological conflict resulting from incongruous beliefs and attitudes held simultaneously. That's what happens when you tell visitors of [American] wealth Europeans had never imagined" ("Monthly Curator Series," 5). Though Smith does not provide a citation for "cognitive dissonance," one may assume his is derived from Festinger's original concept.

Bibliography

"About the CMU and Tribal Relationship." 2015. Office of the Provost, Institutional Diversity. Central Michigan University. https://www.cmich. edu/office_provost/OID/NAP/HP---ToBeAChippewa/Pages/CMU_and_Tribal_Relationship.aspx.

"About the National Museum of the American Indian." 2007. National Museum of the American Indian. http://www.nmai.si.edu/subpage.cfm?subpage=vis itor&second=about&third=about.

"About Us—Haskell Cultural Center and Museum." 2015. Haskell Indian Nations University. http://www.haskell.edu/cultural-center/about.php.

Albright, Andrea. 2001. "Haskell Dedicates New Building." *Topeka Capital Journal*, July 28. http://cjonline.com/stories/072801/kan_haskell.shtml.

American Indian Boarding Schools: An Exploration of Global Ethnic and Cultural Cleansing. 2011. Curriculum Guide. Mount Pleasant, MI: Ziibiwing Center of Anishinabe Culture & Lifeways. http://www.sagchip.org/ziibiwing/ planyourvisit/pdf/AIBSCurrGuide.pdf.

Anderson, Gail, ed. 2012. *Reinventing the Museum: The Evolving Conversation on the Paradigm Shift*. 2nd ed. New York: Altamira.

Anderson, Joyce Rain. 2015. "The Truth about America's Story: Decolonizing Static Histories at Museums in Massachusetts." Conference Presentation. Native American and Indigenous Studies Conference. NAISA. Washington, DC. June 3–6.

Anderson, Maria. 2015. "5 Reasons the Inka Road Is One of the Greatest Achievements in Engineering." *Smithsonian Science News*, May 20. http:// smithsonianscience.si.edu/2015/05/5-reasons-the-inka-road-is-one-of-the- greatest-achievements-in-engineering/.

"Appendix A: Profile and Mission Statement." 2007. *Programs and Services Guide: 2007–2008*. Smithsonian Institution, National Museum of the American Indian. http://nmai.si.edu/collaboration/files/CS_Guide_English0708.pdf.

"Archaeology at the Mount Pleasant Indian Industrial Boarding School." 2014. Panel. *Debwewin/Truth: The Mount Pleasant Indian Industrial Boarding School Experience*. Exhibit. March 15–September 30. Mount Pleasant, MI: Ziibiwing Center of Anishinabe Culture & Lifeways.

"Archivist Working to Tell Haskell's History." 1999. *Topeka Capital Journal*, December 20. http://cjonline.com/stories/122099/kan_haskellhistory.shtml.

Archuleta, Elizabeth. 2008. "Gym Shoes, Maps, and Passports, Oh My!: Creating Community or Creating Chaos at the National Museum of the American Indian?" In *The National Museum of the American Indian: Critical Conversations*, edited by Amy Lonetree and Amanda J. Cobb, 181–207. Lincoln: University of Nebraska Press.

Atalay, Sonya. 2008. "No Sense of the Struggle: Creating a Context for Survivance at the National Museum of the American Indian." In *The National Museum of the American Indian: Critical Conversations*, edited by Amy Lonetree and Amanda J. Cobb, 267–289. Lincoln: University of Nebraska Press.

———. 2010 "'Diba Jimooyung'—Telling Our Story: Colonization and Decolonization of Archaeological Practice from an Anishinabe Perspective." In *World Archaeological Congress (WAC) Handbook of Postcolonial Archaeology*, edited by Jane Lydon and Uzma Z. Rizvi, 61–72. Walnut Creek, CA: Left Coast Press.

———. 2012. *Community-Based Archaeology: Research with, by, and for Indigenous and Local Communities*. Berkeley: University of California Press.

Atalay, Sonya, Lee Rains Clauss, Randall H. McGuire, and John R. Welch, eds. 2014. *Transforming Archaeology: Activist Practices and Prospects*. Walnut Creek, CA: Left Coast Press.

"Awards." 2014. Ziibiwing Center of Anishinabe Culture & Lifeways. http://www.sagchip.org/ziibiwing/aboutus/awards.htm.

Barker, Joanne. 2005. "For Whom Sovereignty Matters." In *Sovereignty Matters: Locations of Contestation and Possibility in Indigenous Struggles for Self-Determination*, edited by Joanne Barker, 1–32. Lincoln: University of Nebraska Press.

Barringer, Tim, and Tom Flynn. 1998. *Colonialism and the Object: Empire, Material Culture, and the Museum*. New York: Routledge.

Bawarshi, Anis S., and Mary Jo Reiff. 2010. *Genre: An Introduction to History, Theory, Research, and Pedagogy*. West Lafayette, IN: Parlor Press.

Berkhofer, Robert F. 1979. *The White Man's Indian: Images of the American Indian from Columbus to the Present*. New York: Vintage/Random House.

Beyond the Reach of Time and Change. 2005–present. Exhibit. Lawrence, KS: Haskell Cultural Center and Museum.

Beyond the Reach of Time and Change. 2005. Simon J. Ortiz, ed. Tucson: University of Arizona Press.

Bird, S. Elizabeth. 1996. *Dressing in Feathers: The Construction of the Indian in American Pop Culture*. New York: Westview Press.

Blair, Carole. 1999. "Contemporary U.S. Memorial Sites as Exemplar's of Rhetoric's Materiality." In *Rhetorical Bodies*, edited by Jack Selzer and Sharon Crowley, 16–57. Madison: University of Wisconsin Press.

"Calendar." 2016. Ziibiwing Center of Anishinabe Culture & Lifeways. http://www.sagchip.org/ziibiwing/calendar/calendar.htm.

Carpio, Myla Vicenti. 2008. "(Un)disturbing Exhibitions: Indigenous Historical Memory at the National Museum of the American Indian." In *The National Museum of the American Indian: Critical Conversations,* edited by Amy Lonetree and Amanda J. Cobb, 290–304. Lincoln: University of Nebraska Press.

Carr, Margie. 2012. "Lawrence Locales: Haskell Cultural Center." *Lawrence Journal-World*, May 6. http://www2.ljworld.com/news/2012/may/06/lawrence-locales-haskell-cultural-center/.

Carroll, Diane. 2002. "American Indian Culture Has New Home at Haskell." *Kansas City Star*, January 2.

"Center to Enlighten the World on Heritage and History of the Saginaw Chippewa Tribe." 2004. *Tribal Observer*, January 15. http://www.sagchip.org/tribalobserver/article_old_archive.aspx?article=291#.VqfcEfHIQvo.

"The Central Michigan University Chippewas." 2015. Office of the Provost, Institutional Diversity. Central Michigan University. https://www.cmich.edu/office_provost/OID/NAP/HP---ToBeAChippewa/Pages/The_CMU_Chippewas.aspx.

Cerámica de los Ancestros: Central America's Past Revealed. 2013–2015. Exhibit. Washington, DC: Smithsonian Institution, National Museum of the American Indian.

Cerámica de los Ancestros: Central America's Past Revealed: Gallery Guide for Young People and Their Families. 2013. Exhibit Brochure. Washington, DC: Smithsonian Institution, National Museum of the American Indian.

"Ceramics Provide a View into the Dynamic Life and History of Seven Central American Countries." 2013. Washington, DC: Smithsonian Institution, National Museum of the American Indian. http://newsdesk.si.edu/releases/ceramics-provide-view-dynamic-life-and-history-seven-central-american-countries.

Cheyfitz, Eric. 2006. "The (Post)Colonial Construction of Indian Country: U.S. American Indian Literatures and Federal Indian Law." In *The Columbia Guide to American Indian Literatures of the United States Since 1945*, edited by Eric Cheyfitz, Kimberly M. Blaeser, and Michael A. Elliott, 13–152. New York: Columbia University Press.

Child, Brenda J. 2009. "Creation of the Tribal Museum." In *Contesting Knowledge: Museums and Indigenous Perspectives*, edited by Susan Sleeper-Smith, 251–256. Lincoln: University of Nebraska Press.

"Chivington." Label. 2014. *Debwewin/Truth: The Mount Pleasant Indian Industrial Boarding School Experience*. Exhibit. March 15–September 30. Mount Pleasant, MI: Ziibiwing Center of Anishinabe Culture & Lifeways.

Cloutier, Frank. 2010. "Boundary Settlement Finalized: Federal Court Judge Makes Ruling in Five Year Old Litigation over Reservation Boundaries." *Tribal Observer*, December 1. http://www.sagchip.org/tribalobserver/archive/2010-swf/120110-v21i12.htm.

"Community Pride." 2004. *Tribal Observer*, June 1.

Coombes, Annie, ed. 2006. *Rethinking Settler Colonialism: History and Memory in Australia, Canada, Aotearoa New Zealand, and South Africa*. New York: Manchester University Press.

Cooper, Karen Coody, and Nicolasa I. Sandoval, eds. 2006. *Living Homes for Cultural Expression: North American Native Perspectives on Creating Community Museums*. Washington, DC: Smithsonian Institution, National Museum of the American Indian.

"Creating the Isabella Reservation." 2014. Clarke Historical Library. Central Michigan University. https://www.cmich.edu/library/clarke/ResearchResources/Native_American_Material/Treaty_Rights/Historical_Issues/Land_Distribution_and_Ownership/Pages/Creating-the-Isabella-Reservation.aspx.

Crupper, Carol. 2010. "A Healing Garden Grows: Haskell Indian Nations University." *Native Peoples Magazine*, May-June. http://www.nativepeoples.com/Native-Peoples/May-June-2010/A-Healing-Garden-Grows-Haskell-Indian-Nations-University/.

"Cultural Center: About Us." 2015. Haskell Indian Nations University. http://www.haskell.edu/cultural-center/about.php.

Debwewin/Truth: The Mount Pleasant Indian Industrial Boarding School Experience. 2014. Exhibit. March 15–September 30. Mount Pleasant, MI: Ziibiwing Center of Anishinabe Culture & Lifeways.

Deloria, Philip J. 1998. *Playing Indian*. New Haven, CT: Yale University Press.

———. 2004. *Indians in Unexpected Places*. Lawrence: University Press of Kansas.

Devitt, Amy J. 2004. *Writing Genres*. Carbondale: Southern Illinois University Press.

Diba Jimooyung: Telling Our Story. 2004–Present. Exhibit. Mount Pleasant, MI: Ziibiwing Center of Anishinabe Culture & Lifeways.

Diba Jimooyung: Telling Our Story: A History of the Saginaw Ojibwe Anishinabek. 2005. Mount Pleasant: Saginaw Chippewa Indian Tribe of Michigan and the Ziibiwing Cultural Society.

"Diba Jimooyung." 2004. Panel. *Diba Jimooyung: Telling Our Story*. Exhibit. Mount Pleasant, MI: Ziibiwing Center of Anishinabe Culture & Lifeways.

Dickinson, Greg, Carole Blair, and Brian L. Ott, eds. 2010. *Places of Public Memory: The Rhetoric of Museums and Memorials*. Tuscaloosa: University of Alabama Press.

Dingfelder, Sadie. 2015. "'The Great Inka Road' Details the Empire's Amazing Thoroughfare." *Washington Post Express*, June 25. https://www.washingtonpost.com/express/wp/2015/06/25/the-great-inka-road-details-the-empires-amazing-thoroughfare/.

DouglasCounty Newcomersguide. 2007. Lawrence, KS: Sunflower.

Eakins, Paul. 2001. "Haskell Cultural Center Nears Completion." *Topeka Capital Journal*, October 20. http://cjonline.com/stories/102001/kan_culturecenter.shtml.

Edwards, Elizabeth, Chris Gosden, and Ruth Phillips, eds. 2006. *Sensible Objects: Colonialism, Museums, and Material Culture*. New York: Bloomsbury Academic.

Ekdahl, Bonnie. 2005. "Ziibiwing Center of Anishinabe Culture & Lifeways Celebrates First Anniversary." *Tribal Observer*, August 16. http://www.sagchip.org/tribalobserver/article_old_archive.aspx?article=1128#.VqfZ_vHIQvo.

———. 2007. Interview with the author. March 8.

The Enduring Spirit of Our People: A Photographic Retrospective of the Saginaw Chippewa Indian Tribe of Michigan. 2004–Present. Exhibit. Mount Pleasant, MI: Soaring Eagle Casino and Resort and Ziibiwing Center of Anishinabe Culture & Lifeways.

The Enduring Spirit of Our People: A Photographic Retrospective of the Saginaw Chippewa Indian Tribe of Michigan. 2015. Exhibit brochure. Mount Pleasant, MI: Ziibiwing Center of Anishinabe Culture & Lifeways. http://www.sagchip.org/ziibiwing/exhibits/images/ESprt.pdf.

Epstein, Edward. 2004. "From Conquest to Casinos in Eyes of Indians: New Museum Shows Vitality of Cultures." *San Francisco Gate*, September 26. http://www.sfgate.com/travel/article/From-conquest-to-casinos-in-eyes-of-Indians-New-2722353.php.

"Exhibition Website: *The Great Inka Road.*" 2015. Smithsonian Institution: National Museum of the American Indian. http://www.nmai.si.edu/inkaroad/.

"Exhibitions: The Great Inka Road: Engineering an Empire." 2015. Smithsonian Institution: National Museum of the American Indian. http://www.nmai.si.edu/explore/exhibitions/item/?id=945.

"Ezhimaamiikowaadjimigoo Yaang: The Outlandish Stories Told About Us." 2004. Panel. *Diba Jimooyung: Telling Our Story.* Exhibit. Mount Pleasant, MI: Ziibiwing Center of Anishinabe Culture & Lifeways.

"Fact Sheet: *The Great Inka Road* Exhibit." 2015. Smithsonian Institution: National Museum of the American Indian. http://nmai.si.edu/sites/1/files/pdf/press_releases/Inka-Road-Fact-Sheet.pdf.

"Fact Sheet: *Nation to Nation* Exhibition." 2014. Newsdesk: Newsroom of the Smithsonian. Smithsonian Institution. http://newsdesk.si.edu/factsheets/nation-nation-exhibition.

Falk, John. 2012. "The Museum Visitor Experience: Who Visits, Why, and to What Effect?" In *Reinventing the Museum: The Evolving Paradigm Shift*, 2nd ed., edited by Gail Anderson, 317–329. New York: Altamira Press.

Falk, John, and Lynn Dierking. 2011 (1992). *The Museum Experience.* Walnut Creek, CA: Left Coast Press (Whalesback, 1992).

———. 2013. *The Museum Experience Revisited.* Walnut Creek, CA: Left Coast Press.

Ferguson, Bruce W. 1996 (1994). "Exhibition Rhetorics: Material Speech and Utter Sense." In *Thinking about Exhibitions*, edited by Reesa Greenberg, Bruce W. Ferguson, and Sandy Nairne, 175–190. New York: Routledge.

Fields, Johnnie. "Sacrifice Panel." *Honoring Our Children* exhibit. Lawrence, KS: Haskell Cultural Center and Museum.

Fisher, Marc. 2004. "Indian Museum's Appeal, Sadly, Only Skin Deep." *Washington Post*, September 20. http://www.washingtonpost.com/wp-dyn/articles/A36831-2004Sep20.html.

"4-Year Report: 2004–2008." 2015. Ziibiwing Center of Anishinabe Culture & Lifeways. http://www.sagchip.org/ziibiwing/aboutus/pdf/4YrReportFinal.pdf.

"Gallery Guide for Young People and Their Families." 2013. Brochure. *Cerámica de los Ancestros* exhibition. 2013–2015. Washington, DC: Smithsonian Institution, National Museum of the American Indian.

Giago, Tim. 2004. "A Museum Should Show the Bad along with the Good." *Native Times*, September 29. http://www.bluecorncomics.com/nmai.htm.

The Great Inka Road: Engineering an Empire. June 2015–April 2018. Exhibit. Washington, DC: Smithsonian Institution, National Museum of the American Indian.

Gover, Kevin. 2014. "Let's Begin a New Chapter in NMAI History." *National Museum of the American Indian Blog.* September. http://blog.nmai.si.edu/main/2014/09/a-new-chapter.html.

"Great Lakes Native American Collection." 2015. Flyer. Mount Pleasant, MI: Ziibiwing Center of Anishinabe Culture & Lifeways. http://www.sagchip.org/ziibiwing/promo/2015/Nov/cranbrook%20flyer.pdf.

Haas, Angela. 2007. "Wampum as Hypertext: An American Indian Intellectual Tradition of Multimedia Theory and Practice." *Studies in American Indian Literatures* 19 (4): 77–100.

Habu, Junko, Clare Fawcett, and John M. Matsunaga, eds. 2008. *Evaluating Multiple Narratives: Beyond Nationalist, Colonialist, Imperialist Archaeologies.* New York: Springer-Verlag.

The Haskell Cultural Center & Museum. 2007. Brochure. Lawrence, KS: Haskell Indian Nations University.

"Haskell Cultural Center and Museum: About Us." 2014. Haskell Indian Nations University. http://www.haskell.edu/cultural-center/about.php.

"Haskell Cultural Center and Museum: Museum Collections and Archives." 2015. Haskell Indian Nations University. http://www.haskell.edu/cultural-center/collections-archives.php.

"Haskell Foundation: Capital Campaigns, Educational Support, Fundraising." 2015. Haskell Foundation. http://www.haskellfoundation.org/home/.

Hasselman, Lori. 2014. "Venida Chenault Becomes Haskell's 7th President." *Indian Leader,* September 23. http://www.theindianleader.com/2014/09/23/venida-chenault-becomes-haskells-7th-president/.

———. 2015. "Art Education Makes a Comeback at Haskell." Indian Country Today Media Network, August 9. http://indiancountrytodaymedianetwork.com/2015/08/09/art-education-makes-comeback-haskell-161213.

Heard, Anita. 2007. Interview with the author. March 8.

Hendricks, Mike, and Mará Rose Williams. "Haskell Hopes for Independence as Campus Mires in Disappointment." 2015. *Kansas City Star,* October 6. http://www.kansascity.com/news/government-politics/article38038422.html.

Her Many Horses, Emil. 2003. "Our Universes Introductory Panel." *Our Universes: Traditional Knowledge Shapes Our World.* Exhibit. Washington, DC: Smithsonian Institution, National Museum of the American Indian.

———. 2007. Interview with the author. May 16.

Hiatt, Fred. 2014. "Moving Beyond the 'Imaginary Indians' Perception." *Washington Post*, September 21. http://www.washingtonpost.com/opinions/ fred-hiatt-moving-beyond-the-imaginary-indians-perception/2014/09/21/ ea1ee614-3f3b-11e4-9587-5dafd96295f0_story.html.

Hill, Charles A., and Marguerite Helmers, eds. 2004. *Defining Visual Rhetorics*. Mahwah, NJ: Routledge.

Hillier, Bill, and Kali Tzortzi. 2011. "Space Syntax: The Language of Museum Space." In *A Companion to Museum Studies*, edited by Sharon Macdonald, 282–301. Malden, MA: Wiley-Blackwell.

"History." 2015. City of Mount Pleasant Michigan. http://www.mt-pleasant. org/our_city/history.asp.

"History of the Tribe." 2015. Ziibiwing Center of Anishinabe Culture & Lifeways. http://www.sagchip.org/ziibiwing/aboutus/history.htm.

History Map: Directory of Historical Sites and Organizations. 2005. Kansas City, MO: Heritage League of Greater Kansas City.

Hoelscher, Steven. 2011. "Heritage." In *A Companion to Museum Studies*, edited by Sharon Macdonald, 198–218. Malden, MA: Wiley-Blackwell.

Hoffman, Bryce T. 2004. "Telling Their Story—Saginaw Chippewa's to Open Cultural Center and Museum." *Grand Rapids Press*, May 19. http://www. sagchip.org/ziibiwing/aboutus/articles/Telling_There_Story_Cultural_ Center.htm.

"Honoring, Healing, and Remembering." 2015. Flyer. Saginaw Chippewa Indian Tribe. http://www.sagchip.org/news/files/Flyer_2015-05-18.pdf.

Honoring Our Children Through Seasons of Sacrifice, Survival, Change, and Celebration. 2002–present. Exhibit. Bobbi Rahder, Theresa Milk, Hope Melius, Charlotte Wilkinson, Gil Hood, Johnnie Fields, Dianne Reyner, curators. Lawrence, KS: Haskell Cultural Center and Museum.

Honoring Our Children: Through Seasons of Sacrifice, Survival, Change, and Celebration. 2002. Exhibit brochure. Lawrence, KS: Haskell Indian Nations University.

Hooper-Greenhill, Eilean. 1999a. *The Educational Role of the Museum*. 2nd ed. New York: Routledge.

———. 1999b. *Museum, Media, Message*. New York: Routledge.

———. 2000. *Museums and the Interpretation of Visual Culture*. New York: Routledge.

———. 2007. *Museums and Education: Purpose, Pedagogy, Performance*. New York: Routledge.

"Inka Road Still a Monumental Achievement after 500 Years." 2015. *Popular Archaeology*, June 28. http://popular-archaeology.com/issue/summer-2015/article/inka-road-still-a-monumental-achievement-after-500-years.

Isaac, Gwyneira. 2008. "What Are Our Expectations Telling Us?: Encounters with the National Museum of the American Indian." In *The National Museum of the American Indian: Critical Conversations,* edited by Amy Lonetree and Amanda J. Cobb, 241–266. Lincoln: University of Nebraska Press.

Jamieson, Kathleen M. 1975. "Antecedent Genre as Rhetorical Constraint." *Quarterly Journal of Speech* 61 (December): 406–415.

Johnson, William. 2014. "Honoring, Healing, and Remembering." Label. *Debwewin/Truth: The Mount Pleasant Indian Industrial Boarding School Experience*. Exhibit. March 15–September 30. Mount Pleasant, MI: Ziibiwing Center of Anishinabe Culture & Lifeways.

Jonaitis, Aldona. 2006. "Review Essay: 'Listening to Our Ancestors: The Art of Native Life along the North Pacific Coast.'" *Museum Anthropology* 29 (2): 128–132.

———. With Janet Catherine Berlo. 2008. "'Indian Country' on the National Mall: The Mainstream Press versus the National Museum of the American Indian." In *The National Museum of the American Indian: Critical Conversations,* edited by Amy Lonetree and Amanda J. Cobb, 208–240. Lincoln: University of Nebraska Press.

Kennicott, Philip. 2014. "'Nation to Nation': Full of the Intriguing, Often Maddening Details of History." *Washington Post*, September 23. http://www.washingtonpost.com/entertainment/museums/nation-to-nation-full-of-the-intriguing-often-maddening-details-of-history/2014/09/23/a46b9aca-4019-11e4-b0ea-8141703bbf6f_story.html.

Kilian, Michael. 2004. "The Universes of the American Indian." *Chicago Tribune*, September 26. http://articles.chicagotribune.com/2004-09-26/travel/0409250225_1_douglas-cardinal-space-museum-national-museum.

King, Lisa. 2008. *Representing the Museum and the People: Rhetorical Sovereignty and the Representational Genres of American Indian Museums*. PhD diss. University of Kansas, Lawrence, 96.

———. 2011. "Speaking Sovereignty and Communicating Change: Rhetorical Sovereignty and the Inaugural Exhibits at the NMAI." *American Indian Quarterly Journal* 35 (1): 75–103.

———. 2014a. "Competition, Complicity, and (Potential) Alliance: Native Hawaiian and Asian Immigrant Narratives at the Bishop Museum." Native/Asian Encounters Special Issue, *College Literature* 41 (1): 43–65.

———. 2014b. "Sovereignty Out from Under Glass: Native Hawaiian Rhetorics at the Bishop Museum." In *Huihui: Navigating Art and Literature of the*

Pacific, edited by Jeffrey Carroll, Brandy Nālani McDougall, and Georganne Nordstrom. Honolulu: University of Hawai'i Press.

Kreps, Christina. 2003. *Liberating Culture: Cross-Cultural Perspectives on Museums, Curation, and Heritage Preservation*. New York: Routledge.

Lawlor, Mary. 2006. *Public Native America: Tribal Self-Representations in Casinos, Museums, and Powwows*. New Brunswick, NJ: Rutgers University Press.

"Let Debwewin/Truth be revealed . . ." 2014. Label. *Debwewin/Truth: The Mount Pleasant Indian Industrial Boarding School Experience*. Exhibit. March 15–September 30. Mount Pleasant, MI: Ziibiwing Center of Anishinabe Culture & Lifeways.

Lewin, Sam. 2004. "Museum Comes Under Fire from AIM: Activists Unhappy with Displays, Lack of Information." *Native Times*, September 23. http://www.bluecorncomics.com/nmai.htm.

Lied Center of Kansas: 2007–2008 Season. 2007. Lawrence: University of Kansas Lied Center.

Listening to Our Ancestors: The Art of Native Life Along the North Pacific Coast. 2006–2007. Exhibit. Washington, DC: Smithsonian Institution, National Museum of the American Indian.

Listening to Our Ancestors: The Art of Native Life Along the North Pacific Coast. 2007. Exhibit Brochure. Smithsonian Institution, National Museum of the American Indian. http://nmai.si.edu/listening/listening_brochure.pdf.

Lonetree, Amy. 2008a. "'Acknowledging the Truth of History': Missed Opportunities at the National Museum of the American Indian." In *The National Museum of the American Indian: Critical Conversations*, edited by Amy Lonetree and Amanda J. Cobb, 305–330. Lincoln: University of Nebraska Press.

———. 2008b. "Review: 'Diba Jimooyung: Telling Our Story.'" *Journal of American History*. 95, no. 1 (June): 158–163.

———. 2009. "Museums as Sites of Decolonization: Truth Telling in National and Tribal Museums." In *Contesting Knowledge: Museums and Indigenous Perspectives*, edited by Susan Sleeper-Smith, 322–337. Lincoln: University of Nebraska Press.

———. 2012. *Decolonizing Museums: Representing Native America in National and Tribal Museums*. Chapel Hill: University of North Carolina Press.

Lonetree, Amy, and Amanda J. Cobb-Greetham, eds. 2008. *The National Museum of the American Indian: Critical Conversations*. Lincoln: University of Nebraska Press.

"Loss of Reservation Land." 2014. Clarke Historical Library, Central Michigan University. https://www.cmich.edu/library/clarke/ResearchResources/

Native_American_Material/Treaty_Rights/Historical_Issues/Land_
Distribution_and_Ownership/Pages/Loss-of-Reservation-Land.aspx.

Love, K., and D. Webster. 2006. *Garden of Healing: Haskell Indian Nations University Cultural Center and Museum*. Lawrence, KS: Haskell Indian Nations University.

Ludwig, Joy. 2001. "HINU Cultural Center, Museum Celebrated with Ceremony." *Lawrence Journal World*, July 28. http://www2.ljworld.com/news/2001/jul/28/hinu_cultural_center_museum/.

Lyons, Scott Richard. 2000. "Rhetorical Sovereignty: What Do American Indians Want from Writing?" *College Composition and Communication* 51, no. 3 (February): 447–468.

———. 2010. *X-Marks: Native Signatures of Assent*. Minneapolis: University of Minnesota Press.

Macdonald, Sharon, ed. 2011. *A Companion to Museum Studies*. Malden, MA: Wiley-Blackwell.

Mahaffey, Holly. 2014. "Ziibiwing Center Opens New Indian Boarding School Exhibit." *Morning Sun News*, March 18. http://www.sagchip.org/ziibiwing/aboutus/articles/2014/031814-exhibit.pdf.

Map and Guide: National Museum of the American Indian, Smithsonian Institution. 2004. London: Scala.

Martin, Shannon. 2007. Interview with the author. March 8.

———. 2008. "Letter from the Director." In "4-Year Report: 2004–2008." Mount Pleasant, MI: Ziibiwing Center of Anishinabe Culture & Lifeways. http://www.sagchip.org/ziibiwing/aboutus/pdf/4YrReportFinal.pdf.

———. 2014. Interview with the author. July 17.

McMullen, Ann. 2007. Interview with the author. May 17.

———. 2014. Interview with the author. July 1.

Mihesuah, Devon. 2000. *Repatriation Reader: Who Owns American Indian Remains?* Lincoln: University of Nebraska Press.

Milk, Theresa. 2007. Interview with the author. August 9.

———. 2010. *Haskell Institute: 19th Century Stories of Sacrifice and Survival*. Lawrence, KS: Mammoth.

Miller, Carolyn R. 1994. "Genre as Social Action." In *Genre and the New Rhetoric*, edited by Aviva Freedman and Peter Medway, 23–42. Bristol, PA: Taylor & Francis.

"Mission Statement." 2014. Smithsonian Institution, National Museum of the American Indian. http://www.nmai.si.edu/about/mission/.

"Mission Statement." 2006. Ziibiwing Center of Anishinabe Culture & Lifeways. http://www.sagchip.org/ziibiwing/aboutus/mission.htm.

"Mount Pleasant Facility Chronicles Mid-Michigan Tribe." 2004. *Detroit News*, May 23. http://www.sagchip.org/ziibiwing/aboutus/articles/Mt_Pleasant_Facility_chronicles_Tribe.htm.

Narration: This Is about History and about the Past—Two Different Things. 2003. Film. Paul Chaat Smith and Herbert R. Rosen. Dir. Jeff Weingarten. Perf. Floyd Favel.

Nation to Nation: Treaties between the United States and American Indian Nations. 2014–2018. Exhibit. Washington, DC: Smithsonian Institution, National Museum of the American Indian.

"Nation to Nation: Treaties between the United States and American Indian Nations." 2014. Smithsonian Institution, National Museum of the American Indian. http://americanindian.si.edu/explore/exhibitions/item/?id=934.

The Native Universe and Museums in the Twenty-First Century: The Significance of the National Museum of the American Indian. 2005. Washington, DC: Smithsonian Institution, National Museum of the American Indian.

Neuman, Johanna. 2004. "The Capital Salutes Its First Nations." *Los Angeles Times*, September 18. http://articles.latimes.com/2004/sep/18/entertainment/et-neuman18.

"New Changing Exhibit March 21–September 26, 2015." 2015. *Ziibiwing's Blog*. Ziibiwing Center of Anishinabe Culture & Lifeways. https://ziibiwing.wordpress.com.

"New Changing Exhibit Opens November 4, 2014." 2014. *Ziibiwing's Blog*. Ziibiwing Center of Anishinabe Culture & Lifeways. https://ziibiwing.wordpress.com.

The Official Kansas Visitors Guide 2006. 2005. Topeka: Kansas Department of Commerce, Travel and Tourism Division.

Our Lives: Contemporary Life and Identities. 2004–2015. Exhibit. Washington, DC: Smithsonian Institution, National Museum of the American Indian.

Our Peoples: Giving Voice to Our Histories. 2004–2014. Exhibit. Washington, DC: Smithsonian Institution, National Museum of the American Indian.

"Our Peoples: Giving Voice to Our Histories." 2004. Exhibit brochure. Washington, DC: Smithsonian Institution, National Museum of the American Indian.

Our Universes: Traditional Knowledge Shapes Our World. 2004–present. Exhibit. Washington, DC: Smithsonian Institution, National Museum of the American Indian.

Pamp, Judy. 2014. Interview with the author. July 17.

Paskus, Laura. 2011. "Moving toward Healing." *Tribal College Journal of American Indian Higher Education* 23, no. 1 (August 11). http://www.tribalcollegejournal.org/archives/7824.

Pearce, Roy Harvey. 1988 (1953). *Savagism and Civilization: A Study of the Indian and the American Mind.* Berkeley: University of California Press.

Pekarik, Andrew J., and Barbara Mogel. 2010. "Ideas, Objects, or People? A Smithsonian Exhibition Team Views Visitors Anew." *Curator: The Museum Journal* 53 (October): 465–482.

Pember, Mary Annette. 2004. "The National Museum of the American Indian: An Overdue Honor." *Grand Forks Herald*, September 26 (via Blue Corn Comics). http://www.bluecorncomics.com/nmai.htm.

———. 2009. "Haskell Indian Nations University Commemorates 125th Anniversary, Recognizes Painful History." *Diverse: Issues in Higher Education*, June 1. http://diverseeducation.com/article/12608/.

———. 2011. "Ignorance: Is It Bliss?" *Tribal College Journal of American Indian Higher Education* 23, no. 1 (Fall).

———. 2013. "Tiny Horrors: A Chilling Reminder of How Cruel Assimilation Was—And Is." *Indian Country Today Media Network*. http://indiancountrytodaymedianetwork.com/article/tiny-horrors-chilling-reminder-how-cruel-assimilation-was%E2%80%94and-146664.

Phillips, Ruth B. 2006. "Show Times: De-celebrating the Canadian Nation, De-colonising the Canadian Museum, 1967–92." In *Rethinking Settler Colonialism: History and Memory in Australia, Canada, Aotearoa New Zealand, and South Africa*, edited by Annie Coombes, 121–139. New York: Manchester University Press.

———. 2011. *Museum Pieces: Toward the Indigenization of Canadian Museums.* Montreal: McGill-Queen's University Press.

Pierpoint, Mary. 2001a. "Haskell Cultural Center Rises." *Indian Country Today Media Network*, August 13. http://indiancountrytodaymedianetwork.com/2001/08/13/haskell-cultural-center-rises-84813.

———. 2001b. "Haskell Uses Cypress Logs for Cultural Center." *Tribal College: Journal of American Indian Higher Education*, November 15. http://www.tribalcollegejournal.org/archives/8910.

Pittman, Kagan. 2015. "Building a 25,000 Mile Road with Only Stone, Wood, and Bronze Tools." Engineering.com, June 23. http://www.engineering.com/DesignerEdge/DesignerEdgeArticles/ArticleID/10313/Building-a-25000-Mile-Road-with-only-Stone-Wood-and-Bronze-Tools.aspx.

"Plant Walk Exhibit." 2014. Ziibiwing Center of Anishinabe Culture & Lifeways. http://www.sagchip.org/ziibiwing/exhibits/plantwalkexhibit.htm.

Powell, Malea. 2002. "Rhetorics of Survivance: How American Indians *Use* Writing." *College Composition and Communication* 53:393–434.

———. 2004. "Down by the River, or How Susan La Flesche Picotte Can Teach Us about Alliance as a Practice of Survivance." *College English* 67:38–60.

———. 2008. "Dreaming Charles Eastman: Cultural Memory, Autobiography and Geography in Indigenous Rhetorical Histories." In *Beyond the Archives: Research as a Lived Process,* edited by Liz Rohan and Gesa Kirsch, 115–127. Carbondale: Southern Illinois University Press.

Pratt, Richard H. 1892. Excerpt from "Official Report of the Nineteenth Annual Conference of Charities and Correction." 1973 (1892). Reprinted in "The Advantages of Mingling Indians with Whites," in *Americanizing the American Indians: Writings by the "Friends of the Indian" 1880–1900.* Cambridge, MA: Harvard University Press, 2012. Web access via "'Kill the Indian, and Save the Man': Capt. Richard H. Pratt on the Education of Native Americans." History Matters. http://historymatters.gmu.edu/d/4929/.

Prelli, Lawrence, ed. 2006. *Rhetorics of Display.* Columbia: University of South Carolina Press.

"Press Release: Bike Blessing and Rez Ride." 2007. Ziibiwing Center of Anishinabe Culture & Lifeways. http://www.sagchip.org/ziibiwing/aboutus/press/bikeblast2007_press_release.htm.

"Press Release: The Saginaw Chippewa Indian Tribe and Ziibiwing Cultural Society Announce Opening of the Ziibiwing Center." 2004. Ziibiwing Center of Anishinabe Culture & Lifeways. March 31.

"Press Release: 3rd Annual Monarch Butterfly Celebration." 2009. Ziibiwing Center of Anishinabe Culture & Lifeways. August 19. http://www.sagchip.org/ziibiwing/aboutus/press/081909_press_release.htm.

Rahder, Bobbi. 2003. "The Haskell Cultural Center and Museum." 2014. Kansas City Area Archivists. *The Dusty Shelf* 21 (3). http://www.umkc.edu/KCAA/DUSTYSHELF/DS21-3.pdf.

———. 2007. Interview with the author. September 23.

———. 2014. Interview with the author. June 16.

Rand, Judy. 2012. "The Visitors' Bill of Rights." In *Reinventing the Museum: The Evolving Conversation on the Paradigm Shift,* edited by Gail Anderson, 315–316. New York: Altamira Press.

Ranney, Dave. 2000a. "Haskell Plans for a Museum." *Lawrence Journal World,* September 12. http://www2.ljworld.com/news/2000/sep/12/haskell_plans_for/.

———. 2000b. "Offer of Help Still on Table for Haskell Foundation." *Lawrence Journal World,* October 10. http://www2.ljworld.com/news/2000/oct/10/offer_of_help/.

———. 2001. "Haskell History Gets a Home." *Lawrence Journal World*, April 6. http://www2.ljworld.com/news/2001/apr/06/haskell_history_gets/.

———. 2002. "Center Heralds Haskell's History." *Lawrence Journal World*, September 13. http://www2.ljworld.com/news/2002/sep/13/center_heralds_haskells/.

"Report of Findings from the Study of Micro-Aggressions and Other Hostile Encounters between Tribal Members and Non-Natives in Isabella County." 2014. Human Rights Committee of Isabella County. http://www.isabellacounty.org/images/stories/pdf/hrc/IsabellaMicroaggressionNativeReport2014-9-9.pdf.

Resta, Paul, Mark Christal, and Loriene Roy. 2004. "Digital Technology to Empower Indigenous Culture and Education." In *World Yearbook of Education 2004: Digital Technologies, Communities, and Education*, 179–195. London: RoutledgeFalmer.

Richard, Paul. 2004. "Shards of Many Untold Stories: In Place of Unity, a Melange of Unconnected Objects." *Washington Post*, September 20. http://www.washingtonpost.com/wp-dyn/articles/A36886-2004Sep20.html.

Rickard, Jolene, and Gabrielle Tayac. 2004. "Survivance Is More than Just Survival." Label. *Our Lives: Contemporary Life and Identities* exhibit. Washington, DC: Smithsonian Institution, National Museum of the American Indian.

———. With Cynthia L. Chavez and Gabrielle Tayac. 2004. "Now: 21st Century." Label. *Our Lives: Contemporary Life and Identities* exhibit. Washington, DC: Smithsonian Institution, National Museum of the American Indian.

Rickert, Levi. 2014. "Indian Boarding School Exhibit Opens at Ziibiwing Center in Mt. Pleasant." Native News Online, March 21. http://nativenewsonline.net/currents/indian-boarding-school-exhibition-opens-ziibiwing-center-mt-pleasant/.

Riley-Mukavetz, Andrea. 2014. "Towards a Cultural Rhetorics Methodology: Making Research Matter with Multi-Generational Women from the Little Traverse Bay Band." *Rhetoric, Professional Communication and Globalization 5* (February): 1.

Rothstein, Edward. 2004. "Museum Review: Museum with an American Indian Voice." *New York Times*, September 21. http://query.nytimes.com/gst/fullpage.html?res=9E01E4D71539F932A1575AC0A9629C8B63.

———. 2014. "Understanding Wasn't Mutual: 'Nation to Nation' at the Museum of the American Indian." *New York Times*, October 22. http://www.nytimes.com/2014/10/22/arts/design/nation-to-nation-at-museum-of-the-american-indian.html?ref=arts&_r=1.

Roy, Loriene, and A. Arro Smith. 2002. "Supporting, Documenting, and Preserving Tribal Lifeways: Library Services for Tribal Communities in the United States." *World Libraries* 12, no. 1 (Spring). http://www.chrisdaydesign.com/worldlib/vol12no1/roy_v12n1.shtml.

"School History." 2015. Haskell Indian Nations University. http://www.haskell.edu/about/history.php.

Schupman, Ed. 2014. "So What's Up with All Those Questions about Treaties on Columns through the Museum?" *National Museum of the American Indian Blog.* October 7. http://blog.nmai.si.edu/main/education/.

Selzer, Jack, and Sharon Crowley, eds. 1999. *Rhetorical Bodies.* Madison: University of Wisconsin Press.

Shaffer, Randi. 2013. "Central Michigan University Events Center Commemorates Relationship with Saginaw Chippewa Indian Tribe with New Permanent Exhibit." *Morning Sun News,* January 25. http://www.themorningsun.com/article/MS/20130125/NEWS01/130129820.

Shannon, Jennifer A. 2014. *Our Lives: Collaboration, Native Voice, and the Making of the National Museum of the American Indian.* Santa Fe, NM: School for Advanced Research Press.

Shepherd, Sara. 2014a. "Haskell Looks to Future with Inauguration of New President." *Lawrence Journal World,* September 17. http://www2.ljworld.com/news/2014/sep/17/haskell-looks-future-inauguration-new-president/.

———. 2014b. "Haskell Foundation Reorganizing after Years of Problems, Inactivity." *Lawrence Journal World,* October 8. http://www2.ljworld.com/news/2014/oct/08/haskell-foundation-reorganizing-after-years-proble/.

Simpson, Moira. 1996. *Making Representations: Museums in the Post-Colonial Era.* New York: Routledge.

Sleeper-Smith, Susan, ed. 2009. *Contesting Knowledge: Museums and Indigenous Perspectives.* Lincoln: University of Nebraska Press.

Smith, Paul Chaat. 2003a. "The Storm: Guns, Bibles, and Governments." Label. *Our Peoples: Giving Voice to Our Histories* exhibit. Washington, DC: Smithsonian Institution, National Museum of the American Indian.

———. 2003b. With Anne McMullen. "Making History." Label. *Our Peoples: Giving Voice to Our Histories* exhibit. Washington, DC: Smithsonian Institution, National Museum of the American Indian.

———. 2005. "Monthly Curator Series" Lecture. Washington, DC: Smithsonian Institution, National Museum of the American Indian. March 4.

"Smithsonian Exploring Great Engineering Feat that Was the Inka Road." 2015. *Fox News Latino,* June 24. http://latino.foxnews.com/latino/lifestyle/2015/06/24/smithsonian-exploring-great-engineering-feat-that-was-inka-road/.

"Soaring Eagle Casino and Resort." 2016. http://www.soaringeaglecasino.com.

Sowmick, Joseph V. 2015. "'Honoring, Healing, and Remembering' Event Sheds Light on the Mount Pleasant Indian Industrial Boarding School." *Saginaw Chippewa Indian Tribe*, July 20. http://www.sagchip.org/news. aspx?newsid=479#.VqPXLDYfeMI.

Stromberg, Ernest, ed. 2006. *American Indian Rhetorics of Survivance: Word Medicine, Word Magic.* Pittsburgh, PA: University of Pittsburgh Press.

"Study of Micro-Aggressions and Other Hostile Encounters between Tribal Members and Non-Natives in Isabella County." 2014. Human Rights Committee of Isabella County. http://www.isabellacounty.org/images/ stories/pdf/hrc/IsabellaMicroaggressionNativeFactSheet2014-12-14.pdf.

Tait, Matt. 2015. "Haskell Suspends Football Program, Possibly Others, to Cut Costs." *Lawrence Journal World*, May 21. http://www2.ljworld.com/ news/2015/may/21/haskell-suspends-football-program-2015-season/.

Tayac, Gabrielle. 2014. Interview with the author. June 23–24.

"To Be a Chippewa." 2015. Office of the Provost, Institutional Diversity. Central Michigan University. https://www.cmich.edu/office_provost/OID/NAP/ HP---ToBeAChippewa/Pages/default.aspx.

Trahant, Mark. 2004. "Indian Museum Is Alive—and Working toward a Brighter Future." *Seattle Post-Intelligencer*, September 25. http://www. seattlepi.com/local/opinion/article/Indian-museum-is-alive-and-working- toward-a-1154993.php.

Trope, Jack F. 2013. "The Case for NAGPRA". In *Accomplishing NAGPRA: Perspectives on the Intent, Impact, and Future of the Native American Graves Protection and Repatriation Act*, edited by Sangita Chari and Jaime M. N. Lavallee, 19–54. Corvallis: Oregon State University Press.

Tuhiwai Smith, Linda. 2012. *Decolonizing Methodologies: Research and Indigenous Peoples.* 1999. New York: Zed.

"20 Stunning Views along the Great Inka Road." 2015. Indian Country Today Media Network.

June 23. http://indiancountrytodaymedianetwork. com/2015/06/23/20-stunning-views-along-great-inka-road-160827.

"Undocumented Deaths." 2014. Label. *Debwewin/Truth: The Mount Pleasant Indian Industrial Boarding School Experience.* Exhibit. March 15–September 30. Mount Pleasant, MI: Ziibiwing Center of Anishinabe Culture & Lifeways.

United Nations. 2008. "United Nations Declaration on the Rights of Indigenous Peoples." UN.org.

"U.S. Government Approves Agreement between Saginaw Chippewa Indian Tribe, United States, State of Michigan, Isabella County and City of

Mt. Pleasant to Settle Jurisdiction." 2010. Press release. United States Department of Justice. http://www.justice.gov/opa/pr/us-court-approves-agreement-between-saginaw-chippewa-indian-tribe-united-states-state.

"Venida Chenault Inaugurated as President of Haskell." 2014. Prairie Band Potawatomi, September 17. http://www.pbpindiantribe.com/news.aspx?id=1284.

Vision, Space, Desire: Global Perspectives and Cultural Hybridity. 2006. Washington, DC: Smithsonian Institution, National Museum of the American Indian.

"Vision Statement." 2015. Haskell Indian Nations University. http://www.haskell.edu/about/vision.php.

"Walking with Our Sisters." 2016. Saginaw Chippewa Indian Tribe website. January 4. http://www.sagchip.org/news.aspx?newsid=675#.VqPbxDYfeMI.

Warrington, Jancita. 2014. Interview with the author. June 17.

Warrior, Robert. 1995. *Tribal Secrets: Recovering American Indian Intellectual Traditions.* Minneapolis: University of Minnesota Press.

"Welcome." 2014. Panel. *imagiNations Activity Center.* Washington, DC: Smithsonian Institution, National Museum of the American Indian.

West, W. Richard, Jr., ed. 2000. *The Changing Presentation of the American Indian.* Seattle: University of Washington Press.

West, W. Richard, Jr., and Amanda J. Cobb. 2005. "Interview with W. Richard West, Director, National Museum of the American Indian." *American Indian Quarterly* 29 (3-4): 517–537.

Wildcat, Daniel. 2007. Interview with the author. August.

Witcomb, Andrea. 2003. *Reimagining the Museum: Beyond the Mausoleum.* New York: Routledge.

Woodland Exhibit: Honoring Haskell's 7th President, Dr. Venida Chenault. September 2014–June 2015. Exhibit. Curators Jancita Warrington and Hattie Mitchell, in consultation with the Prairie Band Potawatomi. Lawrence, KS: Haskell Cultural Center and Museum.

"Ziibiwing Centre of Anishinabe Culture & Lifeways." 2016. *Walking With Our Sisters.* http://walkingwithoursisters.ca/events/2016-2/mount-pleasant/.

"Ziibiwing Center of Anishinabe Culture and Lifeways." 2004. *Tribal Observer,* June 1.

Ziibiwing Cultural Society. 2005. *Ziibiwing Center of Anishinabe Culture & Lifeways: Take a Walk in Our Shoes.* Berrien Center, MI: Penrod/Hiawatha.

Index